PATRICK KELLY

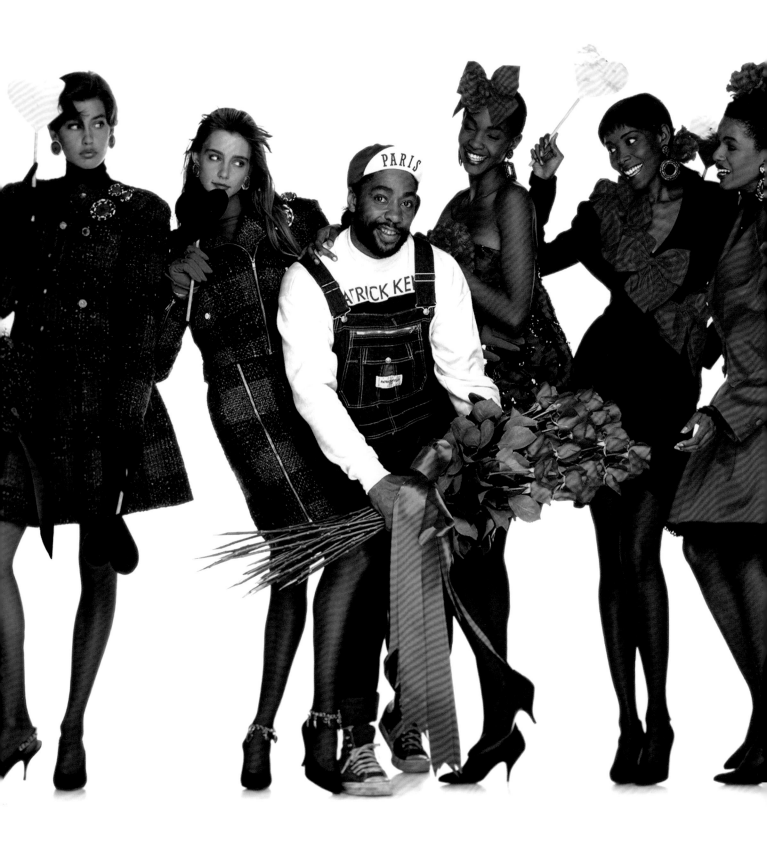

PATRICK KELLY
RUNWAY OF LOVE

LAURA L. CAMERLENGO

WITH

DILYS E. BLUM

AND

SEQUOIA BARNES, DARNELL-JAMAL LISBY,
MADISON MOORE, AND ERIC DARNELL PRITCHARD

WITH A SPECIAL CONTRIBUTION BY
ANDRÉ LEON TALLEY

PUBLISHED BY THE FINE ARTS MUSEUMS OF SAN FRANCISCO
IN ASSOCIATION WITH YALE UNIVERSITY PRESS, NEW HAVEN AND LONDON

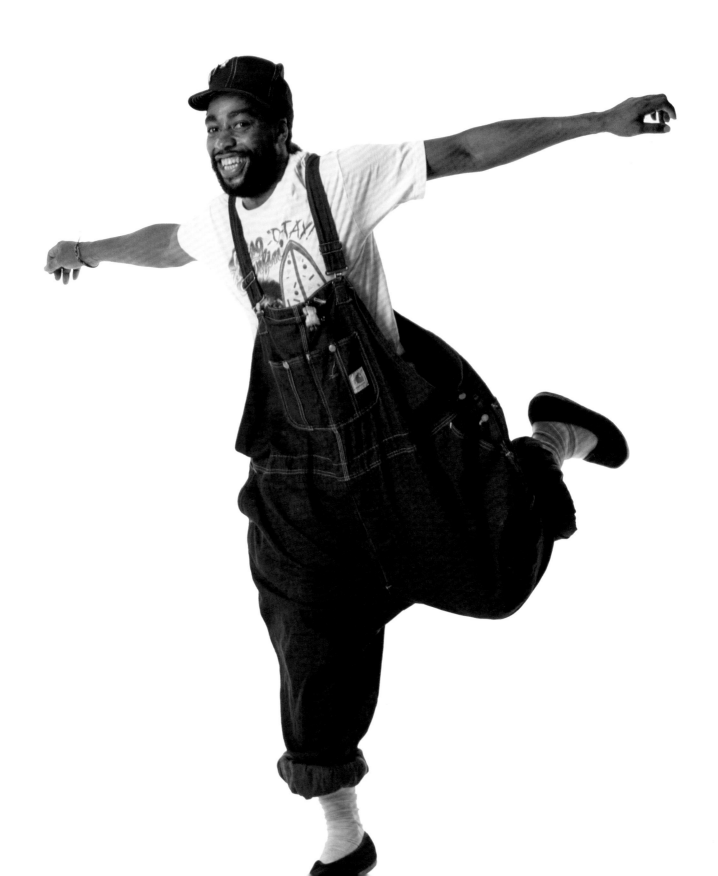

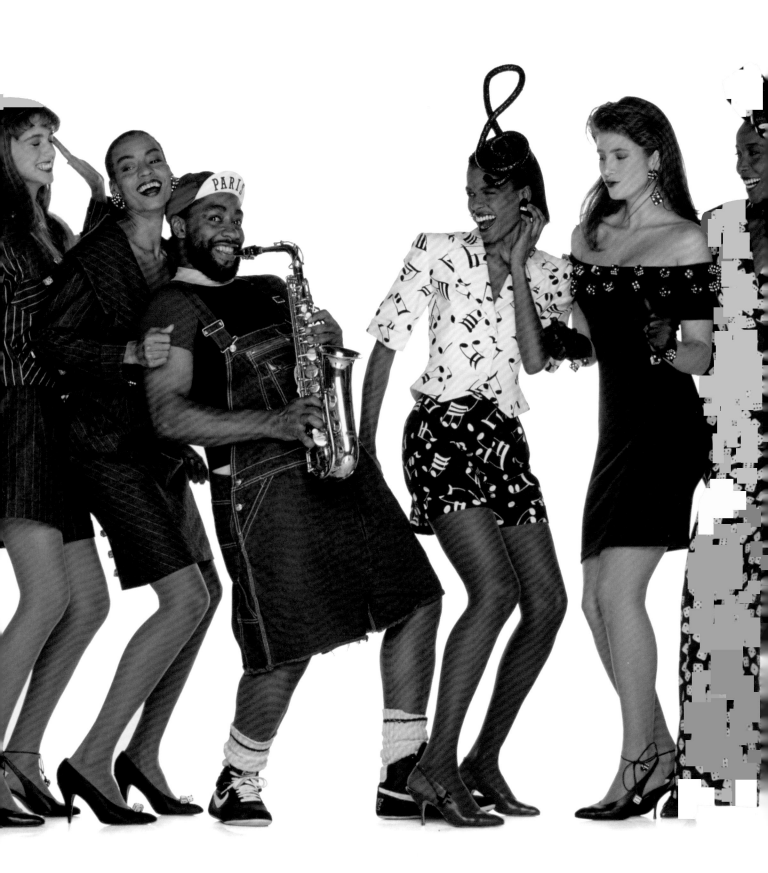

Foreword

THOMAS P. CAMPBELL, DIRECTOR AND CEO

The Fine Arts Museums of San Francisco's presentation *Patrick Kelly: Runway of Love* celebrates the remarkable career and enduring legacy of the fashion designer Patrick Kelly (American, 1954–1990). Although Kelly's company operated for just five years (1985–1990), his lighthearted yet sophisticated designs inspired by his Mississippi childhood, by New York and Parisian nightlife, and by fashion, art, and Black histories, pushed boundaries in his day, and he remains a potent cultural figure. First organized and presented by the Philadelphia Museum of Art in 2014, the exhibition displays eighty-two fully accessorized ensembles, dating from 1984 to 1990, from the Philadelphia Museum's archive of Kelly's work. Photographs, runway footage, sketches, memorabilia, and ephemera accompany these designs to form a lively show that embodies the joyful spirit of the designer and his creative output.

This project builds upon our previous efforts to ensure that our exhibition program highlights artists who have been historically underrepresented or marginalized, to ensure balance in who and what we present. This presentation rebuts not only the exclusionary and unrepresentative Western art canon, but also the equally limited canon of fashion. As such, *Patrick Kelly: Runway of Love* lauds the artistry of a pathbreaking, yet still underrecognized, Black fashion designer whose work continues to captivate. We are delighted that the Philadelphia Museum of Art agreed to share this exhibition, the result of many years of research, with our audiences. We are grateful to Timothy F. Rub, the George D. Widener Director and Chief Executive

Officer at the Philadelphia Museum, for his support of the presentation, and to organizing curator, Dilys E. Blum, the Jack M. and Annette Y. Friedland Senior Curator of Costume and Textiles, for realizing Kelly's matchless vision anew. We also acknowledge the late Monica E. Brown, senior collections assistant for costume and textiles, who spearheaded the Philadelphia Museum's acquisition of the Patrick Kelly archive, and provided unparalleled curatorial support throughout the realization of this gift and the organization of the ensuing exhibition. We are thankful that the presentation will travel to the Peabody Essex Museum in Salem, Massachusetts, after its presentation by the Fine Arts Museums.

The Fine Arts Museums are immensely proud to serve as the only West Coast venue for the revised exhibition, and to include in our presentation additional artworks from several key lenders and donors. We are grateful for the extraordinary generosity of Bjorn Guil Amelan, Kelly's former business and life partner, and Bill T. Jones, for sharing the designer's personal effects with the Museums, including photographs, papers, ephemera, and collections. We thank Kevin Young, director of the Schomburg Center for Research in Black Culture, The New York Public Library, and Cheryl Beredo, curator of the Manuscripts, Archives and Rare Books Division, for sharing sketches by Patrick Kelly uniquely with our Museums. Additionally, fashions by Kelly from our renowned costume holdings enrich this presentation. We are immensely grateful for these recent gifts to the Museums' collection by Kelly's dear friends and colleagues Elizabeth "Ms. Liz" Goodrum and Audrey Smaltz.

Our Board of Trustees, led by its president, Jason Moment, and its chair emerita, Diane B. Wilsey, has supported bringing this project to our Museums. We acknowledge the tremendous efforts of staff across departments to organize this exhibition and its accompanying catalogue. We thank especially Laura L. Camerlengo, associate curator of costume and textile arts at the Museums, who previously supported the development of this project as exhibition assistant for costume and textiles at the Philadelphia Museum, and has organized its updated presentation at the Fine Arts Museums. We are grateful to Sequoia Barnes, University of Edinburgh, for her thoughtful guidance on this presentation as advising scholar, and we thank the writers who contributed texts to this catalogue: Darnell-Jamal Lisby, madison moore, Eric Darnell Pritchard, André Leon Talley, and other friends and colleagues of Kelly's who have shared their wonderful memories of the artist. We also specially recognize Anna Wintour for her support of this project.

We are immensely indebted to our presenting sponsor, Diane B. Wilsey, who has made this valuable project possible. We also thank the Textile Arts Council of the Fine Arts Museums of San Francisco and Mr. Hanley T. Leung for additional support. Lastly, we are thankful to Patrick Kelly, for his jubilant artistic vision. As Patrick Kelly himself proclaimed, "I want my clothes to make you smile." We are thankful that our audiences will have the opportunity to do so in *Patrick Kelly: Runway of Love*.

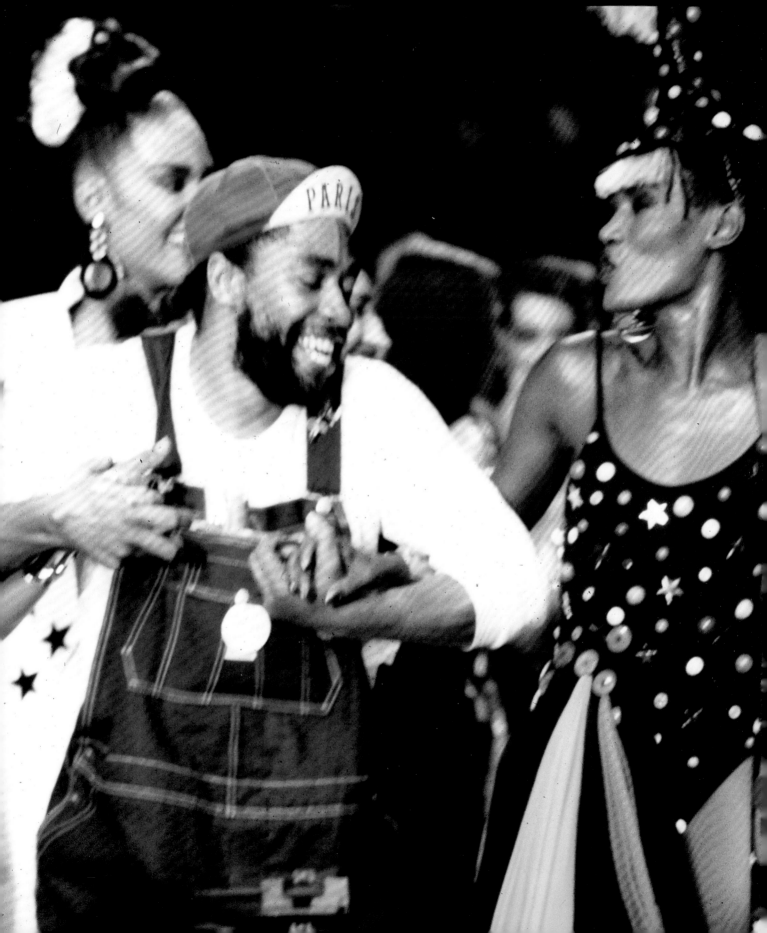

Runway Jubilee

ANDRÉ LEON TALLEY

Patrick Kelly, in his short thirty-five years, lived to be the only Black fashion designer to turn Paris upside down, inside out, on its venerable fashion shoulders. His meteoric rise in the world of ready-to-wear fashion, and his couture collections, have earned him a significant place in fashion history. His was a brand that was financially lucrative.

Paris embraced him the way they embraced Josephine Baker, his favorite muse, another individual who rose from the American Black Southern tradition to become famous worldwide.

Patrick struggled, yet he sustained success, scoring hits despite the many bumps on his journey. His clothes were sold in stores like Bergdorf Goodman and Neiman Marcus during his reign in the eighties. In 1987, three years before his death, due to complications from AIDS, he signed a licensing deal with Warnaco, which enabled him to manufacture his collections to sell all over the world. Pierre Bergé, the partner of the great Yves Saint Laurent and the business genius behind the couturier's brand, and Sonia Rykiel, another designer who soared to the top of ready-to-wear (based on the little knit sweaters she designed in her Paris apartment while pregnant with her first child), sponsored Patrick for membership in France's Chambre Syndicale du Prêt-à-Porter des Couturiers et des Créateurs de Mode, the prestigious governing body of French fashion designers.

Patrick, born in Vicksburg, Mississippi, in 1954, turned the folklore and memorabilia of his humble, Jim Crow, segregated roots into his distinctive personal style. He began collecting inspiration from the *Vogue* magazines his grandmother brought home from her white employer. From an early age, he vowed that he was going to make clothes for his people—Black women—and he did that. Not only did he dress Black women, but he also dressed women of all races. One of his famous clients was the great actress Bette Davis. In her later years, she always appeared on talk shows in the ubiquitous Patrick Kelly. One dress she wore was a simple black jersey sheath, its collar graphically sewn with a three-strand trompe l'oeil pearl necklace like a full circular bib. Davis and Patrick became friends. Frail, thin, and small, she was at that time a cancer survivor. My fondest memory is of Davis, devoted to Patrick's tube shapes, adorned with bright multicolored buttons.

In fact, his favorite uniform was a hat he found with "Paris" on the brim, worn turned upward, and a pair of old denim overalls, associated with the agricultural workwear that he saw in Vicksburg as a young child. On those outsize one-piece overalls, he would pin several plastic buttons in the colors of the rainbow.

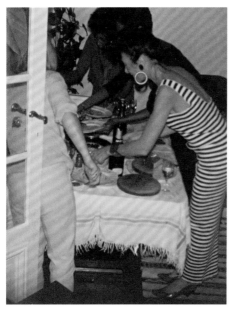

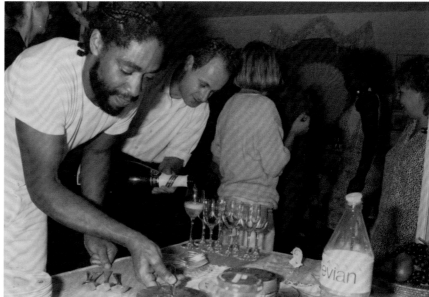

The soaring strength of his work, as well as his incredible success, was like that of many Black cultural giants born in the American South—a world of inequality to people of color due to the continued abuse of systemic racism in America—such as Bessie Smith, Eartha Kitt, or Ma Rainey. Josephine Baker (whom Patrick loved as a mythological heroine) was his great inspiration. He flooded his atelier showroom with original vintage photographs and posters of "La Baker." He knew when there were good ones, giant ones—and he had dozens.

Patrick's mother, a home-economics teacher, taught him to draw, and her sister taught him to sew. After dropping out of college, he moved to Atlanta, where he opened a shop in the early seventies, called Moth Ball Matinee, in a hair salon. What an incredibly brilliant name for an enterprise where he sold vintage clothing and created dresses of his own. And when I met him, in New York at a friend's atelier, he was known for selling vintage Louis Vuitton pieces as well. The fact that Patrick became who he was is because he was smart, educated, and a student of fashion

and fashion history. I think this was the key to his success. When he briefly attended Jackson State University, in Mississippi, before dropping out, he most likely spent his time reading *Vogue*, *Harper's Bazaar*, and any and every book he could find on fashion. He dressed the local campus queens as well as anyone he came across. He was self-taught and ambitious. He dreamed of becoming the personification of the top fashion designer that he so gloriously and joyously became.

Patrick, and I knew him well, was a wonderful man. His spirit was pure; he could charm you into his world of Black Southernness. He collected racist memorabilia: Aunt Jemima cookie jars, Uncle Ben's posters, little Black dolls, everything that had to do with Southern Black folklore. He celebrated the revisionist golliwog doll, transforming it into a symbol of pride, and, drawing from that world of folklore, he turned it into his own personal aesthetic (see moore, this volume). Pivotal to his style were buttons; he used them as decoration on his work. Not only buttons, but also bows, and yes, a T-shirt dress with prints of happy golliwogs. That simple

white dress, stamped with this image, became a garment that was powerful in its historical relevance, designed by a Black man, as well as a sophisticated, cool message print.

He used buttons as decorative trim; integral to his many simple tubelike sheaths, buttons were used to design motifs, messages, shapes. For example, red buttons were sewn on a simple black dress to create heart shapes. Multicolored buttons were embroidered to create a big heart torso. In one design, he created the red lips and big white eyes of blackface on a simple little black dress. Only Patrick Kelly in his day could appropriate the stereotypical racist memes of such cultural images and make them real. He treated them with great sophistication, with respect, and wit. In this realm of ornamentation (using

ANDRÉ LEON TALLEY

white mother-of-pearl buttons to spell his full name down the length of a sleek black evening sheath), his work brings to mind the wonderful, madcap elegance of Elsa Schiaparelli, who became the master of trompe l'oeil conceits. His work is outstanding and is aligned with the success of the Italian brand Moschino, which also fused wit and irony into every seam of a garment. Without buttons (in every size and shape and color!), which he must have discovered in his mother's and her mother's sewing drawers, or perhaps inside the console of a Singer sewing machine, his work would not have caused so much uproarious joy. It was a thrill to attend a fashion show and see the mannequins strike a pose in Patrick's creations. And it took a young Black gay man from Vicksburg, Mississippi, to create such a world of wonder. It was a joy to know Patrick Kelly, a man with an extraordinary presence and a smile that seemed like it was as generous as warm butter on toast.

In 1979, Patrick Kelly moved to Paris, where he was flying high. He at first lived with my friend, Javier Arroyuelo, in his flat near the famous Church of Saint-Sulpice. Patrick was struggling then, but he met Arroyuelo, from Buenos Aires and a brilliant writer, through me. They met at the atelier of Kevin & Robert, two men's designers, in downtown New York; it was love, like a thunderbolt. Arroyuelo had borrowed my best black Valentino leather blouson jacket one evening to wear to dinner. When I asked for it back, he said he had given it to Patrick Kelly. Patrick went to Paris with the jacket, and I never saw it again.

Their relationship lasted for the first two years Patrick was in Paris, while Patrick was fast and furious on his way to the top of the fashion world. He staged guerrilla street fashions at first and evolved his work through his love of antique Black dolls and golliwogs (something that remained, no doubt, from his childhood). Audrey Smaltz, the Ebony Fashion Fair personality, got him a freelance job designing sweaters and, with the support of his lifelong friend Connie Uzzo, of Yves Saint Laurent and personal assistant to Pierre Bergé, his career was made.

Patrick was at work twenty-four hours a day, seven days a week. When he met his partner, Bjorn Guil Amelan, he found stability, and Amelan found them a spacious, beautiful Paris apartment with a view. It was there that, when I attended the collections in Paris, I would be invited for Sunday breakfast-brunch, and Patrick would make the best buttermilk pancakes, country bacon, and biscuits, served with maple syrup he found in Paris (figs. 1–2). These quiet, intimate Sunday gatherings would last well into four or five p.m., where the talk was about everything from the latest Josephine Baker poster he found through a dealer or at a flea market, to the last collection of his favorite designer, Yves Saint Laurent.

In the final years of his life, he had a close relationship with Linda Wachner of Warnaco. She championed him and helped get him into the Chambre Syndicale—supported by her complete belief in his marketing stratagems. "He was a big star," said Wachner, the formidable former CEO of Warnaco, with whom he signed a deal in 1987.

"I met him through Gloria Steinem. She was in Paris and had met Patrick; she called me and asked would I meet with him; he was struggling to keep afloat. I met him and I thought he was just great. He was all about simple dresses with adornment. The whole idea of button chic was his own," said the retired executive.

"He at all times expressed optimism in the future. He was full of joy."

Patrick Kelly died on January 1, 1990. I never went to see him in the hospital, but I know his close-knit friends would go to see him, propped up in bed, smiling and full of life until the end. He requested that he be buried in Père Lachaise Cemetery in Paris. I didn't attend his memorial service in New York at the Fashion Institute of Technology, because I was mourning the death of my grandmother, and of my mentor and dear friend, Diana Vreeland, both of whom had died in 1989.

It was on a Sunday four years later that I paid homage to Patrick. On a bright July day in Paris, I went to Père Lachaise with Deeda Blair, a great friend. That July day she wore a beautiful straw portrait hat with huge silk to drape around her neck to protect her from the sun. We walked around the cemetery looking for Patrick's grave. We discovered that he is resting with giants: Marcel Proust, Oscar Wilde, Edith Piaf, Jim Morrison, Molière, Isadora Duncan, and the literary lion, Honoré de Balzac. It is fitting he desired not to be sent home to Mississippi—his legacy endures in the Paris firmament of this resting place. His elegant, simple sarcophagus is marked with two of his favorite symbols: a red heart and the simple big-eyed Black face of a female golliwog with a huge smile and two bright yellow circles as earrings. These designs are colorful in this eternal gravesite of cold, cold gray stone; they reflect the soul of Patrick Kelly, one big happy moment of joy. And a heart as big as the Mississippi sun.

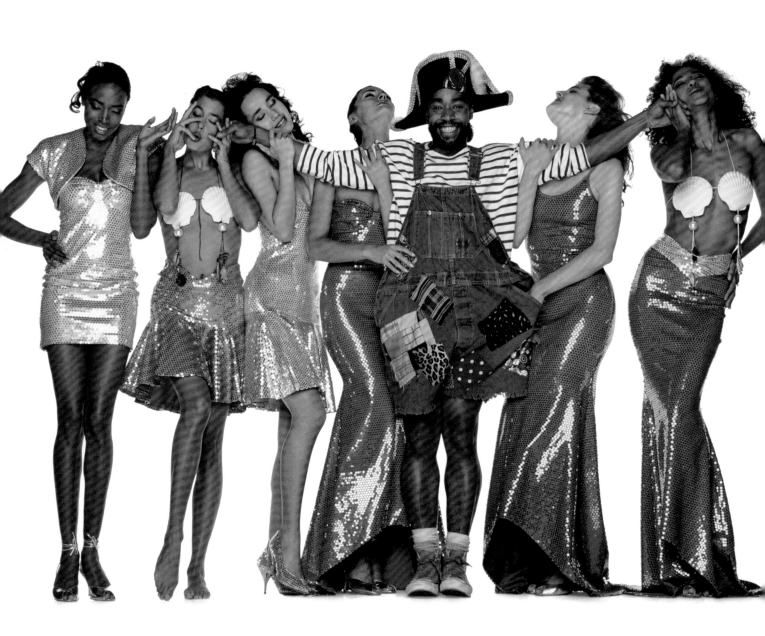

ESSAYS

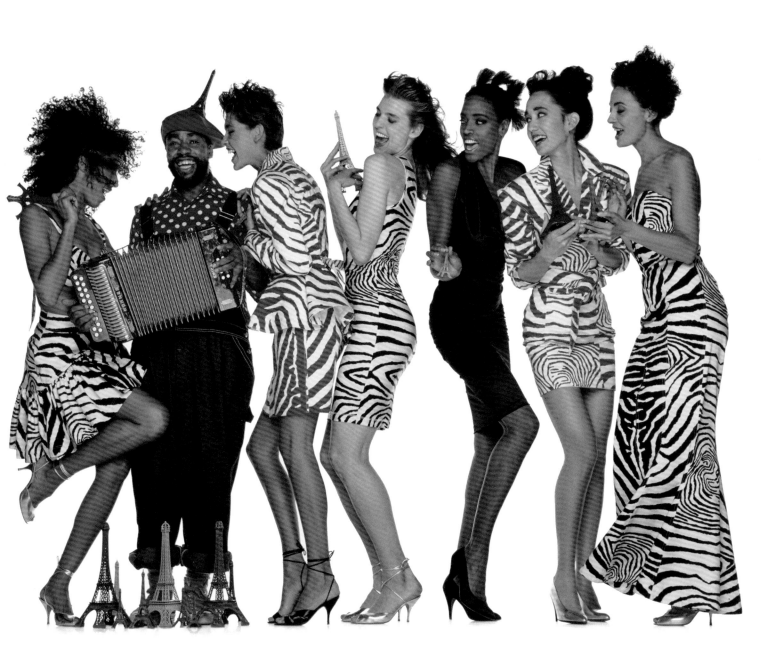

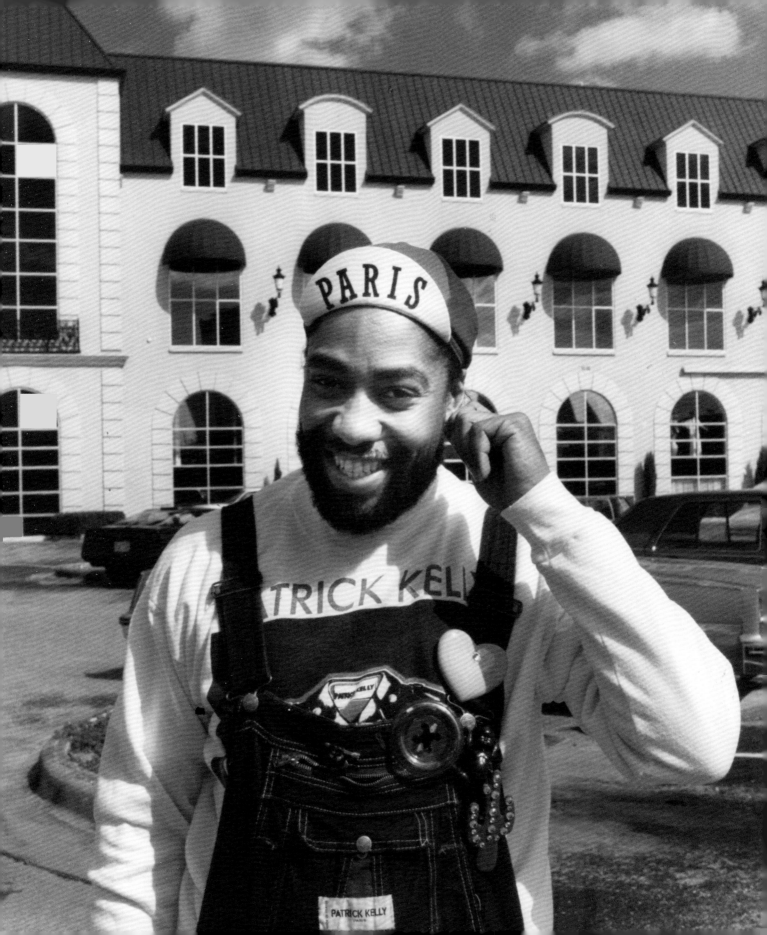

Introduction
Patrick Kelly and Paris Fashion

DILYS E. BLUM

In June 1988, Patrick Kelly became the first American, and the first Black designer, to be elected to France's prestigious Chambre Syndicale du Prêt-à-Porter des Couturiers et des Créateurs de Mode, the official governing body of the French ready-to-wear industry. Kelly's sponsors, Pierre Bergé, founder of the Chambre and cofounder of Yves Saint Laurent, and knitwear designer Sonia Rykiel, thought that his modern attitude, enthusiasm, and youthfulness would help energize the forty-four-member Chambre. The small, custom collection Kelly presented during the haute-couture showings earlier in the year, in January, had made clear that his talents also extended to high fashion. It paid homage to three of fashion's most influential couturiers: Madame Grès, whom Kelly idolized, Elsa Schiaparelli, and Christian Dior. For a designer who was known for spoofing fashion, the collection was elegant and, for the most part, restrained. Kelly transformed Grès's Grecian-like gowns into a figure-hugging black jersey minidress draped in the couturier's signature polka dots of the 1950s (and recently reprised by Emanuel Ungaro) (pl. 47). Schiaparelli's surrealist wit was celebrated in a gray silk-denim suit combining red sequined roses, hearts, stars, and lips, and references that were as much to Michael Jackson as they were to those associated with the couturier: white gloves with red fingernails, a sequined snake, and a medal suspended from a ribbon. Christian Dior's "New Look" was updated to 1988 in a full-skirted black-lace party dress, taffeta apron-like overskirt, and lace bodice embroidered with Dior crimson roses, bringing to mind the short lace dresses Kelly had seen at Geoffrey Beene's Fall/Winter 1987–1988 show the previous April. Kelly's designs subtly merged high fashion with his African American and Southern roots: polka dots were associated with the racially charged Aunt Jemima character, denim with sharecropper and laborer's overalls and, later, civil-rights activists, and aprons with the maid's uniform worn by his grandmother. In October 1988, Kelly presented his first ready-to-wear collection as a member of the Chambre, joining the select group in the Louvre's courtyard for the Spring/Summer 1989 presentations. He imagined that he had been invited by Mona Lisa, the former palace's most famous "resident," and he irreverently framed himself as her alter ego, Kelly Lisa (see Chronology, this volume).

Born in 1954 in Vicksburg, Mississippi, Patrick Kelly evinced a love of fashion from an early age. At age six, after he and his grandmother, Ethel B. Rainey (1897–1994), observed that there were no Black models in the fashion magazines she brought home from her white employer, Kelly announced

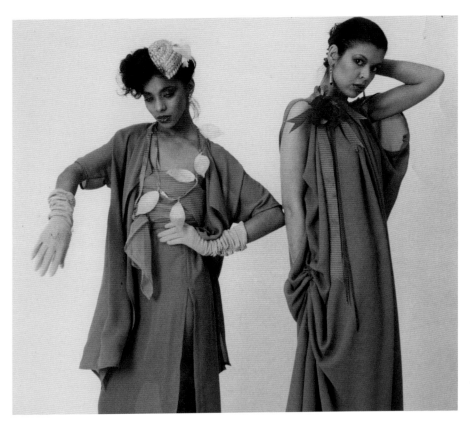

3. Billie Holiday–inspired ensembles, designed by Patrick Kelly, ca. 1974–1979

his intention to become a designer. His mother, Letha Kelly (1922–2014), a home-economics teacher, taught him the basics of drawing, and an aunt taught him how to sew.[1] Kelly adored his grandmother and credited her with being the "backbone of a lot of my tastes."[2] On Sundays, his Black Baptist church in Vicksburg was the ultimate fashion parade, and Kelly later described his grandmother and the other ladies as being dressed "as fierce as the ladies at Yves Saint Laurent haute-couture shows."[3] She encouraged him to follow his dream, wisely counseling: "A sore thumb stands out. If you start to be like everybody else, nobody pays attention to you"–advice he took to heart.[4] By high school Kelly was designing for his friends, and during the year and a half he was enrolled in Jackson State University,

he also styled the Miss Jackson State University and Miss Black Mississippi pageants.

Kelly discovered Paris couture at the Ebony Fashion Fair as a teenager. The experience was a revelation: "I was really impressed, and excited and mad. Even if you had money in Mississippi, who went to see a fashion show?"[5] From 1958 to 2009, the annual traveling extravaganza brought the best in international high fashion to a mostly Black audience in lively, fast-paced productions that lasted more than two hours. The presentations became the model for Black fashion shows across the United States, including those Kelly participated in while living in Atlanta, from 1974 to 1978, and influenced his Paris shows, where he choreographed fashion,

movement, and music into fast-moving narratives and vignettes mostly centered around the African American experience. Audrey Smaltz, Ebony Fashion Fair's commentator from 1970 to 1977, recalled meeting him at her first show in Atlanta, called *The Liberated Look*. The production included Paris couturiers Marc Bohan for Christian Dior, Pierre Cardin, Nina Ricci, Yves Saint Laurent, and Emanuel Ungaro; American fashion icons such as Bill Blass and Rudi Gernreich; and established and up-and-coming Black designers such as Willi Smith, who was making his Fashion Fair debut.

After the show, Kelly, then a gregarious teenager, introduced himself to Smaltz. Impressed by his talent, Smaltz would hire him a decade later, in 1980, to help style a fashion tribute to Black hairstylist Camello "Frenchie" Casimir at Lincoln Center in New York. They would reconnect in Paris, where from 1985, Smaltz and her Ground Crew staff managed Kelly's runway shows backstage. While living in Atlanta, Kelly participated in many local fashion shows. One of the most memorable was *Headline News*, in 1976, organized by rising fashion-show producer Dennis Shortt, then a senior at Morehouse College. It included ready-to-wear from the city's Yves Saint Laurent Rive Gauche, Emilio Pucci, and Givenchy boutiques and designs by "the fabulous Patrick Kelly."[6] Pat Cleveland and Iman, in her American runway debut, modeled for the show (and later for Kelly in Paris). One of his friends remembered the dramatic opening: "a girl in huge overalls throwing newspapers to the audience."[7]

DILYS E. BLUM

Soon after his arrival, Kelly opened a small shop, Moth Ball Matinee, in the back room of the Wizard of Ahs hair salon, where he sold vintage and remodeled clothing and his own designs. He loved trying out new ideas on the salon's stylists. Although he could sew, Kelly did not know how to draft patterns, so he developed his own idiosyncratic construction methods: "He would take a piece of cloth, make a twirl, pin here and there, run to his apartment and poof, a wonderful creation" (fig. 3).[8] During his early years in Paris he continued to design dresses with minimal or no sewing from fabric purchased from the markets, and later from La Soie de Paris knits (fig. 4). Fashion journalist Carol Mongo recalled that "he would show you a million different ways the garment could be worn or styled as he was working with it."[9]

The opening of an Yves Saint Laurent Rive Gauche boutique in Atlanta, in 1974, the same year Kelly moved to the city, provided him with a unique opportunity to study firsthand the best examples of couture-inspired ready-to-wear. The window displays he styled for the luxury boutique, first as a volunteer, were legendary: "People used to take pictures of them. He would do illusions of white tulle, creating clouds on the floor. He would spend the entire day doing the shop. You know he would fluff the whole deal."[10] Connie Uzzo, Rive Gauche's American marketing director, was impressed by Kelly's talent and became a close friend and advocate when he moved to Paris. (She introduced him to Pierre Bergé, who would later sponsor Kelly for membership in the Chambre Syndicale.) Each year the Rive Gauche Fall/Winter collection was presented at Atlanta's Fox Theatre to raise money for charity, and it is very likely that Kelly

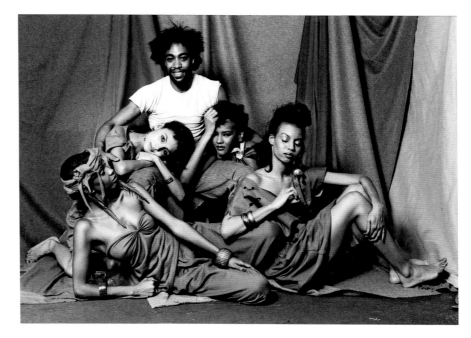

4. Patrick Kelly with Sheila Ming, Carol Miles, Janet Chandler, and Bonni, photographed by Eddie Kuligowski, April 1983

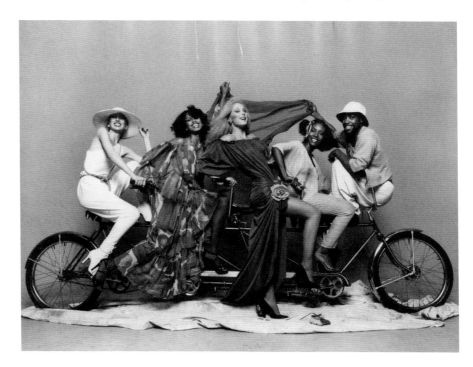

5. Patrick Kelly and models in Atlanta, ca. 1977–1978

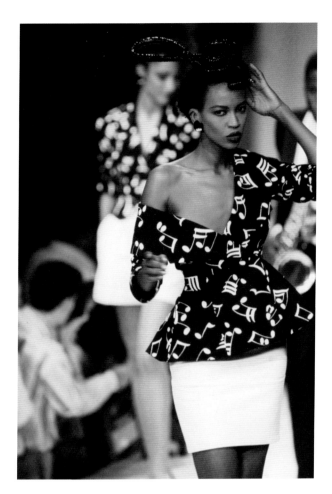

6. A model walks the runway at the Patrick Kelly Paris Spring/Summer 1989 fashion show during Paris Fashion Week, October 1988.

reimagine the couturier's silhouettes and reference Saint Laurent's signature textile designs for his own collections (fig. 6 and pls. 53–55 and 59). Kelly was unapologetic about riffing on the work of his favorite designers, past and present, and according to his former assistant, Elizabeth "Ms. Liz" Goodrum, it was to prove that not only could he do it better and less expensively, but also with a sense of humor. Among his most irreverent send-ups of couture traditions was the fashion show within a fashion show. For Fall/Winter 1986–1987, Kelly spoofed the classic lipstick Rouge Dior, and its many shades, in a runway sequence where the commentator called out the same red color by different names. For his first made-to-order collection, playfully called Mock-Couture, because it was presented unofficially during the traditional haute-couture showings, models carried white cards bearing each outfit's style number as they would have during the 1950s and 1960s. The invitation featured Horst P. Horst's photograph of Kelly dressed in black tie, hair slicked back, cigarette in hand, exuding 1930s male glamour (fig. 7). Horst slyly connects Kelly to the legendary Gabrielle Chanel by posing him reclining on a chaise, re-creating his original portrait of the couturier (fig. 8) from 1937, published in *Vogue*. Kelly's lampoon of Chanel's classics for Fall/Winter 1988–1989 included Miss Cou Cou tweed suits (pls. 41 and 42), some with moto-style "biker" jackets, adorned with look-alike jewelry made with Kelly's signature buttons surrounded by twisted gilt ropes and her faux pearls splashed over body-conscious knit dresses and gauntlet gloves (pl. 43).

Kelly moved to New York in 1978 to attend Parsons School of Design. Remembered as a terrible student, he barely lasted two semesters.[13] Most

helped style the shows, as he did for the fashion and accessory trend events at the Merchandise Mart. An undated photograph of Kelly's work, presented during a small, private showing of his own designs before leaving for New York (fig. 5), includes two looks inspired by Yves Saint Laurent's legendary peasant collection from Spring/Summer 1977. Kelly's versions of the couturier's flowy off-the-shoulder blouses included a see-through blouse, like the original, worn with a flounced skirt, and another design reinterpreted the rose-printed full skirt as a slinky wraparound, open to the thighs (later a Kelly signature), and held in place by an oversize artificial rose. The

show was remembered for its staging (including a four-person bicycle) and shock value: "It was a very avant-garde show. Most of the Mart people, executives, and all of the fashion staff went. One of the outfits was a see-through long-sleeved blouse. At the time, though things were getting pretty wild with *Oh! Calcutta!* and all, that was very risqué for Atlanta."[11]

Kelly attended every Yves Saint Laurent runway show he could get into after he moved to Paris. In 1986, *Women's Wear Daily* noted that he was one of the young designers "who came to worship the master."[12] Saint Laurent remained a touchstone for Kelly, who would

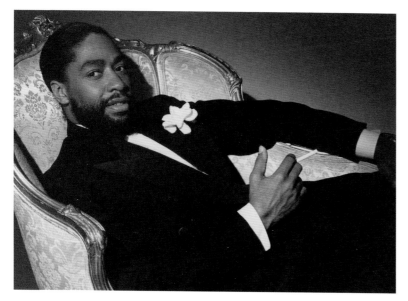

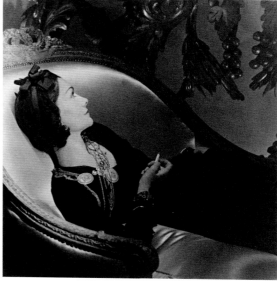

7. Patrick Kelly posed as Gabrielle Chanel, photographed by Horst P. Horst, 1989

8. Portrait of Gabrielle Chanel, photographed by Horst P. Horst, *Vogue*, 1937

nights were spent at Paradise Garage, the gay underground club, dancing into the early hours. His friend Mel West, also a fashion designer, described Kelly as "the perfect self-promoter"[14] who wanted everyone to know who he was. Each night he would bring one or two outfits for the club kids to wear. Soon two fashion insiders, Bobby Breslau, a leather-accessories designer who had worked for Halston, and Geoffrey Beene protégé Jesper Nyeboe, were pushing Kelly to do something with his talent. They introduced him to DJ Larry Levan, who asked him to design a miniskirt for Taana Gardner to wear for her debut performance on the Paradise Garage stage. West recalled that Kelly always listened to music when designing. However, it was not the club sounds he found most inspiring, but "Billie Holiday, Sarah Vaughan, or Dinah Washington,

who represented a style and chic of their own that he wanted to somehow encapsulate and reenergize and bring to women of his generation."[15] Freelance jobs, including projects for other students, were few and far between. Kelly worked briefly with Jack Fuller, a successful Black ready-to-wear designer and 1978 Coty Award nominee, whom he had met in Atlanta in 1975 when the two participated in a National Urban League convention fashion show. Later, Kelly credited Fuller with helping him "master his craft."[16]

Everything changed in late 1979, when Kelly's roommate, hair stylist Rudy Townsel, reintroduced him to Pat Cleveland. Sensing Kelly's increasing frustration and struck by his single-minded determination to succeed, Cleveland bought the aspiring designer a one-way ticket to Paris. On the flight over, Kelly met Larry

Vickers, the Black creative director of Le Palace, Paris's answer to New York's legendary Studio 54, who offered him a job designing costumes for *Boogey Woogey Wonderland*, one of the club's extravagant stage productions. Kelly was in over his head, and after a few days Elizabeth Goodrum was hired as his assistant, a role she later continued with Patrick Kelly Paris. Although he looked for positions with Paris fashion houses, he lacked the requisite training and skills in French couture sewing and design. Paco Rabanne took Kelly under his wing, and he briefly joined the designer's atelier for the Fall/Winter 1981–1982 haute-couture collection. At the time, Rabanne was exploring non-Western fashion, an interest that coincided with his founding of Centre 57 in 1983, an art, dance, and exhibition center for African diaspora artists. Kelly, like many other designers at the time, was experimenting

9. Patrick Kelly ensemble, likely created while working with Paco Rabanne, ca. 1981–1982

with the newly popular "ethnic" look (fig. 9), which drew from a wide range of sources including the rural clothing influences of Japanese avant-garde fashion and North African aesthetics.

Paris fashion during the early 1980s was increasingly international and multicultural, attracting a broad spectrum of designers from many countries. Fashion journalist Marian McEvoy noted that by 1985, "Of the one hundred or so *créateurs* showing their collections on official French *prêt-à-porter* runways or showrooms, at least a dozen are Japanese; there are another dozen Italians, a couple of Spaniards, a

Vietnamese, a Norwegian, a Dutchman, several Germans, an Algerian and an American."[17] Paris unequivocally embraced Kelly, who to the French was both American and Black. Mel West moved to Paris the same week as Kelly and recalled the early 1980s as "like being back in 1925—a Josephine Baker revival. Blacks had a second chance there" (see Remembering Patrick Kelly, this volume).[18]

For Kelly, Kenzo Takada stood out as an outsider, one who successfully reimagined his heritage and turned it into a marketable style that was colorful and fun. Inspired, Kelly reinterpreted

several of Kenzo's signature looks, including dropped-waist dresses from the 1981 collection (fig. 10). In October 1983, Kelly attended Kenzo's Spring/Summer 1984 runway show with Janet Chandler, who wore one of Kelly's unfinished knit dresses (fig. 11). Kelly reworked the designer's layered plaid wrap (fig. 12) as a loose self-fringed coat that included an oversize rectangle of fabric that could serve as a scarf, shawl, head wrap, sarong, baby carrier, or shopping bag. Kelly's most memorable translation of Japanese style was his one-seam coat based on Issey Miyake's iconic cocoon coat, first designed in

DILYS E. BLUM

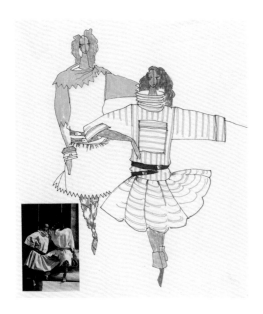

10. Patrick Kelly dresses inspired by Kenzo's dropped-waist dresses from the early 1980s

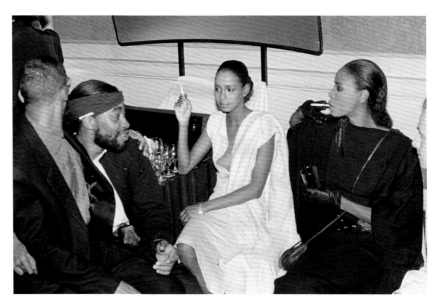

11. Patrick Kelly, Janet Chandler, Naomi Campbell, and an unidentified male guest at Kenzo's Spring/Summer 1984 opening

1976. Kelly, like Cristóbal Balenciaga in 1961, Issey Miyake in 1976, and Ronaldus Shamask in 1981, took up the challenge of creating a coat from a single piece of cloth using only one seam (pl. 11). Kelly sold his coats during the early 1980s on a corner in Saint-Germain-des-Prés. His model friends paraded nearby in brightly colored unfinished cotton-knit dresses cut from inexpensive tubular jersey, and when asked who designed the dresses, they responded, "Patrick Kelly. He's new in town."[19] Miyake continued to inspire Kelly, and for his Spring/Summer 1986 collection (September 1985), he offered a more wearable version of the Japanese designer's oversize jumpsuit from Spring/Summer 1984.

Kelly's first paid job, designing sweaters for the Venice-based fashion house Roberta di Camerino in 1983, facilitated by Audrey Smaltz, introduced him to Italian knitwear manufacturing. His first clothing collection was a collaborative project with the Turin-based design studio, Studio Invenzione, founded by architect Loredana Dionigio and Marco Fattuma Maò, a young Italian-Somali artist whom Kelly had met in Paris. The project, named *Progetto S-Cambia* (*Project S Change*), was first presented as an art-gallery installation with a photo-narrative and Kelly's designs decorated with interchangeable elements that served as a means of communication. The shapes snapped on and off, anticipating the removable buttons and bows Kelly sold later. The project was followed by a fashion collection manufactured by the Italian knitwear company La Maison Blu and a short video, called *Sveglia la notte bruciando cacao* (*Wake-Up the Night-Burning Cacao*), featuring Kelly's designs, which he art-directed (figs. 14–15). Both

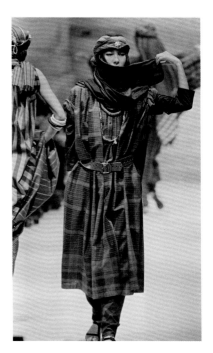

12. Kenzo Spring/Summer 1984

13. Page spread from the catalogue for the Milan Fall/Winter 1984–1985 collection, featuring Patrick Kelly designs

were presented in Milan for Fall/Winter 1984–1985 (fig. 13). The collection was sold at Bergdorf Goodman and Henri Bendel in New York and at Harrods in London (pls. 7 and 8).

Meanwhile, much-needed direction and focus for Kelly's buoyant creativity was provided by a fortuitous reconnection with Bjorn Guil Amelan, a photographers' agent whom Kelly had originally met in New York in 1982 at the opening of Willi Smith's new showroom, and met again in Paris in early 1983. Amelan became Kelly's life and business partner, and for the next few years the fashion house was sustained by Amelan's earnings and Kelly's income from freelance projects. While Kelly was extremely disappointed that the collection presented in Milan

was not sold under his own name, he continued to freelance anonymously for design houses in France and Italy, including for Benetton (figs. 16–17). Only 3 Suisses and Bon Magique credited him by name.[20]

Knowing that the pioneering fashion boutique, Victoire, located on the same street as Kenzo, had launched many young designers including Azzedine Alaïa, Thierry Mugler, and Claude Montana, Amelan made an appointment with its owner, Françoise Chassagnac. Instead of sketches, Kelly brought along Janet Chandler, wearing one of his "unfinished" dresses. Chassagnac, intrigued by Kelly's quirky style and ebullient personality, introduced him to Nicole Crassat, editor in chief of French

Elle. The result, a six-page spread in the magazine's February 1985 issue, photographed by Oliviero Toscani, was unheard of for an unknown designer (fig. 18). In September, Kelly was featured in *Elle*'s inaugural American issue. For French *Elle*'s opening image, Toscani reworked a Kenzo advertisement from 1981 where models tussled over an oversize portrait of the designer. Victoire provided space above their offices for Kelly to show his small collection and sent out copies of *Elle* to all the buyers attending the Fall/Winter 1985–1986 ready-to-wear presentations. Dawn Mello, of Bergdorf Goodman, knew Kelly from Milan and immediately placed a special order for all the cotton-jersey dresses featured in *Elle*, which the store planned

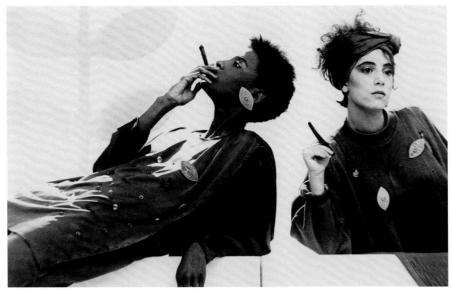

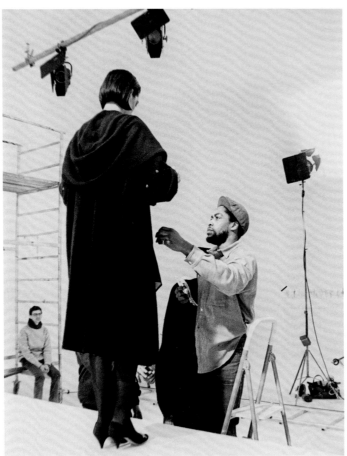

to showcase in its 57th Street windows in New York, space that was dedicated to new designers (fig. 19). To meet the rushed deadline, Kelly sewed the dresses himself.

Victoire's offer of work space and production assistance in return for exclusive designs quickly propelled Patrick Kelly Paris into a viable business. Rachida (Abou El Wafa) Afroukh was hired as the pattern cutter and sample maker, and she promptly became indispensable to Kelly and an "extension of his mind and creative process."[21] When Victoire announced that it was expanding and could no longer produce Kelly's collections after Fall/Winter 1987–1988, Ghinea, a manufacturer located in Perugia, Italy, took over. After producing one collection the company announced that the volume was more than it could handle. While the fashion press continued to focus on Kelly's body-conscious knits, anointing him the reigning "King of Cling,"[22] he was adamant that he wasn't exclusively a knitwear designer. Although he had been offered further work by Enrico Coveri after freelancing for the designer's Touche collection for Fall/Winter 1985–1986, he refused: "I had to stop because they pegged me as a jersey person, but I am not a very jersey person. Most Black designers get labeled as jersey designers, but I do structured things like blazers, too."[23]

16. Benetton advertisement featuring a design by Patrick Kelly, *Mademoiselle*, September 1987

17. Benetton advertisement featuring a design by Patrick Kelly, *Vogue*, August 1987

Later in 1985 he commented: "My idea is to make a fashionable line, like Montana, like Mugler, like everybody, but at a real price."[24]

Kelly's association with Warnaco came just in time. In July 1987, Kelly signed a multimillion-dollar contract with the American apparel giant under its new CEO, Linda Wachner, for the worldwide rights for ready-to-wear, with Mary Ann

Wheaton as president of Kelly's brand. The Wachner years were difficult, and sadly ended with the cancellation of Kelly's October 1989 collection for Spring/ Summer 1990, and the termination of his contract for non-compliance, because of Kelly's declining health—he was dying of complications from AIDS. The new ready-to-wear brand, also called Patrick Kelly Paris, launched on October 21, 1987,

with the Spring/Summer 1988 collection, two days after the infamous Black Monday stock-market crash. Over the next two years, Warnaco pressured Kelly to tone down his freestyle approach and create a more mainstream look for its target customer, women between the ages of thirty-five and fifty. In addition, and to Kelly's annoyance, Warnaco refused to allow Kelly to use golliwog imagery in the

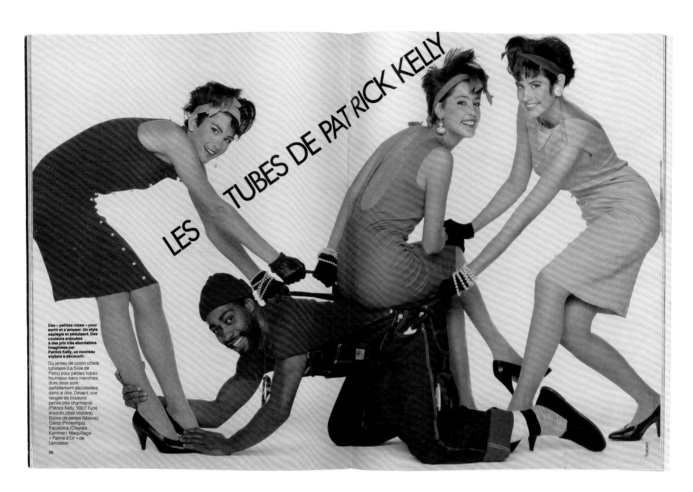

Des « petites robes » pour
sortir et s'amuser. Un style
espiègle et séduisant. Des
couleurs enjouées
à des prix très abordables.
Imaginées par
Patrick Kelly, un nouveau
styliste à découvrir.

Du jersey de coton côtelé
tubulaire (La Soie de
Paris) pour petites robes
fourreaux sans manches,
dont deux sont
parfaitement décolletées
dans le dos. Devant, une
rangée de boutons
perlés très charmants
(Patrick Kelly, 900 F l'une
environ, chez Victoire).
Bijoux de perles (Mauve).
Gants (Printemps).
Escarpins (Charles
Kammer). Maquillage
« Palme d'Or » de
Lancaster.

88

Toscani

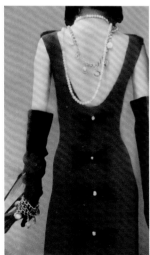

18. "Les Tubes de Patrick Kelly,"
photographed by Oliviero Toscani
for French *Elle*, February 1985

19. Bergdorf Goodman window display
featuring Patrick Kelly designs, 1985

United States, although it remained on Patrick Kelly Paris shopping bags and on other items sold in the boutique next to the Paris showroom. Kelly had adopted the golliwog character as his label's logo in 1985. One of the many racially charged images represented in his vast personal collection of Black racist memorabilia (see madison moore, this volume), it was prominently featured on printed textiles for the Spring/Summer 1986 collection presented in Victoire's studio (pl. 17), and on knit dresses as button arrangements for Fall/Winter 1986–1987 (pls. 18–19). Kelly defended his use of such images: "If you don't know where you've been in your history, then you don't know where to go."[25] The

runway shows under Warnaco continued to act as a forum for addressing issues of identity, race, racism, and sexuality. Invitations for the ready-to-wear and mock-couture presentations in 1988 and 1989 featured Kelly caricaturing himself as one of many racist stereotypes. For the first Warnaco-produced collection, for Summer 1988, he appeared as a naked cutout paper doll (drawing from the pickaninny and the Black baby-doll pins he handed out to everyone he met) with a five-piece wardrobe (fig. 20). On the invitation for his final Fall/Winter 1989–1990 collection he was costumed as a blackamoor for Pierre et Gilles's stylized photograph. Dressed as the richly clothed Black servant depicted in

20. Invitation to Patrick Kelly Paris Summer 1988 collection presentation

21. Patrick Kelly Paris fashion-show invitation with Pierre et Gilles portrait for Fall/Winter 1989–1990 collection

NOTES

1. Kelly identified the aunt who taught him to sew by two names. A Mississippi newspaper article from 1987 refers to Kelly's aunt as "Bernard;" however, from 1987 on he identifies her as "Bertha." Bertha G. Rainey Scott (1930–2012) lived in Tallulah, Madison Parish, Louisiana, and is buried in Cedar Hill Cemetery, Vicksburg, where Kelly's grandfather William Q. Rainey (1897–1968) is interred. Bertha is listed in the 1940 census with a Bernard [Bernard Joanne Rainey Thomas (1932–1993)] who is misidentified as a son, age 7.

2. Bonnie Johnson, "In Paris, His Slinky Dresses Have Made Mississippi-Born Designer Patrick Kelly the New King of Cling," *People*, June 15, 1987.

3. Ibid.

4. *The Province* (Vancouver, B.C.), May 11, 1989, 2.

5. Nina Hyde, "From Pauper to the Prints of Paris," *Washington Post*, November 9, 1986.

6. Fashion-show advertisement, *Atlanta Constitution*, September 2, 1976.

7. Glenn Turner, interview by Laura L. Camerlengo, November 20, 2013.

8. www.talkingwithtami.com, response from aka Jhon, June 6, 2011.

9. Carol Mongo, interview by Laura L. Camerlengo, March 26, 2013.

10. Mitzi Gammon, "Dolling for Dollars," *Atlanta Constitution*, March 13, 1988.

11. Ibid.

12. "Paris Splits into 2 Camps," *Women's Wear Daily*, July 31, 1986, 2.

13. Kelly's former business and life partner, Bjorn Guil Amelan, has also commented that racism may have come into play. Kelly had received a scholarship to attend Parsons, but "once the dean of Parsons discovered that 'Patrick Kelly' wasn't an Irishman, he refused to give him the scholarship he had won." Antwaun Sargent, "Patrick Kelly Was the Jackie Robinson of High Fashion," *Vice*, September 25, 2017, https://www.vice.com/en/article/kz77yv/patrick-kelly-was-the-jackie-robinson-of-high-fashion.

14. Mel West, interview by Laura L. Camerlengo, July 22, 2013.

15. Ibid.

16. Renée Minus White, "Patrick Kelly's Spring '84 Fashions," *New York Amsterdam News*, April 21, 1984.

17. Marian McEvoy, "Dial M for Mode," in *Paris Arts on Seine*, ed. William Mahder (Paris: Editions Autrement, 1985), 178.

18. Mel West, interview by Laura L. Camerlengo, May 17, 2013.

19. Mel West, interview by Laura L. Camerlengo, May 10, 2013.

20. Eres (1986), Bon Magique (1986), 3 Suisses (F/W 1986-1987, F/W 1987-1988), Benetton (F/W 1987-1988).

21. Bjorn Guil Amelan, interview by the author, November 23, 2010.

22. Johnson, "In Paris, His Slinky Dresses Have Made Mississippi-Born Designer Patrick Kelly the New King of Cling."

23. Hyde, "From Pauper to the Prints of Paris."

24. David Livingstone, "Reasonable Approach to Prices," *Globe and Mail*, January 7, 1986.

25. Julia Reed, "Talking Fashion: Patrick Kelly," *Vogue*, September 1989, 786.

26. Patrick Robinson, interview by Laura L. Camerlengo, June 14, 2013.

27. Bjorn Guil Amelan, interview by the author, February 21, 2021.

European decorative arts, he mirrored the painted figures collected by Chanel, Schiaparelli, and Saint Laurent (fig. 21).

Warnaco's advertisements were, on the surface, less contentious. Oliviero Toscani, the force behind the controversial United Colors of Benetton marketing campaigns, re-created the energy and spontaneity of Kelly's runway shows and substituted a narrative that portrayed Kelly's designs as fresh, fun, and happy (pages 2, 6, 12, 13, 58, 59, and 161). In the ads, surrounded by a posse of cavorting models, Kelly played a wide range of archetypes, including the "Black guy from the South"[26] wearing oversize overalls, a French baker, a Tour de France cyclist, an American businessman, and even an astronaut (page 160). These images recalled the

"realness" of the voguing balls that were popular during the late 1980s—the highly stylized house dance form of the Black and Latino LGBTQ communities. However, to those closest to him, he was ever the enigmatic "Kelly Lisa," who told you what he wanted you to know, not what you wanted to know. Amelan captured Kelly's nature perfectly: "After five minutes you felt immediately that you were his best friend and that you knew everything about him, and after five years you realized you knew nothing about him."[27]

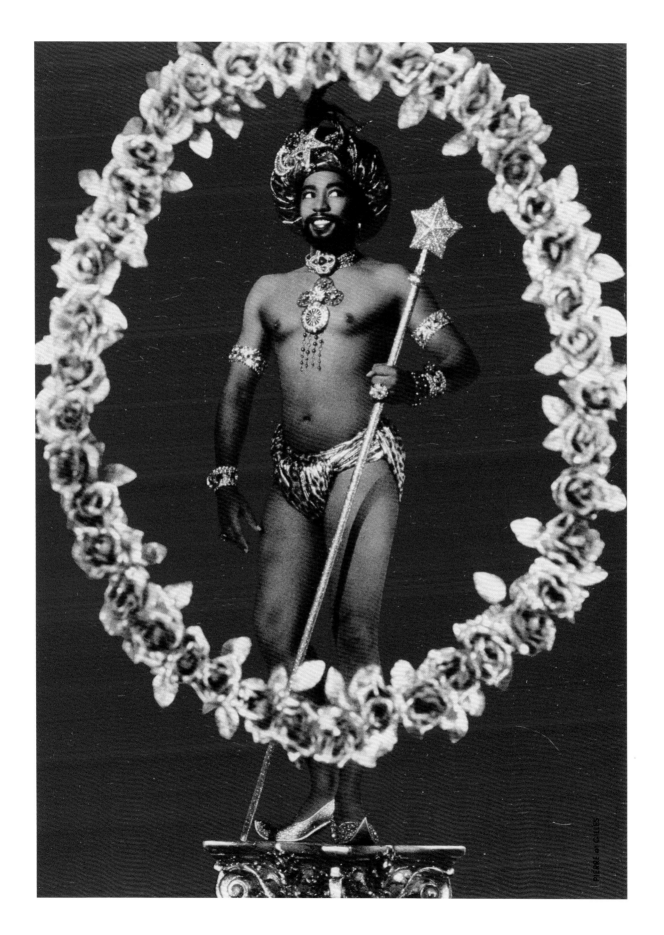

27

From the Church Pew to the Runway

The Influence of the Black Church on Patrick Kelly's Design Aesthetic

DARNELL-JAMAL LISBY

When I was growing up, every Sunday morning, as my mother would say, "We do church." Looking back on it now, our Sunday-morning ritual was, and continues to be, a sacred one that many African Americans historically partake in as both a facet and a foundation of the community. Furthermore, dressing for church was also a ritual. Through the lens of dress, fashion plays an integral role within the Black church as a form of showing respect to God, the pastor, and the congregation. From men dressed in their crisp suits and pointed white-collar shirts to women arrayed in their decorative church hats and color-coordinated and embellished dresses, church members donned their absolute best ensemble in honor of God and sacred spaces. This notion of dress, otherwise known as "Sunday best," is paramount for many Black members of the faith, even more important than dressing in your best to meet the Queen of England or the President of the United States. In 1 Corinthians 3:16–17, the scripture says, "Don't you know that you yourselves are God's temple and that God's Spirit dwells in your midst? If anyone destroys God's temple, God will destroy that person; for God's temple is sacred, and you together are that temple." From a bishop's glorious vestments in a Baptist church to a churchgoer's extravagant buckram brim and tulle-embellished hat in an African Methodist Episcopal church, style and adornment are tangible expressions of the special care many Black Christians take to beautify their God-given bodies, or temples.

In the Black church in the United States, fashion is simultaneously a form of solidarity and a display of individuality. Protocol demands that attendees enter the church in their Sunday best—the absolute finest outfit one can obtain and maintain. It is important to note that during the era of slavery, not all enslaved persons could congregate and worship on their own. For those who could gather, as curator and historian Madelyn Shaw writes, their Sunday best garments were acquired outside of their regular allowance of clothing. Hand-me-downs from their white enslavers, or goods purchased with cash or by barter may have comprised this category of Sunday best clothing.[1] Enslaved persons seen in fashionable dress caused quite a stir among white plantation owners.[2] It is safe to assume that the outrage from the white public derived from the persistent and racist ideology that enslaved, and even freed, Black people were never to present themselves on a par with white people. After the emancipation of enslaved persons, the energy of

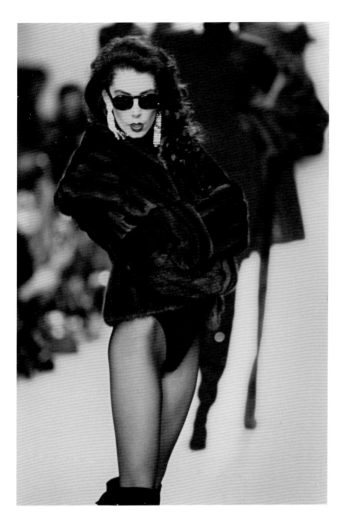

22. A model walks the runway at the Patrick Kelly Paris Fall/Winter 1989–1990 fashion show, March 1989.

Sunday best was in full effect as Black people were able to participate in the fashion system more freely than before. Nicey Kinney, a formerly enslaved woman, expressed that experience directly after emancipation, as more Black churches were being established: "It was some sight to see and hear 'em on meetin' days," she said, describing the parade of congregants attending Sunday service with their fur pieces and shoes, which they would carry until they reached the church in order not to get them dirty.[3]

With each passing generation since emancipation, Sunday best attire has been synonymous with one's finest expression of style. In addition, when looking at what was considered Sunday best for each generation since emancipation, the fashions reflected the contemporary formal attire of each era.[4] Today, the "Sunday best" dress code is slowly being phased out in favor of casual dress as part of a broader movement among Black churches inviting members and nonbelievers to "come as they are" to embrace God's love above all things and not to feel judged based on the walk of life they hail from. Throughout the history of Sunday best in the Black community, there are unequivocal distinctions that separated it from general "high style" formal wear, such as the color-coordinated ensembles and the immensely styled hats, distinctions that remained a major aspect of Black church attire as these elements became less affiliated with mainstream fashion in the twentieth-century. Regardless of its changing dress codes, the Black church has remained a place for members to exaggerate and, to a degree, subvert mainstream formal dress in a way that collectively fortifies the singular identity of Black church style, creating an arena where fashion thrives.

For the Black community, the church plays an integral role of empowerment, literally and abstractly. On the one hand, the church is a symbol of the Black community's continued faith that God will lift them into heightened prosperity despite the community's constant suffering and attacks.[5] On the other hand, the church was and remains a headquarters for political action by the Black community, as seen during the civil-rights movement throughout the first half of the twentieth-century. Elaborating on Black church style, fashion scholar Rikki Byrd writes, "Not only has it become a place of fellowship, organizing, and more, it is also a place where the sartorial ensembles easily rival collections at fashion week."[6] Even further, during the civil-rights movement, Sunday best clothing delineated a disavowal of

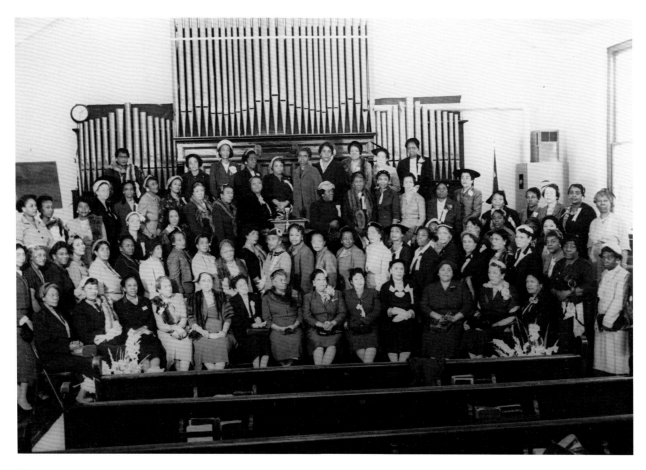

23. Portrait of women posed in front of a church organ, ca. 1948–1970

white people's historically distorted and degraded perception of Black bodies.

Patrick Kelly's grandmother, Ethel Rainey, who was his greatest muse, raised him in the church.[7] It was the essence of the Black church—its styles, energy, and attitudes—that played a significant role in how he developed and presented his aesthetic throughout much of his career. Kelly's frequent interaction with the fabulous women who came dressed in their Sunday best to services every week was unequivocally ingrained in his repertoire. Kelly was known for his

"Love List," a document enumerating his inspirations that he would distribute to his fashion-show guests and the press (see Pritchard, this volume). In a late 1980s "Love List," two entries—churches and gospel music—point directly to the essential role his upbringing in the Black church played in his work.[8]

When Kelly established his label, Patrick Kelly Paris, with his business and life partner, Bjorn Guil Amelan, in 1985, the brand met with immediate success, offering accessible styles ranging from jersey dresses and separates to inter-

seasonal outerwear.[9] Kelly was deemed the "Mr. Cling" by the fashion press, due to his frequent use of jersey and stretch fabrications. These functional yet fashionable aspects of his collections set his work adjacent to legends like Azzedine Alaïa, known as the "King of Cling."[10] Additionally, Kelly's flamboyant touches, such as using a profusion of tulle as a decorative or structural element in his designs, or using bows to add emphasis to his ensembles, established a direct correlation to his Black church–style inspiration.

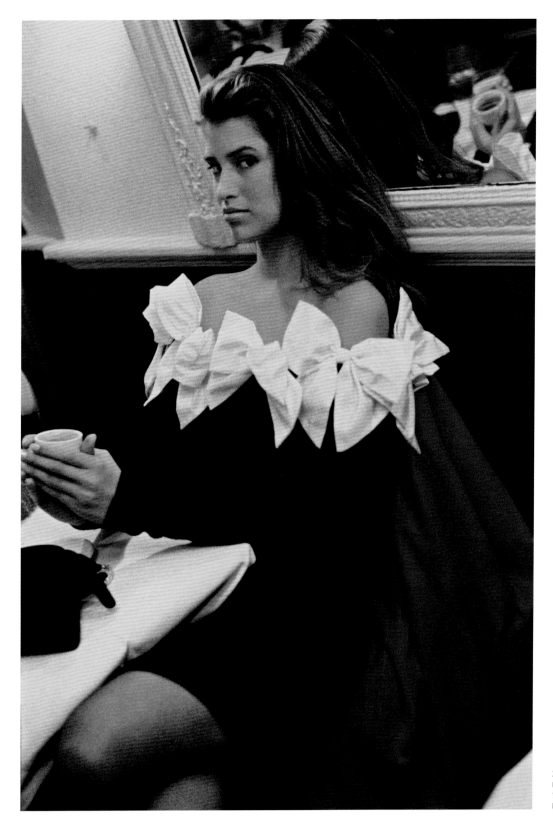

24. Dress with oversize bows, Patrick Kelly Paris Fall/Winter 1988–1989, as pictured in *Vogue*, December 1988

DARNELL-JAMAL LISBY

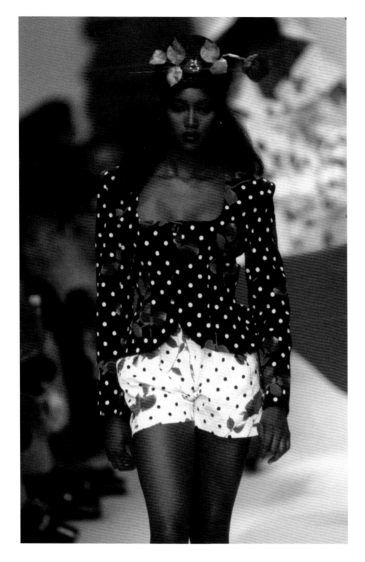

25. Naomi Campbell in the Patrick Kelly Paris Spring/Summer 1989 show in Paris, 1988

an ensemble designed by one of the leading Black designers of the time—should not be overlooked.

A photograph in the collection of the Smithsonian National Museum of African American History and Culture shows a group of Black women posed in front of a church sanctuary's organ (fig. 23). The date of the photo is unidentified, but the dress styles resemble the same styles worn by women Kelly would have seen when he was a young child in Mississippi in the late 1950s into the 1960s. In the photograph, each woman wears gloves, per the social protocol of the era inside and outside the Black community. We also see the integration of gloves in Kelly's designs, almost as an ode to this modest dress style. In the photograph, some of the women pose with their fur stoles across their shoulders in various silhouettes, each styled differently, simultaneously exuding their individual and collective elegance and subtle playfulness and joy. The faux-fur pullover designed by Kelly and worn by Sean Young in the *Harper's Bazaar* article captures those nuances of joy, encompassed in its flamboyant red color and cropped silhouette. Essentially, the faux fur in the article exemplifies how Kelly flipped Black church styles that carry a sense of seriousness on the surface and joviality beneath to radiate happiness, and he wove this narrative throughout his career. To this point, a *Women's Wear Daily* review about the Fall 1987 collection, of which the faux-fur stole and the dress were a part of, says, "Opinion: Uncomplicated and fun, he's the wearable newcomer that makes the retailers smile."[12]

Amplifying the levity of his brand's

His notable outerwear garments included real and faux furs that came in a range of silhouettes from year to year (fig. 22). In an article in the September 1987 issue of *Harper's Bazaar* titled "America's 10 Most Beautiful Women," the actress Sean Young is featured wearing a Patrick Kelly ensemble that includes a scarlet sheen faux-fur pullover on top of a wool-and-cashmere side-stripe minidress from his Fall/Winter 1987–1988 collection.[11] It is

essential to note that actress Lisa Bonet, who was also featured in the article, wore a royal blue stretch-velour dress with matching gloves by Patrick Kelly for the issue's cover photo. The outfit subtly referenced the importance of coordinating colors in Black church style. Bonet's historical feat—a Black woman appearing on the coveted September issue of a leading fashion publication, which was and still is rarely seen, wearing

26. African American churchgoers at Baltimore Bethel AME Church, Baltimore, Maryland, 1973

aesthetic, as mentioned, tulle was a predominant fabric in many of Kelly's designs over the years. *Harper's Bazaar's* January 1987 issue spotlighted a cobalt off-the-shoulder dress swaddled with a tulle overskirt and matching gloves.[13] The lightness of the fabric and its whimsical aura make it the most visually artistic notion of the joy that Kelly emphasizes in his brand imagery. From wedding dresses to hat veils to the outer layer of dresses, tulle has been a common fabric fashioned by Black church attendees. Moreover, bows, often accompanied by tulle in

Black church style, were also integrated into Kelly's designs to accentuate his silhouettes in addition to acting as flirtatious adornment (fig. 24).

As expressed, Kelly's accessories and styling were frequently inspired by fashions he had seen while attending a Black church (fig. 25). During the opening of the Spring 1988 collection fashion show, a line of Amazonian models stood in Kelly's colorful ruffled and layered jersey dresses and illustrious hats with floral appliqué, creating a sense of excitement from the start.[14] In 1 Corinthians 11:6, it says, "For

if a woman does not cover her head, let her also have her hair cut off; but if it is disgraceful for a woman to have her hair cut off or her head shaved, let her cover her head." In conservative sects of Christianity, wearing a head covering in holy places is essential to honoring God. Furthermore, in the Black church, decorative crown-like "church hats" became synonymous with that spiritual relationship (fig. 26). In her 1996 *New York Times* article "In Defense of the Church Hat," Lena Williams describes the impact of the accessory's symbolism within the church and on her life.[15] She writes, "Hats were a crowning glory to God, our mothers and grandmothers told those of us too young to understand a tradition that required us to cover well-primped hairdos that took hours of hot combing and curling."[16] Speaking broadly about the significance of the church hat, Williams writes, "The millinery splendor not only expresses a personal aesthetic, but a community's shared notion of social propriety and cultural values."[17] Based on that perspective, which is ingrained in many generations of the Black community, Kelly's integration of eclectic hats was a celebration of this cultural symbol and a simple way to convey elation as a unifying theme in his ensembles.

Kelly had a genuine admiration for the essence of the Black church. Today, with designers like Kerby Jean-Raymond of Pyer Moss integrating the label's Tabernacle Drip Choir into his fashion-show presentations and campaigns, and additional odes to the Black church, it is safe to say Kelly's impact will continue to persist through many generations of designers to come. In a 1987 issue of *People* magazine, Patrick Kelly said, "The Black Baptist church on Sunday, the ladies are just as fierce as the ladies at Yves Saint Laurent haute-couture shows."[18] In a 2004 *Washington Post* article by fashion editor Robin Givhan, titled "Patrick Kelly's Radical Cheek," she quoted Bjorn Guil Amelan: "While he [Kelly] loved Madame Grès and Yves Saint Laurent, he'd say that in one pew at Sunday church in Vicksburg, there's more fashion to be seen than on a Paris runway."[19] For Kelly and many creatives who went on to use fashion as an outlet for their voices, like André Leon Talley and Billy Porter, the church was where fashion began for them. Kelly was also unequivocally vocal about his cultural background and his firm stance against discrimination and racism. Integrating elements from the church pew to the runway was part of Kelly's magic, built on his legacy of giving Blackness a respected place as a pillar of inspiration in an industry that historically neglected to consistently illuminate the contributions of Black designers, creatives, and culture.

NOTES

1. Madelyn Shaw, "Slave Cloth and Clothing Slaves: Craftsmanship, Commerce, and Industry," Museum of Early Southern Decorative Arts, last modified 2012, accessed March 13, 2021, https://www.mesdajournal.org/2012/slave-cloth-clothing-slaves-craftsmanship-commerce-industry/.

2. Katie Knowles, "The Anti-Craft Activism of Enslaved Americans: Conspicuous Consumption as Resistance," in *Crafting Dissent: Handicraft as Protest from the American Revolution to the Pussyhats*, ed. Hinda Mandell (Lanham, MD: Rowman & Littlefield, 2019), 70.

3. "Plantation Life as Viewed by an Ex-Slave: Nicey Kinney," *Slave Narratives: A Folk History of Slavery in the United States from Interviews with Former Slaves*, Vol. 4, Georgia Narratives (1936–1938): 28, https://memory.loc.gov/mss/mesn/043/043.pdf.

4. Rikki Byrd, "Easter Sunday Is Peak Black Church Fashion: An Appreciation," Zora, last modified April 10, 2020, accessed January 1, 2021, https://zora.medium.com/easter-sunday-is-peak-black-church-fashion-an-appreciation-de84ef2a12cf?gi=sd.

5. Ibid.

6. Ibid.

7. "Mississippi in Paris," Philadelphia Museum of Art, https://www.philamuseum.org/exhibitions/799.html?page=2.

8. "Patrick Kelly's Love List," Philadelphia Museum of Art: Exhibitions, 2014, https://www.philamuseum.org/exhibitions/799.html?page=3.

9. Michelle McVicker, "1954–1990 – Patrick Kelly," Fashion History Timeline, last modified August 4, 2020, accessed January 1, 2021, https://fashionhistory.fitnyc.edu/1954-1990-patrick-kelly/#:~:text=P%20atrick%20Kelly%20was%20the%20first%20American%20designer,%E2%80%9CI%20want%20my%20clothes%20to%20make%20you%20smile.%E2%80%9D.

10. Lucy Chaplin, "The Pulse of Paris," *Harper's Bazaar*, September 1986, 122.

11. "America's 10 Most Beautiful Women," *Harper's Bazaar*, September 1987, 353.

12. "Patrick Kelly," *Women's Wear Daily,* March 26, 1987, 12.

13. "Paris Younger than Springtime," *Harper's Bazaar,* January 1987, 147.

14. Douglasays, "Patrick Kelly Paris 1988 Collection Part 1, from Douglas Says Files," filmed 1987, YouTube, uploaded August 17, 2011, https://www.youtube.com/watch?v=OBCBnFicOmU.

15. Lena Williams, "In Defense of the Church Hat," *New York Times*, May 12, 1996, https://www.nytimes.com/1996/05/12/nyregion/in-defense-of-the-church-hat.html.

16. Ibid.

17. Ibid.

18. Rashida Renée, "The Legacy of Patrick Kelly," *Office*, March 10, 2019, http://officemagazine.net/legacy-patrick-kelly.

19. Robin Givhan, "Patrick Kelly's Radical Cheek," *Washington Post*, May 31, 2004, https://www.washingtonpost.com/archive/lifestyle/2004/05/31/patrick-kellys-radical-cheek/7f404cd3-6f4d-4f28-8a24-6a0b398dba45/.

Sex, Sexuality, and Signifying

Patrick Kelly's Queer Enterprise

ERIC DARNELL PRITCHARD

At the heart of Patrick Kelly's joy was queerness. By *queer*, I am not referring to sexuality generally—nor to Kelly's sexuality in particular—but to a creative practice that was decidedly and deliberately antinormative, or against the grain. In his approach to design, style, and performance, an approach that emerged as the aesthetic enterprise called Patrick Kelly Paris, Kelly created from the margins even as he courted the industry's center. There are many ways to explore queerness in Kelly's work, but the starting place that illuminates the widest array of examples is the presence of the erotic, or desire, and Kelly's signifying upon it.

An overt articulation of Patrick Kelly's desires is his "Love List," an enumeration of the people and objects Kelly held dear (fig. 27). The list includes, for example, "Pearls and Popcorn," "Lycra Dresses and Spare-Ribs," "All Women (Fat, Skinny and Between)," and his grandmother, "Ethel Rainey, Bette Davis, Martin Luther King."[1] At first glance, the items on the list appear irreconcilable, but it is this odd, off-kilter—that is, queer—list that lends itself to boundless intrigue and provocation. For Kelly, the list's mesh of Black history, celebrity, American and Southern culture, European decorative and epicurean high taste and style, and opulent embellishments makes perfect sense. The list tells people who he is, as it models the complexity—and thus full humanity—of an individual and his desires, wholly. It is this fusion of Kelly's many desires that articulates his one-of-a-kind visual vocabulary—a vernacular formed by his self-identity and experience cohering into an aesthetic enterprise the fashion industry had never seen. In addition, the "Love List" evidences the various communities to which he belonged, loved, drew inspiration from, and thought of as interlocutors for his work. To make these inspirations accessible, the list was often distributed with press kits and sometimes placed on the seats at his fashion shows.

The queerness of what Kelly was doing with the "Love List," and in all of his work, was to channel his deep desire to take what he knew—including that which may not be regarded by some then or now as intellectual, or even knowledge—and treat it as valued knowledge. His insights are thus a form of "knowing so deep it's like a secret," which is how the author Toni Morrison described Black women's inherent insight and intellectualism.[2] This means of articulating desire was one way that the otherwise private and secretive Kelly could deliver his message—a joie de vivre that was simultaneously radically open yet personally reticent, a

PATRICK KELLY
PARIS

PATRICK KELLY'S LOVE LIST

I Love:

- Families, especially Grandmothers and Mothers
- Nice People, Work Vacations
- Fried Chicken and "Foie Gras" and "Fauchon" Croissants
- Buttons and Bows
- Dolls
- Hats
- Gardenias
- Pearls and Popcorn
- Pretty Things
- Madame Grès
- Pretty Girls and Valentine Candy Boxes and Fried Catfish
- All Women (Fat, Skinny and Between….)
- Lycra Dresses and Spare-Ribs
- Non-Smokers
- Ethel Rainey, Bette Davis, Martin Luther King
- Josephine Baker and Pat Cleveland
- Connie
- Parties
- "I Love Lucy"
- Music: Gospel, Loud, Classical, Rap, Jazz, Soul, Luther Vandross
- Big Overalls
- Birthdays and Christmas
- Paris in the Springtime, in the Fall, in the Winter,
 BUT ESPECIALLY IN MISSISSIPPI
- Churches
- Buttons, Buttons, Buttons
- Fun
………………and You!

27. Patrick Kelly's "Love List"

hallmark characteristic of what historian Darlene Clark Hine calls the "culture of dissemblance," whereby someone as authentically warm and accessible as Kelly could also preserve a space for himself that he has been able to keep inviolate, even beyond death.[3]

The archive of Kelly's work—both vast and yet limited, due to his untimely death—gives us a set of visual objects, inclusive of but not limited to the "Love List," through which we can explore Kelly's use of design, textiles, styling, photography, runway shows, and decorative arts to enact practices of signifying; interventions that are, I argue, effectively queer. By "signifying" I'm referring to the Black expressive practice as theorized, most notably, by literary critic and historian Henry Louis Gates Jr. In his 1988 study *The Signifying Monkey*, Gates defines signifying as a practice of indirection in communication, what he calls "Black double-voicedness."[4] Through signifying, a person or object disrupts an assigned meaning to symbols, words, phrases, images, or gestures (signification), thereby creating and circulating some other meaning than what was originally intended (signifying) by suggesting a point of view through slightly obscured or stealth tactics. Subsequently, signifying gives a word, an object, or an event, an entirely new orientation—a remix. Signifying is thus a practice that illuminates the agency of the communicator. Centering Patrick Kelly as a communicator—or a creative—we can see how Kelly took signs, symbols, phrases, and other material that could mean or communicate a specific message and created work and events that sometimes intentionally, and at other times unintentionally, refashioned or repurposed that material toward alternative and unanticipated interventions and understandings.

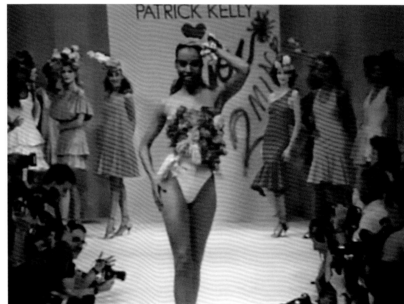

28. and 29. Janet Chandler, house model for Patrick Kelly Paris, steps effervescently onto the runway to begin the Spring/Summer 1988 collection presentation. Chandler is flanked by models wearing colorful minidresses and skirt suits with hats in the style of those worn by Black church women.

The clearest examples of signifying in Kelly's work were often most evident on the runway, where one of Kelly's frequent acts of signifying, like the practice of signifying itself, was grounded in a Black cultural tradition: the thinning of the veil between sacred and secular life. Or, in the parlance of Black cultural criticism, the little daylight between the dance floor on Saturday night and the church house on Sunday morning.

At Kelly's runway shows, always ebullient, raucous, and memorable works of performance art, the themes of desire and pleasure were ever-present in the overarching theme of love in his work on and off the runway. Desire and pleasure were also central in Kelly's signifying on the sacred and the secular. One of the most evident examples of this was in the music at Kelly's runway shows, where one would hear secular rhythm and blues, funk, and pop music such as Howard Johnson's "So Fine," James Brown's "I Feel Good," or Vanessa Williams's "The Right Stuff," on the same playlist as up-tempo hymns and gospel songs one might hear in any Black church in America.

Kelly's signifying on the sacred and secular was also evident in his designs. For instance, part of the DNA of Patrick Kelly Paris was to disrupt tropes of ladylike and unladylike style through an atmosphere manifesting from a mélange of a garment's design, Kelly's styling, the narrative he would assign to each section of a show, and the music played. An example of this is seen in a group of looks presented at the opening of Kelly's runway show for his Spring/Summer 1988 collection. As Janet Chandler—Kelly's friend, house model, and muse—saunters vivaciously onto the runway in a white bodysuit embellished with fabric formed into multicolored flowers placed about the torso (figs. 28–29), rhythm and blues

singer Alexander O'Neal's "Fake" begins to blare, with O'Neal crooning:

Your name was Patty

But now it's Kay

Girl, you seem to change it every day.

And later:

In bed this morning

You called me Clyde

Alex is the name that I go by![5]

The lyrics tell the story of a woman who may not be who she says she is, or more to the point, not who you assume she is, or who you *think* she should be on the basis of preassigned norms and codes of propriety, including normative codes of sex and sexuality. Following Chandler, a sea of women in sexy, simple, flouncy dresses in luminous colors—a loose sleeveless tangerine, an off-the-shoulder aqua, a white clingy dress with a low neckline up top and a three-tiered peplum bottom—storm the runway in unison. These models are followed quickly by models wearing similarly styled dresses in canary, fuchsia, and other colors in the same fabrications. The dresses are paired with woven straw hats adorned with flowers—hats that are more associated with the style of the Black ladies Kelly would have seen in his family's Mississippi church (see Lisby, this volume). The dresses and church hats, paired with O'Neal's song, exemplify Kelly's signifying on the usual binaries of the sacred and secular in ways conversant with other Black cultural productions. By doing so, Kelly persists in queering the binary of ladylike and unladylike style, blurring the line between sex and sexuality in the garments and music, paired with accessories associated with respectability, and indeed sanctity, in women's dress. Similarly, for Spring/Summer 1987, Kelly designed tank-

top dresses with skirts that could be converted from swimsuit to minidress to floor-length dress (pls. 15 and 16). This look also blurred the lines of the binary between sexy and demure dress—all engineered into one garment.

Another activity in Kelly's life that evidences his signifying on a binary, in this case the binary of silence and speaking, was his involvement in charitable work on HIV/AIDS education and prevention. Kelly participated in HIV/AIDS charities in both France and the United States. His work with such charities is another example of signifying in that it speaks overtly to HIV/AIDS even as Kelly himself was covert about his own diagnosis as HIV-positive. In the fashion industry, as in much of the world then, including in the United States, an atmosphere of denial, stigma, and silence surrounding HIV/AIDS was pervasive;[6] when Kelly, American designers Perry Ellis and Willi Smith, and some other fashion-industry luminaries died, their obituaries did not acknowledge that their deaths were connected to AIDS-related health complications.

Despite his silence about his own health, Kelly was intentional about his contributions to efforts to raise awareness about HIV/AIDS and to seek a cure. He used his talents as a designer to contribute to causes that sought to end the epidemic that was taking so many lives, including the lives of gay and bisexual men and trans people. In Paris, for instance, Kelly was one of the thirty-six designers who each designed a single panel for a large quilt that was auctioned off at an October 1988 AIDS-related charity event (fig. 30). The event, held at the Louvre's Cour Carrée, "brought out the most diverse crowd seen in Paris in ages" and was attended by more than eight hundred guests, including Kelly, who was photographed with his date, the model, singer, and actress Grace Jones.[7]

ERIC DARNELL PRITCHARD

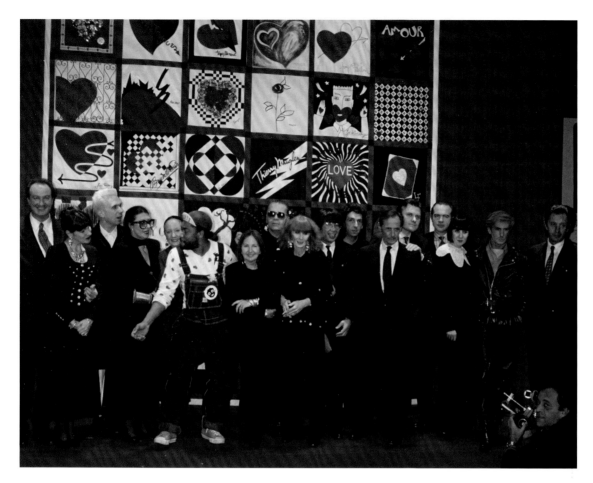

30. Patrick Kelly and other fashion designers in front of a quilt composed of squares they designed, which was auctioned off for a 1988 AIDS-related charity event. Part of Kelly's square, which he dedicated to the late fashion designer Willi Smith, is visible in the top left corner.

Kelly's involvement with HIV/AIDS charitable causes also took him to Atlanta, a city he had called home for five years and where he found a community that sustained him as he pursued his dreams of fashion superstardom. It was Atlanta's importance to him that drew him back in July 1988 for an AIDS charity fashion show. The theme of the show was "A Fashion Salute to Heart Strings." Heart Strings was the name of the local project of a larger organization, Design Industries Foundation Fighting AIDS (DIFFA). Founded in 1984, DIFFA is a pioneering organization of professionals working in the fashion, furniture, architecture, and graphic design industries that raises funds for AIDS-related services, education, and research.

For the "A Fashion Salute to Heart Strings" fashion show Kelly called upon his longtime friend, Audrey Smaltz, a former announcer at the legendary Ebony Fashion Fair—which was created by Eunice Johnson in 1958—and a former fashion editor at *Ebony* magazine. Smaltz, who coordinated the presentation of every one of Kelly's collections in Paris, was sent, along with other staff, to Atlanta to coordinate the show ahead of Kelly's arrival. Though the show featured more than 131 of Kelly's trademark whimsical garments and accessories, including one-of-a-kind shoes designed by frequent Kelly collaborator Maud Frizon, the standout look was a gown Kelly designed especially for the event. Dubbed the "Heart Strings" dress, Kelly's design was a long black wool gown with red dress-shirt lapels peeking from the neckline (pl. 5). The gown was paired with black opera gloves embellished with red plastic lips-shaped "fingernails" attached via black thread laced through the center (fig. 31). The gown's notable detail is Kelly's use of red cotton yarn, which he laced through slits in the back and front of the gown to create a heart shape on

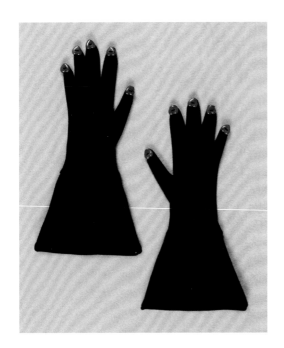

31. Woman's gloves, 1988. Designed by Patrick Kelly to be worn with a matching gown for the DIFFA "A Fashion Salute to Heart Strings" fashion show. Black wool knit with red-plastic lips-shaped buttons. Philadelphia Museum of Art. Purchased with the Costume and Textiles Revolving Fund, 2012-122-1a,b

the bodice and derrière (fig. 32). The heart shapes resemble the "Heart Strings" logo designed for DIFFA by graphic designer Ken Kendrick.[8] Kelly used hearts repeatedly, including at his very first fashion show in Paris, when he spray-painted a red heart on a white backdrop. Though red was a color Kelly frequently used, it was prophetic that he used the color so prominently in this gown; in summer 1991, a year and a half after Kelly himself died from complications related to AIDS, a red ribbon was adopted as the universal symbol of AIDS awareness.

Kelly's "Fashion Salute to Heart Strings" fashion show, as well as his other HIV/AIDS charitable events, is queer in that he was, at the time, among those working against the norm in fashion. As noted in multiple oral and written histories about the impact of AIDS on the fashion industry, the industry did not move quickly to get involved with HIV/

AIDS activism or charitable work, though this was later addressed with fundraising events such as the Council of Fashion Designers of America's Seventh on Sale benefit in 1990 and Susanne Bartsch's iconic Love Ball in 1989.[9] Still, there was, even in the late nineteen eighties, a heightened sense of fear and shame about HIV/AIDS, even in the fashion industry, despite the fact that so many people in the industry were dying of AIDS-related health complications. And in the fashion world, as in the world generally, there was a panic about the disease, and consequently a number of people in fashion were wary of their fashion label being connected to AIDS in any way. One effect of this panic was that some executives discussed not hiring male designers who were assumed to be gay or who were openly gay or bisexual, out of fear that they might become ill, which they believed could have a negative effect on the fashion

label.[10] Others in the industry expressed concern that customers may not want to buy clothes and accessories from a brand with a gay or HIV-positive designer at the helm, feeling that it would mean being associated with the virus.[11] Though Kelly chose not to come forward about his own diagnosis, he was not stunned or shamed into inaction on the AIDS epidemic. In fact, when asked by the *Atlanta Journal-Constitution* why he had chosen to participate in "A Fashion Salute to Heart Strings," Kelly responded with candor, saying, "A lot of my friends are sick, and a lot have died of AIDS."[12]

A frequent subject of discussion and point of dissonance among some queer theorists is the distinction between thinking of "queer" as a marker of identity and way of being versus a methodology, or way of doing. As with the other binaries that Kelly upended with his design, style, and performance, his work is also an invitation to dislodge the "queer" as an identity or as a methodology binary as well. His life and work are awash with a queer sensibility that provides insights that are as multilayered and complex as the intersections of his own identities and experiences. We must look, then, not only to his life and designs, but also to his sense of beauty, style, and performance, and to the choices he made about how to run his label, as objects for analysis that make conspicuous, in the Black queer enterprise he built, his knowledge.

ERIC DARNELL PRITCHARD

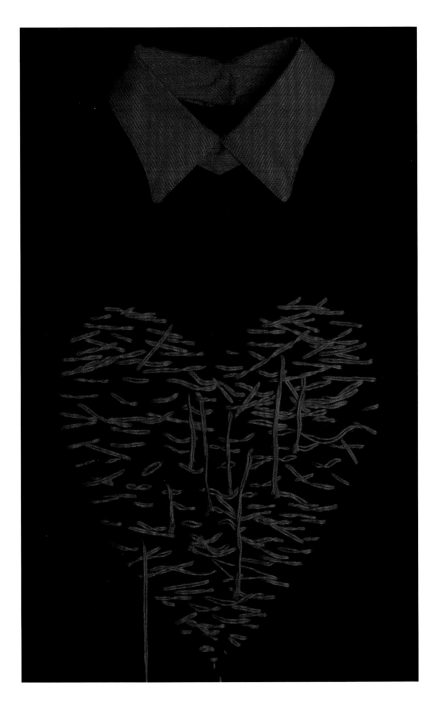

32. Detail (bodice) of the "Heart Strings" gown, 1988. Wool and acetate with cotton knit embroidery. The red lapels appear to be a separate shirt; however, the faux collar fastens to the gown at the back of the neck. Philadelphia Museum of Art. Gift of Bjorn Guil Amelan and Bill T. Jones in honor of Monica Brown, 2014-207-11

NOTES

1. "Patrick Kelly's Love List," Philadelphia Museum of Art: Exhibitions, 2014, accessed January 4, 2021. https://www.philamuseum.org/exhibitions/799.html?page=3.

2. Toni Morrison, "A Knowing So Deep," *Essence*, May 1985, 230.

3. Darlene Clark Hine, "Rape and the Inner Lives of Black Women in the Middle West: Preliminary Thoughts on the Culture of Dissemblance," *Signs* 24, no. 4 (Summer 1989): 912–920.

4. Henry Louis Gates Jr., *The Signifying Monkey: A Theory of African American Literary Criticism* (New York: Oxford University Press, 1988).

5. Alexander O'Neal, "Fake," 1986, track 8 on *Hearsay*, Tabu, 1987, compact disc.

6. Phillip Picardi, "An Oral History of Fashion's Response to the AIDS Epidemic," *Vogue*, accessed December 17, 2020, https://www.vogue.com/aids-epidemic-oral-history; Hamish Bowles, "Queering Culture," October 30, 2020, in *In Vogue: The 1990s*, podcast, https://open.spotify.com/episode/2KEljNspvwgkNCCrkLm9rd?si=bO1Eyt92QlWvoWYrDEOhgA.

7. "Getting It Together," *Women's Wear Daily*, October 31, 1988, 16.

8. "Ken Kendrick," *POBA: A Program of the James Kirk Bernard Foundation*, accessed March 9, 2021, https://poba.org/poba_artists/ken-kendrick/.

9. Picardi, "An Oral History of Fashion's Response to the AIDS Epidemic."

10. Ibid.

11. Ibid.

12. Marilyn Johnson, "Fashionata 1988 Will Go Straight for the Heart Strings," *Atlanta Journal-Constitution*, August 28, 1988, https://www.newspapers.com/image/400277188.

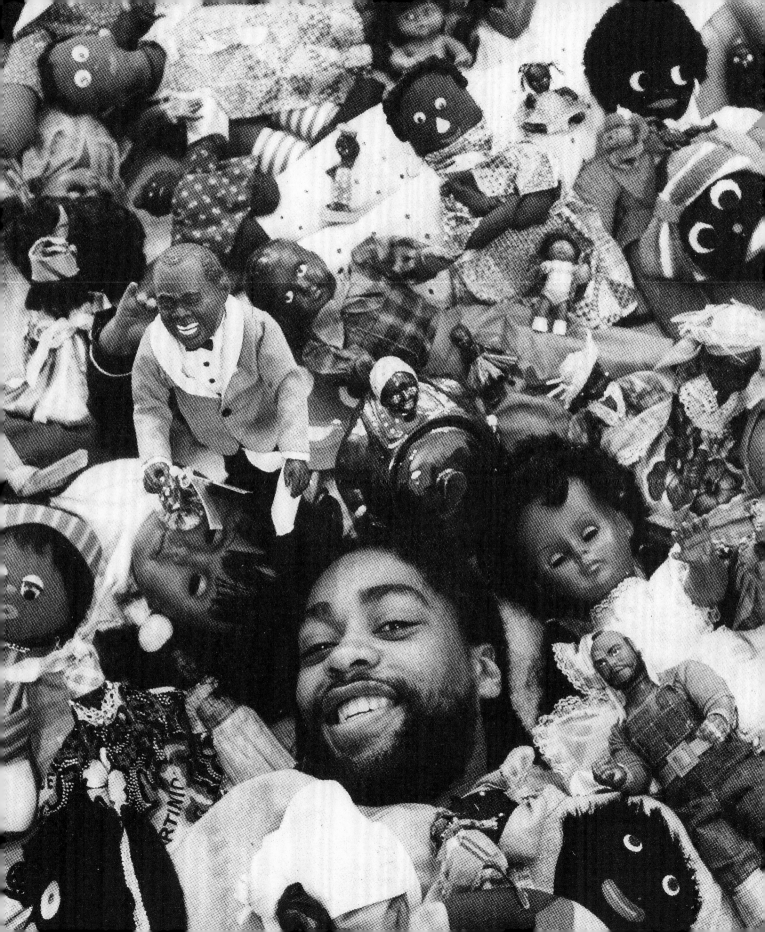

"If we can't deal with where we've been, it's gon' be hard to go somewhere":

Patrick Kelly's Seat at the Table

MADISON MOORE

"I get a lot of criticism from Blacks and from whites and from everybody about who I am and my image," an ebullient Patrick Kelly told a packed auditorium on April 24, 1989, at the Fashion Institute of Technology in New York. "And with the Blacks I always say, if we can't deal with where we've been, it's gon' be hard to go somewhere."[1] Here, Kelly faces head-on a question from the audience about the intent behind his strategic reappropriation of the racist and stereotypical blackface imagery that appears across his brand, images so charged that "when buyers came from the US stores, they said, 'We can't buy this print.'" Warnaco, the textile company that invested big in the house of Kelly, "refused to allow the use of the blackface logo on bags."[2] The image—a golliwog, a racist, fictional Black children's character that began appearing in the late 1800s, whose features included dark black skin, big white eyes, and exaggerated red lips—would become the logo for Patrick Kelly Paris, evidence of the designer's long-standing interest in Black memorabilia and residues of racism, if not also a desire to queer racist iconography, with two snaps and a twist (fig. 33).

As the fashion critic Robin Givhan notes, "No other well-known fashion designer has been so inextricably linked to both his race and his culture," and one need look no further than the playful Patrick Kelly Paris logo for clues.[3] Tellingly, Kelly's golliwog logo shows a Black face against a white background, as apt a metaphor for being Black in fashion as they come. His calculated use of this logo not only forces white fashion consumers to confront a racially supercharged image, but it also ensconces the image deeply in the heart of the Parisian fashion universe, alongside players like Sonia Rykiel and Yves Saint Laurent.

In today's fashion universe, where there are exhausting blackface controversies nearly every season, from Steven Meisel's March 2012 *Haute Mess* editorial in Italian *Vogue* and Prada's 2018 racist keychain to Comme des Garçons's cornrow lace fronts and Gucci's $890 blackface sweater, it often seems as though these controversies are purposefully sought out, season after season, even after a deluge of think pieces, forced brand apologies, and redacted collections have made the rounds. But what might serve as a publicity stunt for some houses, for Kelly was an intense desire to put race front and center in the conversation, as when the photographer Annie Leibovitz shot him for *Vanity Fair* in 1988 flanked by two white models in blackface (!)—an

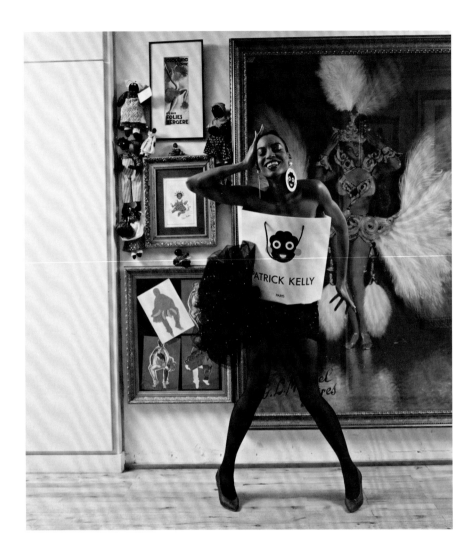

supernova, to use Eric Darnell Pritchard's poignant term, "they gag, ga-a-a-g"[6]

Kelly's determination to inject race into the fashion conversation shows us how it might be possible to reappropriate, repurpose, or queer racist images. Kelly's personal collection of Black memorabilia (also known as racist memorabilia or racial kitsch) was extensive and is said to have once numbered at least eight thousand pieces (see photo, page 44). The collection included watermelon-shaped figures, advertising ephemera, Black figurines, historical artifacts, Aunt Jemimas, and other bits and bobs that reflect histories of racist imagery and the African American experience. "He would purchase these little Black dolls made out of plastic—six hundred a month," his partner, Bjorn Guil Amelan, told fashion critic Robin Givhan, handing out the dolls to everyone in the audience at his fashion shows.[7] And in a significantly layered appearance on *Late Night with David Letterman* in May 1987, the actress Bette Davis, a key supporter of Kelly's, advocated strongly for Kelly on air, telling Letterman that Kelly was "a Black man from Mississippi" and "he is making a big, big way in Paris. As a matter of fact," she told him, "he has a good luck symbol. And it is a little, tiny Black baby, and it's on a pin, and it is his good luck," before giving the baby to Letterman to keep.[8]

For cultural critic Lynn Casmier-Paz, Black folks who collect what she terms "grotesque Black memorabilia" do so because the racist representations they depict "belong to those who were

exploration of racist iconography that also tapped into his personal experience as a Black queer man of the South.

A native of Vicksburg, Mississippi, with a brief stint at Jackson State University, a historically Black college and university, where he studied art history, Kelly knew a thing or two about the machinations of racism as well as the stakes of linking his fashion house so closely to racially loaded imagery. When he was a child, and secondhand books would be sent from a white elementary school across town, Kelly said, "They'd color in the faces of Dick and Sally so they'd be black when they got to us."[4] And if that's not telling enough, consider Kelly's experiences with the Ku Klux Klan, who once sent him hate mail.[5] Or think about how Kelly was penalized for existing while Black, such as being denied entry to a Paris hotel not once but five times, or the difficulty of hailing cabs in New York, or when certain buyers assumed he was a deliveryman, not the designer himself. By the time the buyers realize he was *the* Patrick Kelly, a Black queer

MADISON MOORE

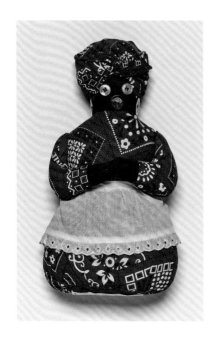

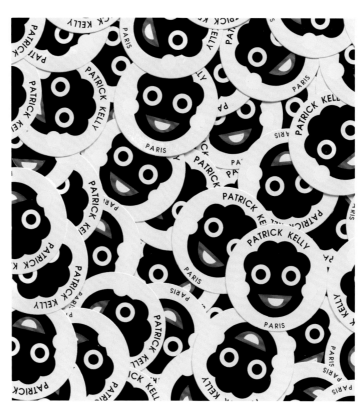

34. A "mammy" doll, made by Patrick Kelly's mother, available for sale in the Patrick Kelly Paris shop

35. Patrick Kelly Paris logo pins

victimized by the stereotypes and the violence they represent," such that white people "will not be able to claim the racism" or ownership of the image.[9] Perhaps like many, Casmier-Paz struggles to understand why Black Americans collect these forms of racist memorabilia, seeing the brutality of these images as a space of anti-Black violence.[10] But fashion historian Sequoia Barnes sees it differently, noting the value of Kelly's decision to queer the image as a Black Southern fashion designer working in, and *werking,* Paris (snap!). For Barnes, Kelly's golliwog logo should be considered "as much as a representation of whiteness than Blackness, as the golliwog is a totem of white dominance and perceptions of the other," a poaching

and remixing of racist imagery (figs. 34–36). From voguing and ballroom culture to Black vernacular speech, Black queer culture is full of creatives remixing and repurposing harmful words and images into something new.[11]

The ability to see through and repurpose technologies and images is the art of the remix, what historian Rayvon Fouché has called Black vernacular technological creativity, and this art of the remix is a central trait of Black expressive culture. For Fouché, "Black vernacular technological creativity results from resistance to existing technology and strategic appropriations of the material and symbolic power and energy of technology."[12] It is, in other words, the strategic seizing and reuse of existing technology for other means.

Kelly's *Mississippi Lisa* offers a key example here of the designer's playful remix of racist iconography (fig. 37). In the image, a Black female figure stirring a pot of gumbo (clearly labeled as such) wearing big gold hoop earrings and a red-and-white head wrap seems like a simple nod to Aunt Jemima. But on closer inspection, we notice that the image is a remix of Leonardo da Vinci's *Mona Lisa* (ca. 1503–ca. 1519), only this time Black and in living color.

Tongue planted firmly in cheek yet dead serious, *Mississippi Lisa* calls to mind other Black contemporary artists who have reimagined canonical works of art with Black people, artists like Mickalene Thomas and Kehinde Wiley. Even pop deities Beyoncé and Jay-Z,

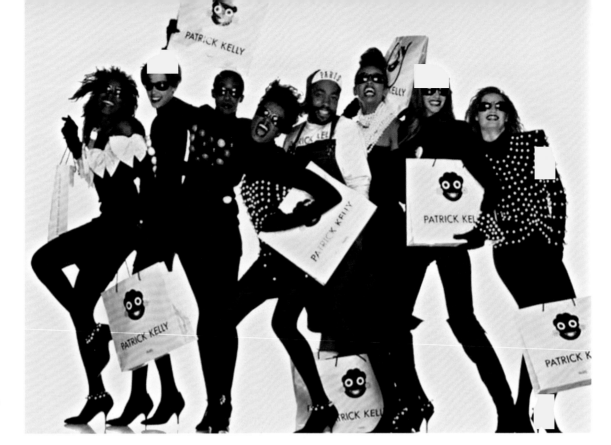

36. Patrick Kelly Paris shopping bags printed with his golliwog logo, photographed by Oliviero Toscani

37. Patrick Kelly Paris Spring/Summer 1989 fashion-show invitation, featuring "Mississippi Lisa," designed by Christopher Hill

who remarkably filmed their 2018 music video "Apeshit" at the Louvre, posed in front of the *Mona Lisa* as a kind of remix, a way of contextualizing themselves within legacies of visual culture while outdoing the painting's relevance.

Kelly's interest in collecting Black memorabilia, and the dissemination of these images across his brand, invite us not only to face these images head-on but also to think about what they teach us when they are remixed from a Black queer perspective. It's not clear there's an answer; Kelly was only able to show eight collections over four years before he died of complications related to AIDS in 1990. But critics like Thelma Golden have argued that Kelly's endeavors suggest a precedent for artists like Kara Walker and others who work with and through difficult racial imagery.[13]

Patrick Kelly was one of the original "girls," those legendary Black queers who made a sizable impact on contemporary culture. Part of the brilliance of Kelly's legacy is that he is part of a big, bold, beautiful Black queer ecosystem that includes Crystal LaBeija and Willi Ninja and Lil Nas X and Frankie Knuckles and Travis Alabanza and Fatima Jamal and Devan Shimoyama and Mickalene Thomas and Telfar Clemens and Shayne Oliver and Olivier Rousteing—all Black queers who dream of beauty and Blackness. Beauty for Black people when no one believed Black people were important. Beauty for Black people when Black folks were strategically excluded from constructions of beauty. In the face of annihilation and subjugation, Patrick Kelly took a seat at the table.

NOTES

1. "Faces and Places in Fashion: Patrick Kelly," YouTube video, 1:02:28, hosted by the Fashion Institute of Technology on April 24, 1989, https://www.youtube.com/watch?v=-_gMSO_KjRc.

2. Robin Givhan, "Patrick Kelly's Radical Cheek," *Washington Post*, May 31, 2004.

3. Ibid.

4. Margot Hornblower, "An Original American in Paris: Patrick Kelly," *Time*, April 3, 1989.

5. Horacio Silva, "Delta Force," *New York Times Magazine*, February 22, 2004.

6. Ben Brantley, "Patrick Kelly's Crazy Couture," *Vanity Fair*, March 1988.

7. Givhan, "Patrick Kelly's Radical Cheek."

8. Bette Davis on "Late Night with David Letterman," YouTube video, May 26, 1987, accessed May 24, 2021, https://www.youtube.com/watch?v=a5GvQ3Fzrj8.

9. Lynn Casmier-Paz, "Heritage, not Hate? Collecting Black Memorabilia," *Southern Cultures* 9, no. 1 (2003): 49, doi.org/10.1353/scu.2003.0009.

10. Casmier-Paz, 50.

11. Sequoia Barnes, "'If You Don't Bring No Grits, Don't Come': Critiquing a Critique of Patrick Kelly, Golliwogs, and Camp as a Technique of Black Queer Expression." *Open Cultural Studies* 1, no. 1 (2017): 685, doi.org/10.1515/culture-2017-0062.

12. Rayvon Fouché, "Say It Loud, I'm Black and I'm Proud: African Americans, American Artifactual Culture, and Black Vernacular Technological Creativity." *American Quarterly* 58, no. 3 (2006): 641, doi.org/10.1353/aq.2006.0059.

13. Silva, "Delta Force."

MADISON MOORE

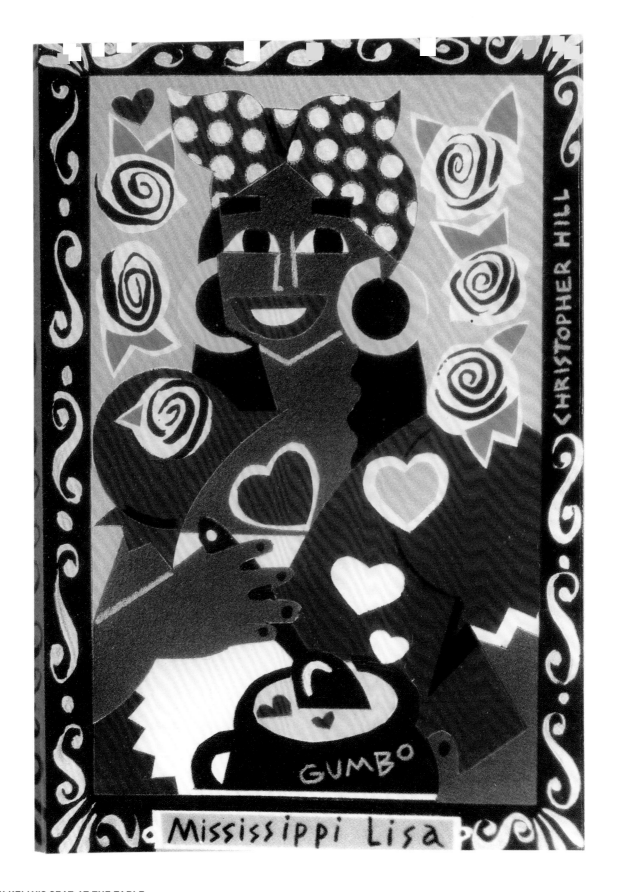

GUMBO

Mississippi Lisa

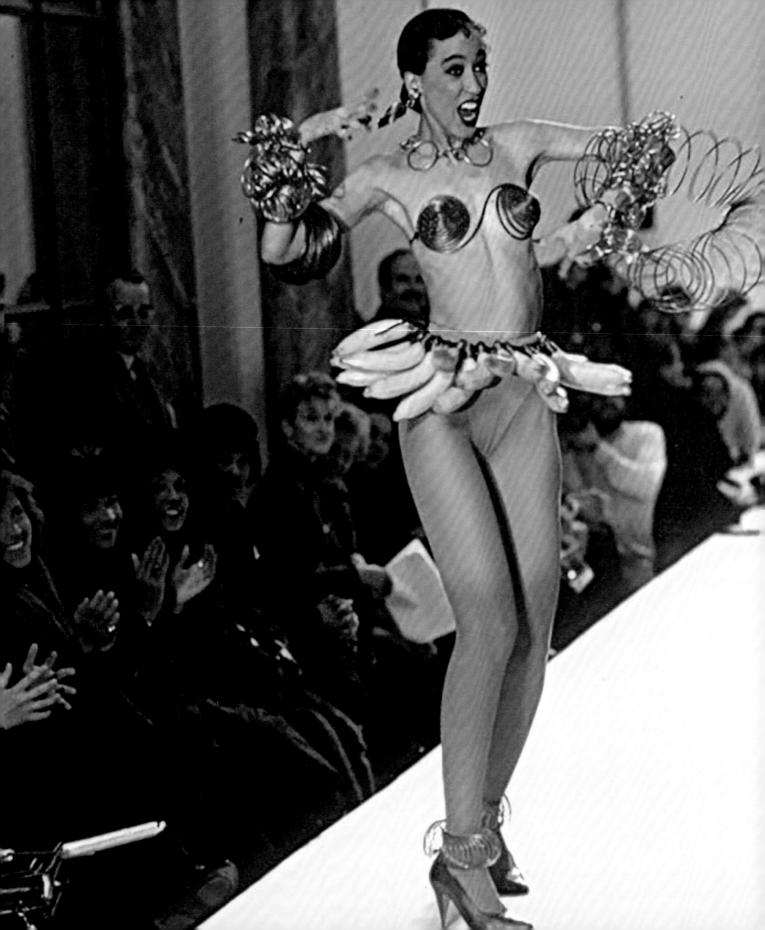

Resurrecting Josephine

Contextualizing Pat Cleveland's Runway Performance for Patrick Kelly Paris

SEQUOIA BARNES

For the finale of Patrick Kelly's Fall/Winter 1986–1987 fashion show, supermodel Pat Cleveland walked out wearing an ensemble that resembled Josephine Baker's famous banana-skirt costume (opposite).[1] Cleveland lip-synced to Baker's "Ram-Pam-Pam" while dancing jauntily, at many points prancing down the runway, and jerking her arms to accentuate the Slinky-like metal coils spiraling from her wrists and arms. Her eyes were emphasized with dark makeup to make them pop and appear larger when she opened them wide. She exaggerated her facial expressions effectively, and her vibrant red lips smiled big as she lip-synced every word of the song in French. She gyrated her body, shook her hips, and spun around enthusiastically, at one point turning around to stick out her derrière, mimicking Baker's iconic posing. Cleveland then pranced back up the runway, and before continuing backstage she stopped to pull a final face and pose, marking the end of the show.

Pat Cleveland's runway performance as Josephine Baker, under Patrick Kelly's creative direction, is a complexity in racial-gendered camp production. I define racial-gendered as an intersectional term, where the marginalization and oppression subverted in camp often comes from a place that intersects between race and gender identity, most often through the aesthetic of femininity. As Susan Sontag stated in *Notes on Camp*, camp has a propensity to reference and resignify the past.[2] By 1986, Cleveland was a known impersonator of Josephine Baker, and Kelly used Cleveland's experience "being" Baker to conjure Baker's specter for his runway show. Yet Kelly's show finale was not the first time Baker appeared on a runway. Fashion historian Caroline Evans states that Baker modeled a Louise Chéruit dress in 1927 at the Grande Nuit de Paris show hosted by *Femina*, a French lifestyle magazine created in 1901 for bourgeois women.[3]

There is no visual documentation or detailed description of Baker's runway moment; what happened is left up to the imagination. Kelly may have known of Baker's runway debut, imagined what could have been, and re-created it with the help of Pat Cleveland's body.

Pat Cleveland: The Josephine Baker of Fashion

Pat Cleveland (b. 1950) is one of the first black supermodels (fig. 38). She is well known for her energy on the runway,[4] and André Leon Talley once called her "the Josephine Baker of the international runways."[5] While models tended to walk the runway with static poise and standardized glamour, Cleveland would spin, twirl, dance, and even run across it,

38. Portrait of Pat Cleveland
wearing a gauzy head wrap
and a fuchsia dress, 1977

SEQUOIA BARNES

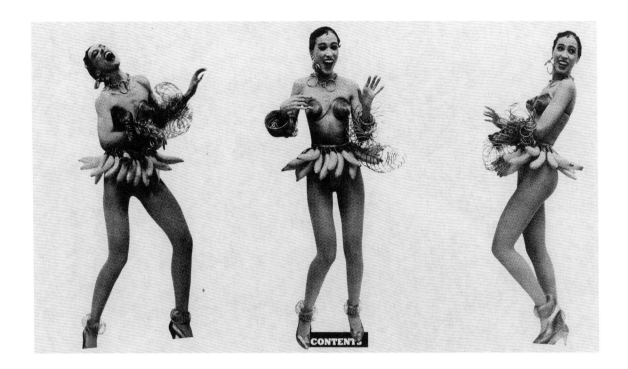

39. Pat Cleveland, photographed by Bill Cunningham, in *Details*, September 1986

conveying how fashion felt versus how it was simply meant to look (fig. 39 and 40). Pat Cleveland is not a clothes hanger—she is an entertainer on the runway, which made her a rebel at the height of her career.

Patrick Kelly created the banana-skirt costume specifically for Cleveland to perform in for his Fall/Winter 1986–1987 show. The costume (pl. 28) was made in collaboration with jewelry designer and metalwork artist David Spada. It consists of a strapless pink bra top, a skirt made out of plastic bananas, high-cut pink bikini bottoms, gold and pink spiral adornments for Cleveland's arms and ankles, and matching pink-satin pumps, as well as one big pink-and-gold spiral earring and a gold necklace made of hoops in various sizes linked together. The metalwork was made with anodized aluminum, a common medium for David Spada's designs. The bra appears to be

one thin metal rod that is spiraled from both ends, in opposite directions, to form cups that cover Cleveland's breasts, and it is held in place with string that ties behind her back. The strapless bra is a slightly coned copy of the very coned strapless bra featured in the costume Spada created with artist Keith Haring for the singer, model, and actress Grace Jones in 1984. The spiraling wire bra also has clear references to Alexander Calder's series of kinetic Josephine Baker portraits (ca. 1927–1930).[6]

Pat Cleveland and Patrick Kelly both idolized Baker. Cleveland had been putting on performances imitating her as early as the 1970s, and she portrayed Josephine Baker several times in print, with most instances occurring prior to Patrick Kelly's Fall/Winter 1986–1987 show. In the 1970s, she was styled by Richard Haines to look like Baker and photographed by Pelito Galvez for *Interview* magazine. In 1980, Cleveland was photographed by Alan Kaplan for *Vogue Italia* wearing a banana-skirt

costume. She then reprised her role as Baker for Jean Paul Gaultier in the December 1990 issue of *Vogue Paris*, photographed by Steven Meisel, nearly a year after Patrick Kelly's death.

Cleveland's performance in Kelly's fashion show was also not the first time that she portrayed Josephine Baker under Kelly's creative direction. Cleveland states that she and Kelly met around 1977 or 1978, although they had previously met in Atlanta.[7] After reconnecting in New York, Kelly convinced her to come with him to a hair show at the Coliseum, a former conference center in New York. Kelly was working on the show, and he wanted Cleveland to dress up in a Josephine Baker–inspired costume that he had made. He also wanted her to perform a Josephine Baker song, because he knew that Cleveland had been performing Baker's songs in various clubs around the city.[8] Cleveland recalled, "Patrick then pulled out of his bag these plastic bananas and cupcakes covered with shiny pink fabric to cover my

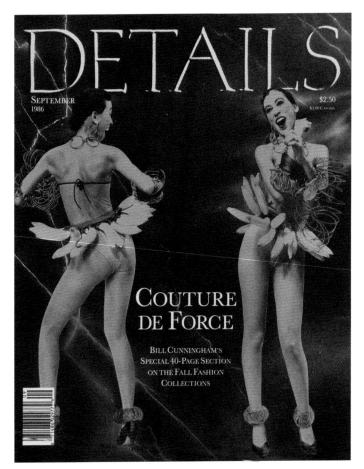

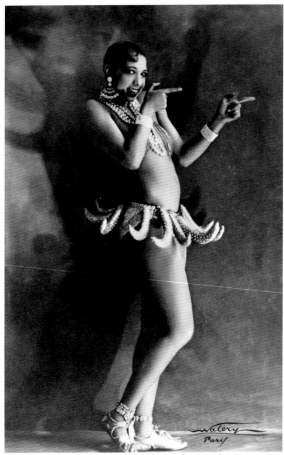

breasts. He put all that on me and stuck a feather in the back of my chignon," while Cleveland wore her own Charles Jourdan pumps (see Remembering Patrick Kelly, this volume). There were no visible cupcakes present in the photograph of her performance at the Coliseum, although there were some similarities in this prototype to the 1986 version; the use of pink, the shape of the strapless bra, the high-cut bikini bottoms, and the string of plastic bananas around her waist. Cleveland's hair was done up into the finger waves that Baker was known for, and she was given fishnet stockings embellished with pearls to wear onstage.

When it was time for her performance, Cleveland seductively came out from behind a gold lamé stage curtain and danced while singing "La Petite Tonkinoise" to an audience of hair-show spectators.[9]

Kelly's relationship with Pat Cleveland provides insight into what is the first evidenced camp design by Patrick Kelly. I have yet to find any other testimonies or images of garments that could be considered camp design while also predating Kelly's migration to Paris. There is also no evidence of Kelly revisiting or re-creating garments from his time in New York later in his career. Therefore,

40. Pat Cleveland, photographed by Bill Cunningham, on the cover of *Details*, September 1986

41. Josephine Baker, 1920s

Kelly's banana-skirt costume prototype for Cleveland shows a deployment of camp aesthetic and performance that predates Patrick Kelly Paris.

Resurrecting Josephine and Patrick Kelly's Visual Tactics

Patrick Kelly was a gay black man from Mississippi, and although his success, and his acceptance into the world of Parisian fashion, may seem almost instantaneous and unanimous, this was not always the case, nor was it easy. Sonia Rykiel stated that the Chambre Syndicale du Prêt-à-Porter des Couturiers et des Créateurs de Mode had early reservations about admitting Kelly, because, "all we knew was that he did his (button and bow) patchwork thing really well . . . now a recognizable Kelly woman has clearly emerged and Kelly has proved he is not just a flash in the pan."[10] In an episode of CNN's *Runway Club*, which showcased Kelly's first show at the Louvre, the interviewer asked Kelly, "Do you get upset when people ignore [you] or expect to see someone white in the showroom?" Kelly responded by saying "hello" and extending his hand for an imaginary person to shake, explaining, "They treat me like a cleaning man and walk right past me." He goes on to state that his two white staff members (Mary Ann Wheaton, the president of Patrick Kelly Paris Inc., and Bjorn Guil Amelan, his partner) ask these customers if they would like to meet Patrick Kelly, then "direct them towards the black man they ignored." The customers apologized and Kelly responded, "Don't be sorry. Buy more dresses."[11] When asked about the death threats he received from the Ku Klux Klan, Kelly responded by calling them the "Cha Cha Cha" and asked the reporter, "Honey, what do they know about fashion except for a white robe?"[12]

There were likely other undocumented instances of reservations about or resistance to Kelly's presence, and Kelly, in his own humorously subversive way, likely resisted in return. There is an aspect of self-awareness that employs othering as a tool for resisting the alienation and oppression of white-hetero-patriarchal supremacy that Kelly deploys in his design aesthetic. José Esteban Muñoz calls this "disidentification."[13] By making his status as other overt and celebrated, via Josephine Baker's iconography, Kelly was subverting the assumptions and expectations of him as a gay black man to carve out a space for himself as a respected designer. For marginalized, intersectional bodies, like Kelly, it is often hard, and sometimes impossible, to separate oneself from one's own experiences because society will not let them, especially for a creative person.

Patrick Kelly was aware of Josephine Baker's aptitude for subverting the "pleasure of seeing" through humor and cuteness (fig. 41). Homi Bhabha states that the pleasure of seeing is related to objectification and fetishism born out of exoticizing or eroticizing the other. This kind of seeing results in the white gaze's conflicting emotions: desire for and repulsion by the black body.[14] Humor and cuteness acted as breaks from Baker's eroticism—barriers against complete objectification and subjection to white desire. T. Denean Sharpley-Whiting states that "Baker's exoticized body [was] handed to the audience but [was] untouchable because it was imbued with blackness and infantilo-innocence that kept the spectator suspended between fantasy and desire."[15] This fantasy relied on the aesthetics and performance styles

associated with minstrelsy that Baker adopted into her performance.

However, Pamela Robertson states that black camp includes playing with recognition and misrecognition.[16] Muñoz defines misrecognition as assimilation via imagining oneself as something other than the other.[17] Consequently, Josephine Baker represents this potential ambiguity between representation and subjection, because misrecognition appears as if the marginalized subject is complicit in their oppression even though this appearance can be complexly layered with subversion. Although she was a real person, her image and her performances are considered tropes, because she reproduced imagery born from primitivism and the exploitation of Sarah Baartman, which allowed Baker to transform herself into a fetishized subject.[18] Sarah Baartman (1775–1815), who became known as the "Hottentot Venus," or the "Black Venus," was a woman from the Khoikhoi tribe of South Africa. She was taken from her home and put on display across Europe as a racial oddity, until her death, for her distinctive body shape and mythologies around her genitalia. She faced abuse, poor conditions, and enslavement during the five years she was exhibited. After her death, her skeleton was exhibited in Paris at the Muséum National d'Histoire Naturelle (National Museum of Natural History) until 1974 (her body cast remained on view until 1976), but her remains were not returned to South Africa until 2002.

On the surface, Josephine Baker's banana-skirt dance is a fitting example of misrecognition, as her performance referenced the brutal last years of Baartman's life. As a result, Baker's costume and posing are often seen as harmful to the black image. Sharpley-Whiting states

that as an African American outsider with a flair for humor and an abundance of femininity, Baker attached racial-gendered mythologies to herself to have autonomy over her subsequent objectification.[19]

Patrick Kelly was familiar with this backlash against Josephine Baker. As a camp auteur, Kelly recognized the highly fetishized image that Baker capitalized on. However, Kelly perpetuated Baker's misrecognition by reproducing her tropes in his designs. Kelly appears to have capitalized on the banana-skirt trope for fashion's sake. However, as with camp, just because it appeared this way does not make it the complete truth. Muñoz states that misrecognition can be tactical.[20] With camp, a trope can be manipulated and resignified in ways that make difference an advantage for tackling oppression. Josephine Baker used this tactic before it had a name. She took on racializing tropes to gain personal autonomy, creatively and financially, and to acquire influence, which she later used to become a prominent civil-rights activist.

In Kelly's 1986 finale, Baker was reimagined and resurrected via Pat Cleveland, but she was not cleansed of her racial-gendered semiotics. In the banana skirt, Baker is still the "Black Venus," even when performed by a proxy. The adornment did the work, and the audience automatically recognized the aesthetic. For Kelly, Baker was like a postmodern spirit goddess who possessed Pat Cleveland upon his humble request. The audience looked up at Cleveland/Baker swinging her hips and lip-syncing down the runway as if they were ready to worship her (figs. 42–49). They appear truly captivated, as if Cleveland is not just possessed but Baker herself back from the dead. Perhaps she never really died as far as fashion was concerned, and Patrick Kelly thought that we needed reminding.

NOTES

1. In a film of Josephine Baker's banana-skirt dance, performed at the Folies Bergère in Paris in 1927, the stage opens on a jungle scene with a "tribal" jazz beat playing in the background. Baker is at the top of the stage, on a fallen tree. She sneaks across the stage comically, then suddenly runs across the bottom of the stage, landing in a daring split pose. Now on the stage floor, she rises up sensuously and catlike. We see her full costume as she stands: a necklace of big dark-colored baubles (the footage is in black and white; therefore, the colors are indeterminate), which appear to be nuts or stones, not pearls as the popular depictions of Josephine Baker suggest, with bangles on her wrists and arms. A bra made of some illegible material, possibly shells, covers her breasts (which were often bare when she performed). This film was made to be shown in American theaters, and censorship in the US required her to cover up. The infamous skirt was made of shiny, plastic bananas, and she is wearing dancer's shoes that may be metallic colored. Throughout, Baker dances in a gyrating fashion, rotating her hips around in a fast, sexually suggestive nature, and then she makes another face as she strikes another pose. Ending the performance, she does the Charleston and sticks out her derrière, in profile, to resemble the Hottentot Venus.

2. Susan Sontag, Notes on Camp (London: Penguin Books Limited, 2018 [1964]).

3. Caroline Evans, The Mechanical Smile: Modernism and the First Fashion Shows in France and America, 1900-1929 (New Haven, CT: Yale University Press, 2013).

4. Cleveland got her start walking for Ebony Fashion Fair in the 1960s. However, her success did not shield her from racism in the fashion industry, and she struggled to secure herself at an agency for some time. Antonio Lopez, the late fashion photographer and illustrator, convinced her to move to Paris in 1971, where she became highly sought after walking in the Battle of Versailles for Halston and Stephen Burrows in 1973. She was a house model for Karl Lagerfeld at Chloé and a muse for Salvador Dalí. By 1980, Cleveland had been photographed by many of the most prominent artists of the day, such as Andy Warhol, Irving Penn, and Richard Avedon. Still, she vowed to not return to the States until a black model appeared on the cover of Vogue. She returned to the States in 1974, the year Beverly Johnson became the first black model on the cover.

5. André Leon Talley, A.L.T. 365+ (New York: Powerhouse Books, 2005).

6. David Spada's most famous work with Keith Haring and Grace Jones was photographed by Robert Mapplethorpe and features a coned version of the strapless bra worn by Pat Cleveland. This costume featured Grace Jones in a crown, bra, and skirt as well as rubber jewelry created by Spada. Haring created the well-known motifs on the crown and skirt and did the body painting, which repeats the same motifs. Jones's pose in the photograph, as well as the styling, implies that Jones is being racialized and visualized as other. Her eyes are big and her pose is a menacing caricature of tribalism. This visual is highly stylized postmodern primitivism via stereotypes of the African diaspora. The same could be said for Pat Cleveland as Josephine Baker for Patrick Kelly, because of what the banana skirt represents. However, like Jones, Pat Cleveland is also aware of, and often involved in, how she is exoticized and fetishized as other, especially when she was at the height of her career and had a hand in the creative direction of her image.

7. Kevin Sessums, "Pat Cleveland Remembers Patrick Kelly," Sessums Magazine, accessed January 20, 2021, https://sessumsmagazine.com/2019/02/01/pat-cleveland-remembers-patrick-kelly/.

8. Ibid.

9. Ibid.

10. Quoted in "All Decked Out, Ready to Shine," Sunday Capital, October 2, 1988, E4.

11. Patrick Kelly interview, "Runway Club," CNN Style, CNN, 1988.

12. Horacio Silva, "Delta Force," New York Times Magazine, February 22, 2004, accessed July 27, 2020, https://www.nytimes.com/2004/02/22/magazine/delta-force.html.

13. José Esteban Muñoz, Disidentifications: Queers of Color and the Performance of Politics (Minneapolis: University of Minnesota Press, 1999).

14. Homi Bhabha, "Of Mimicry and Man: The Ambivalence of Colonial Discourse," October 28 (Spring 1984): 125-133.

15. T. Denean Sharpley-Whiting, Black Venus: Sexualized Savages, Primal Fears, and Primitive Narratives in French (Durham, NC: Duke University Press, 1999).

16. Pamela Robertson, "Mae West's Maids: Race, 'Authenticity,' and the Discourse of Camp," in Camp: Queer Aesthetics and the Performing Subject; A Reader, ed. Fabio Cleto (Ann Arbor: University of Michigan Press, 2002), 393-408.

17. Muñoz, Disidentifications.

18. Amadeus Harte, "Becoming a Racialized Subject: The Subjectifying Power of Stereotypes in Popular Visual Culture," Social & Political Review XXVI (2016): 74-99.

19. T. Denean Sharpley-Whiting, Black Venus.

20. Muñoz, Disidentifications.

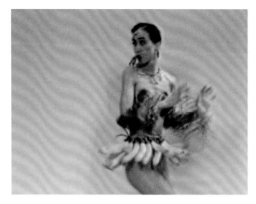
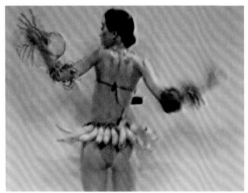
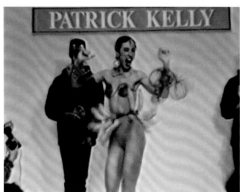

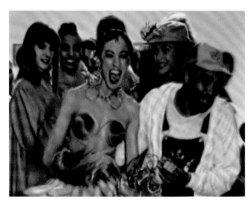

42.–49. Still photographs from Pat Cleveland's performance as Josephine Baker and the finale of the Patrick Kelly Paris Fall/Winter 1986–1987 collection presentation

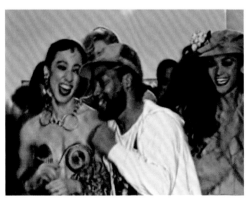
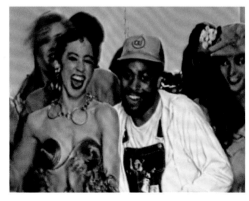

CATALOGUE

Unless otherwise noted, all designs are by Patrick Kelly (American, 1954–1990) and from the collection of the Philadelphia Museum of Art. Accessories that are pictured but not described in the captions are objects from the period or re-created for the project.

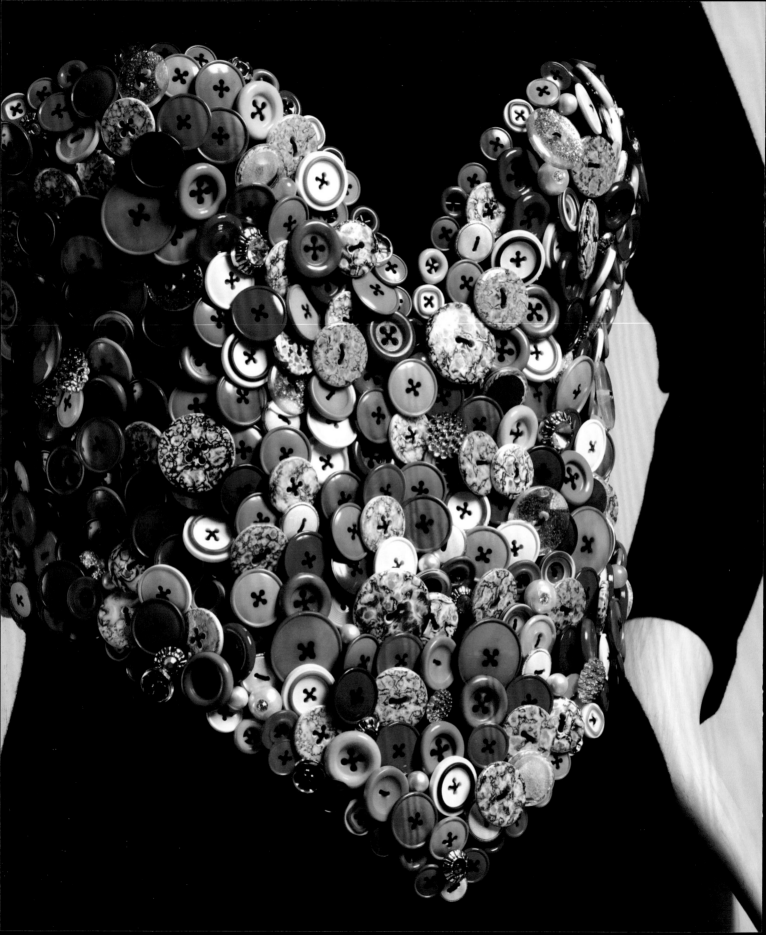

RUNWAY OF LOVE

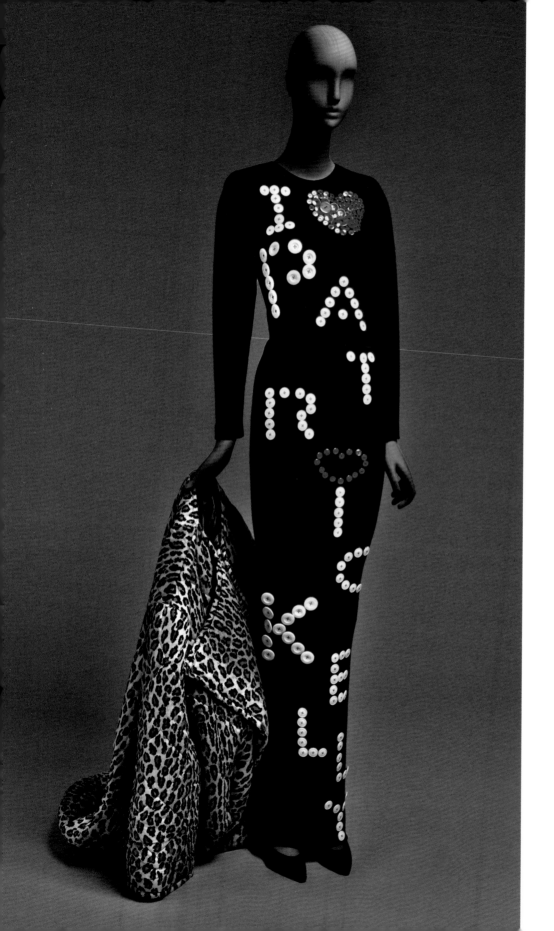

1.

Coat and dress

Fall/Winter 1986–1987

Chez Patrick Kelly collection

Coat: printed and quilted rayon

Dress: wool and spandex knit with plastic buttons

Gift of Bjorn Guil Amelan and Bill T. Jones in honor of Monica Brown, 2015-201-29a,b

2.

Dress and earrings

Fall/Winter 1986–1987

Chez Patrick Kelly collection

Dress: wool and spandex knit with
plastic buttons

Earrings by David Spada
(American, 1961–1996): metal

Gift of Bjorn Guil Amelan and Bill
T. Jones in honor of Monica Brown,
2015-201-124

Private collection (earrings)

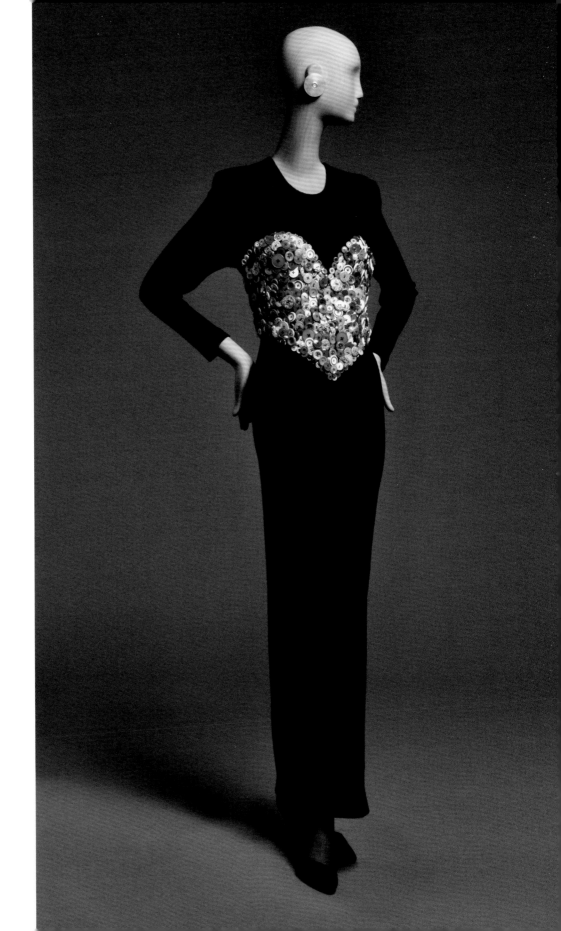

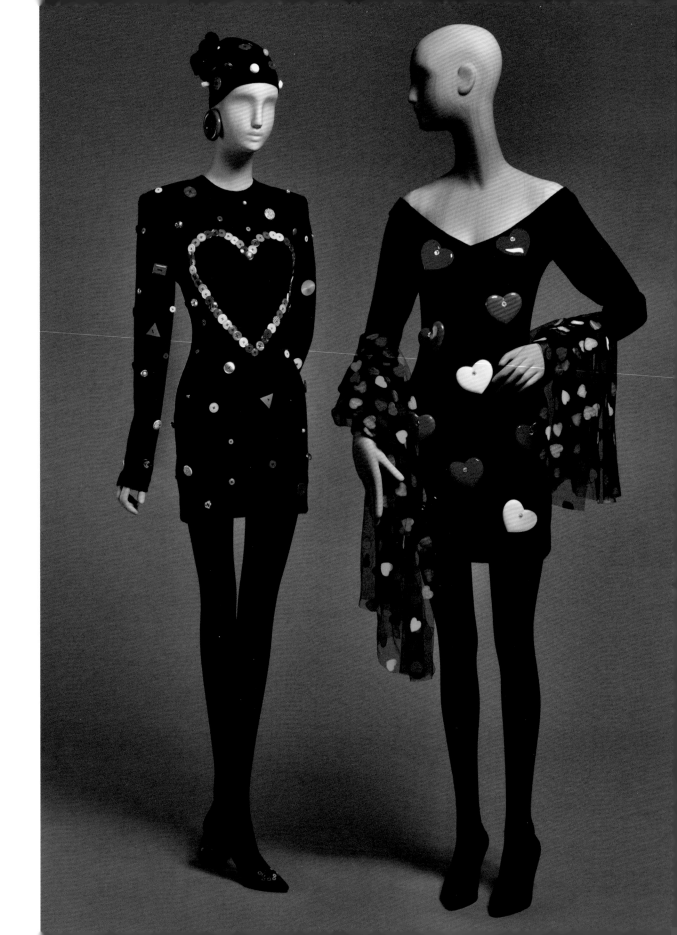

3.

Dress, hat, and shoes

Fall/Winter 1987–1988

Dress and hat: wool and spandex
knit with plastic buttons

Shoes by Maud Frizon (French, est.
1969): suede with plastic

Gift of Bjorn Guil Amelan and Bill
T. Jones in honor of Monica Brown,
2015-201-5a--d

4.

Dress, pins, and shawl

Fall/Winter 1988–1989

More Love collection

Dress: wool and spandex knit

Pins: plastic and rhinestones

Shawl: nylon net with paper and
flocked viscose

Gift of Bjorn Guil Amelan and Bill
T. Jones in honor of Monica Brown,
2014-207-16a--l

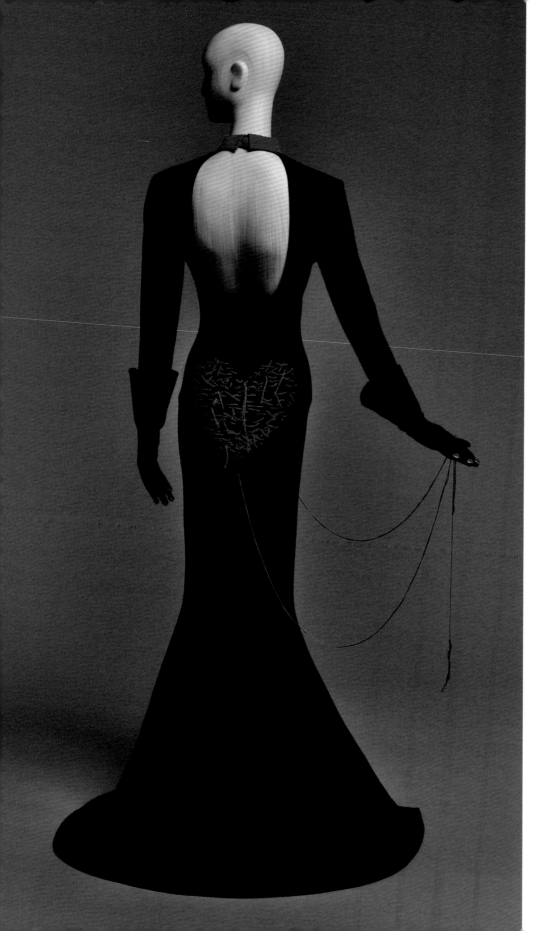

5.

Dress and gloves

Fall/Winter 1988–1989

More Love collection

Exclusive design for "A Fashion Salute to Heart Strings" fashion-show benefit hosted by the Design Industries Foundation Fighting AIDS in Atlanta

Dress: wool and acetate with cotton knit embroidery

Gloves: wool knit with plastic buttons

Gift of Bjorn Guil Amelan and Bill T. Jones in honor of Monica Brown, 2014-207-11 (dress); Purchased with the Costume and Textiles Revolving Fund, 2012-122-1a,b (gloves)

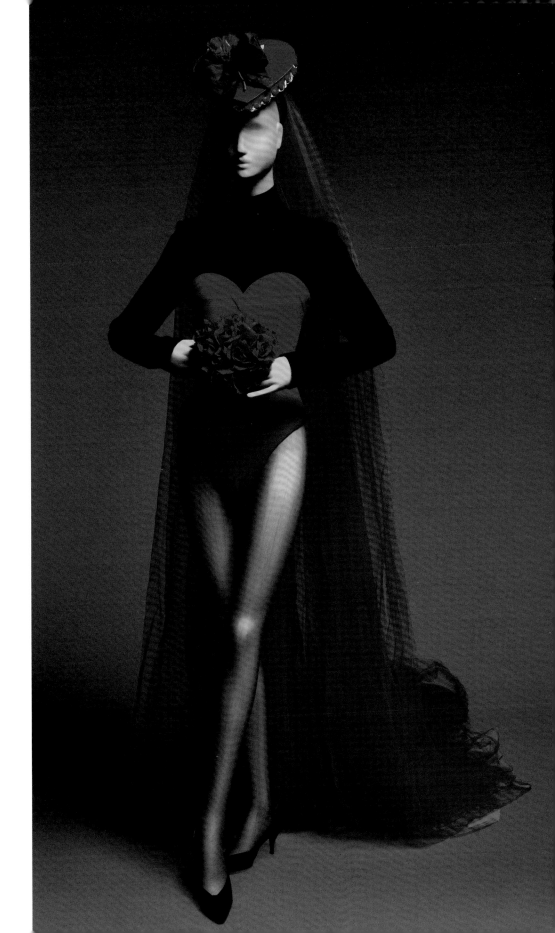

6.

Bodysuit and headpiece with veil

Fall/Winter 1988-1989

More Love collection

Bodysuit: wool knit

Headpiece with veil: paperboard with synthetic leather, velvet, and plastic; synthetic tulle veil

Gift of Bjorn Guil Amelan and Bill T. Jones in honor of Monica Brown, 2014-207-17a,b

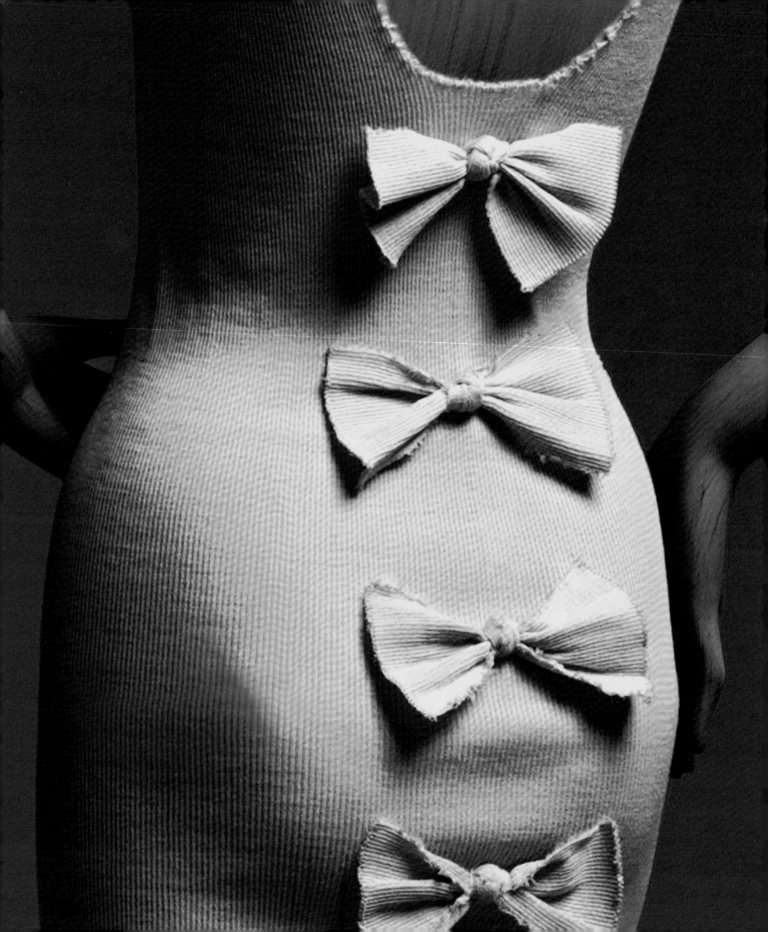

FAST FASHION

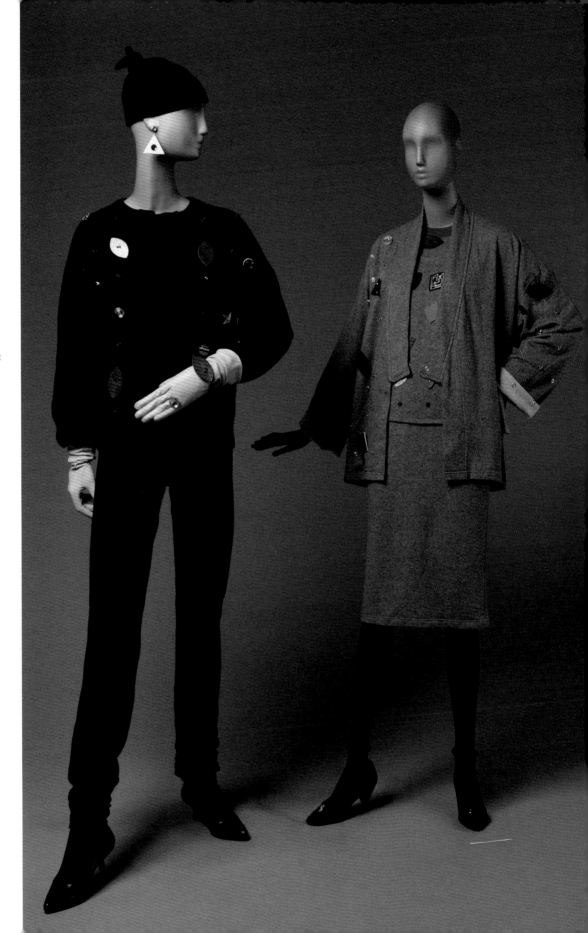

7.
Jacket, top, trousers, gloves, and decorative snaps

Fall/Winter 1984–1985

Studio Invenzione collection

Jacket: cotton and acrylic knit with leather, plastic, glass, and metal decorative snaps

Top: wool, angora, and nylon knit

Trousers: cotton knit

Gloves: suede with plastic decorative snaps

Gift of Bjorn Guil Amelan and Bill T. Jones in honor of Monica Brown, 2015-201-1a--c (jacket, top, trousers); 2015-201-3c,d,g,h (gloves); 2015-201-1d--p,q (decorative snaps)

8.
Jacket, vest, dress, shoes, and decorative snaps

Fall/Winter 1984–1985

Studio Invenzione collection

Jacket, vest, dress: cotton and acrylic knit

Shoes: snakeskin with decorative snaps

Decorative snaps: leather, plastic, rubber, laminate, metal

Gift of Bjorn Guil Amelan and Bill T. Jones in honor of Monica Brown, 2015-201-2a--c (jacket, vest, dress); 2015-201-2d,e (shoes); 2015-201-2f--w (decorative snaps)

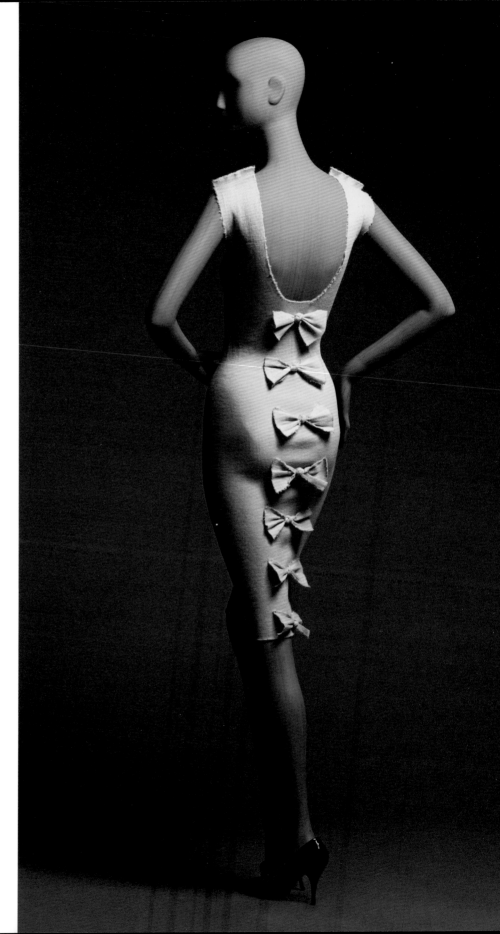

9.

Dress

Dress (1985): wool knit

Gift of Bjorn Guil Amelan and
Bill T. Jones in honor of Monica
Brown, 2015-201-119 (dress)

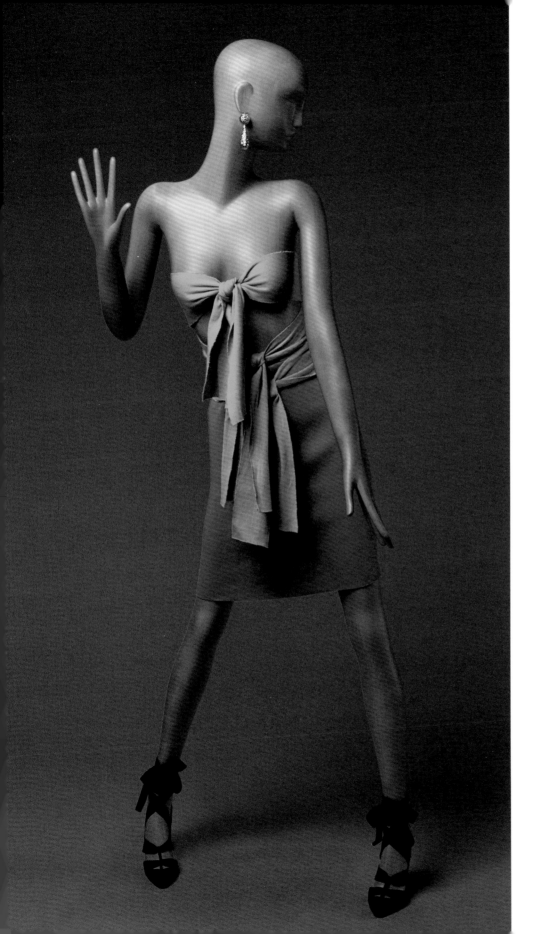

10.

Top, skirt, and earrings

Spring/Summer 1985

Top: cotton knit

Skirt: cotton and acrylic knit

Earring: metal

Gift of Bjorn Guil Amelan and Bill T. Jones in honor of Monica Brown, 2015-201-120 (top); 2015-201-121 (skirt); 2017-240-37a,d (earring composed of separate elements)

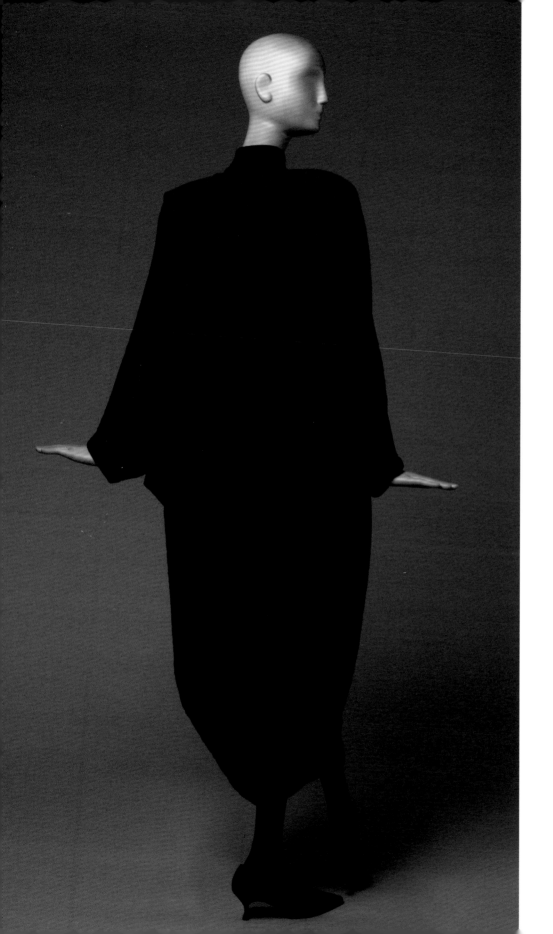

11.

Coat

1985

Cotton knit

Gift of Bjorn Guil Amelan and Bill T. Jones in honor of Monica Brown, 2015-201-4

12.

Coat, dress, hat, and gloves

Fall/Winter 1986–1987

Chez Patrick Kelly collection

Double-knit angora wool

Gift of Ellie Wolfe, 2014-68-1a,c,e,g,h

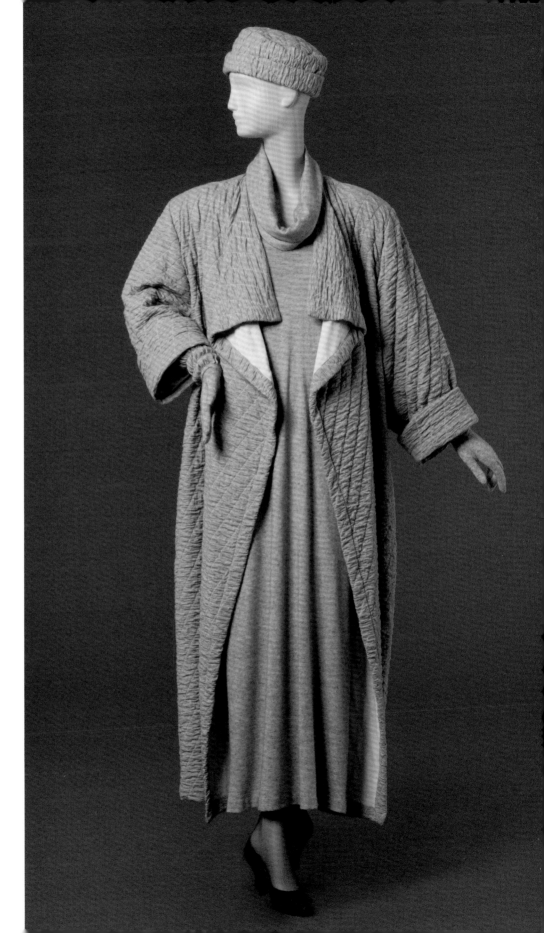

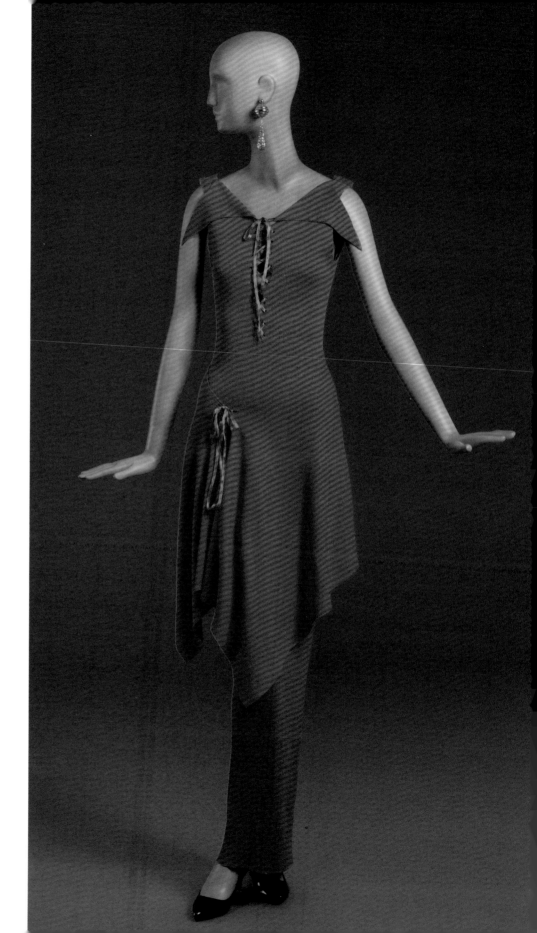

13.

Dress, wrap, and earrings

Spring/Summer 1986

Dress and wrap: cotton and acrylic knit with synthetic satin drawstrings

Earrings: metal

Gift of Bjorn Guil Amelan and Bill T. Jones in honor of Monica Brown, 2015-201-6a--c (dress and wrap); 2017-240-37c, 2017-240-38 (earrings)

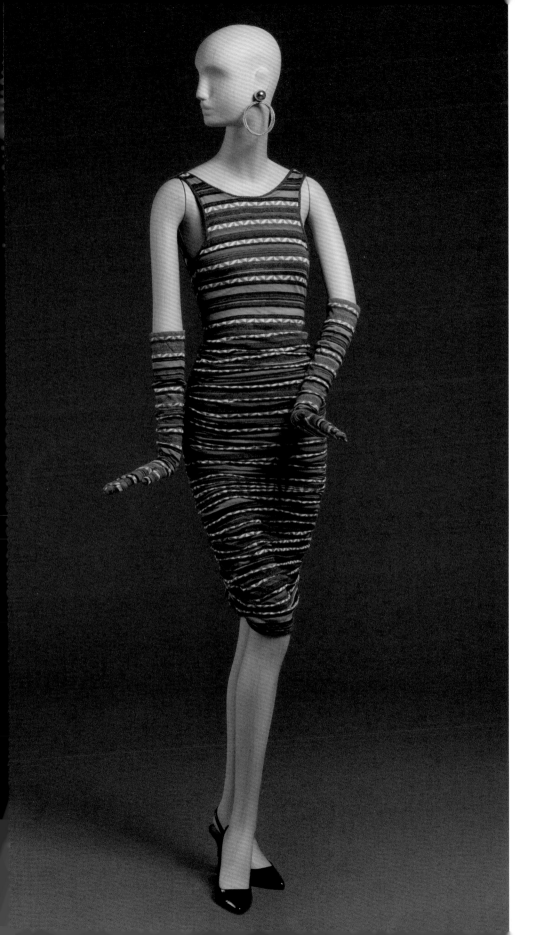

14.

Dress and gloves

Spring/Summer 1986

Cotton and nylon knit

Gift of Bjorn Guil Amelan and Bill
T. Jones in honor of Monica Brown,
2015-201-42a--c

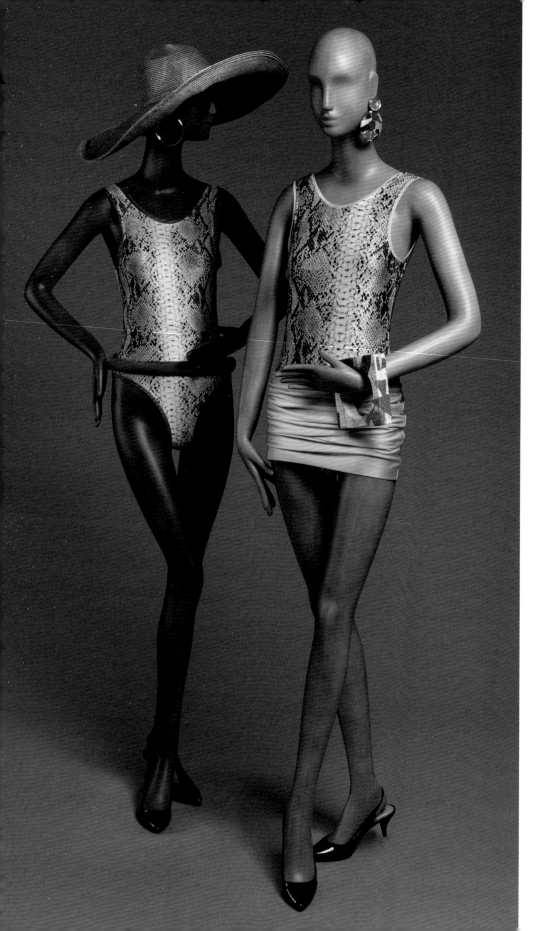

15.

Convertible swimsuit

Spring/Summer 1987

Nylon and spandex knit

Gift of Bjorn Guil Amelan and Bill
T. Jones in honor of Monica Brown,
2015-201-59

16.

**Convertible swimsuit,
earrings, and bracelet**

Spring/Summer 1987

Swimsuit: nylon and spandex knit

Earrings and bracelet by Harmony
of Harlem: painted papier-mâché

Gift of Bjorn Guil Amelan and
Bill T. Jones in honor of Monica
Brown, 2015-201-60 (swimsuit);
2015-201-230a,b (earrings);
2015-201-135 (bracelet)

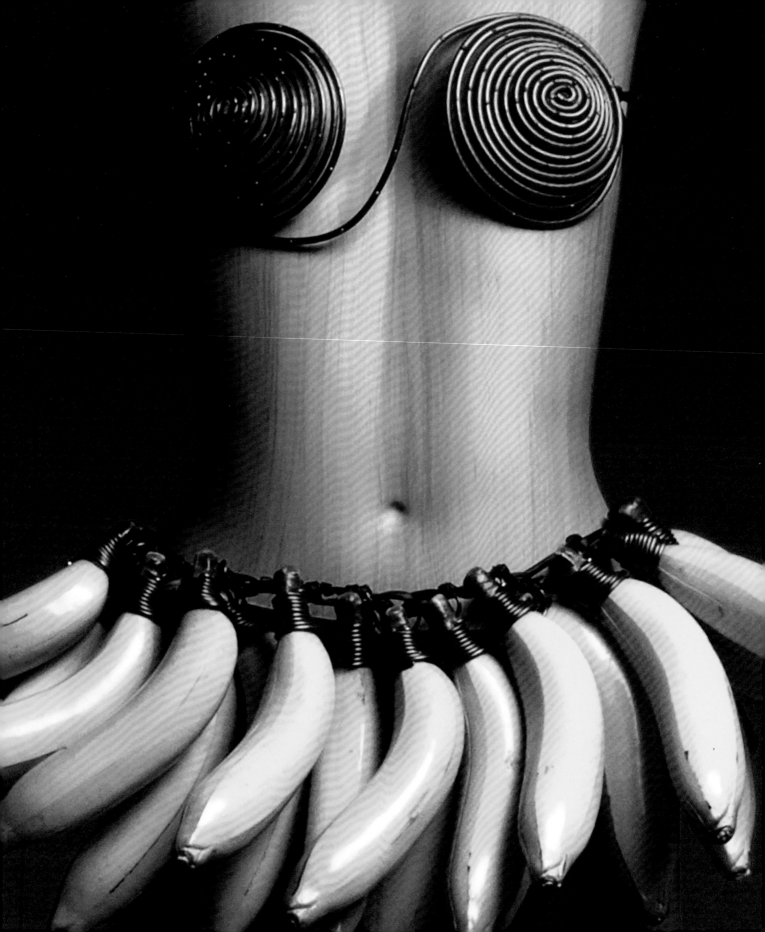

MISSISSIPPI IN PARIS

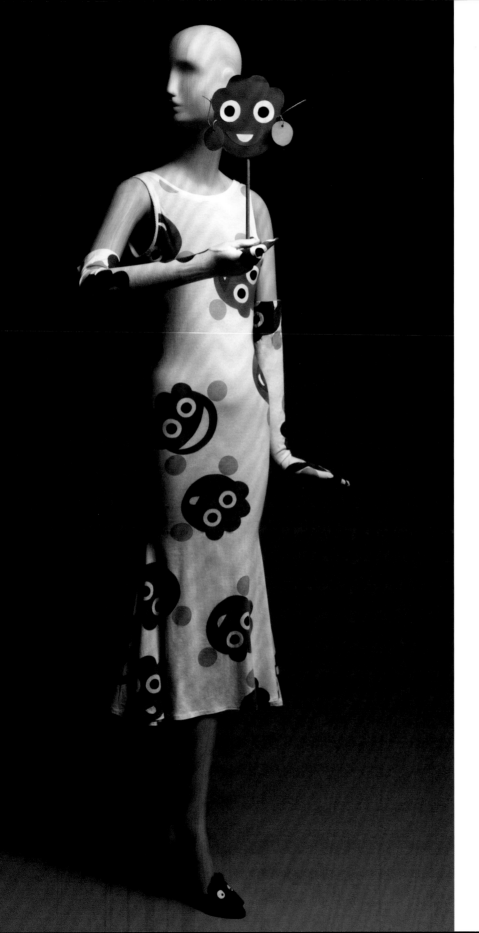

17.

Dress, gloves, mask, and shoes

Spring/Summer 1986

Dress and gloves: cotton and nylon knit; printed by Bianchini-Férier (French, est. ca. 1880)

Mask: paper with wood and hemp

Shoes by Maud Frizon (French, est. 1969): leather

Gift of Bjorn Guil Amelan and Bill T. Jones in honor of Monica Brown, 2015-201-9a--d (dress, gloves, mask); 2015-201-11a,b (shoes)

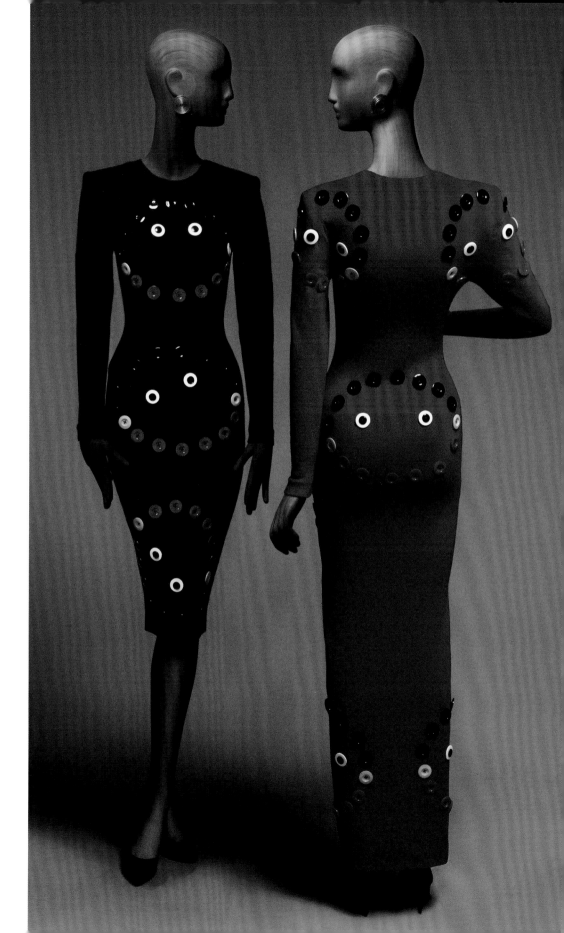

18.

Dress and earrings

Fall/Winter 1986–1987

Chez Patrick Kelly collection

Dress: wool, angora, and spandex knit with plastic buttons

Gift of Bjorn Guil Amelan and Bill T. Jones in honor of Monica Brown, 2015-201-27

Earring by David Spada (American, 1961–1996): metal

Private collection

19.

Dress and bracelet

Fall/Winter 1986–1987

Chez Patrick Kelly collection

Dress: wool, angora, and spandex knit with plastic buttons

Gift of Bjorn Guil Amelan and Bill T. Jones in honor of Monica Brown, 2015-201-26

Bracelet by David Spada (American, 1961–1996): metal

Private collection

20.

Top, skirt, bodysuit, earrings, and necklace

Spring/Summer 1986

Top and skirt: polyester with synthetic lace

Bodysuit: cotton and acrylic knit

Earrings and necklace: metal with synthetic roses and plastic dolls

Gift of Bjorn Guil Amelan and Bill T. Jones in honor of Monica Brown, 2015-201-236 (top); 2015-201-237 (skirt); 2015-201-238 (bodysuit); 2015-201-160a,b (earrings); 2015-201-224 (necklace)

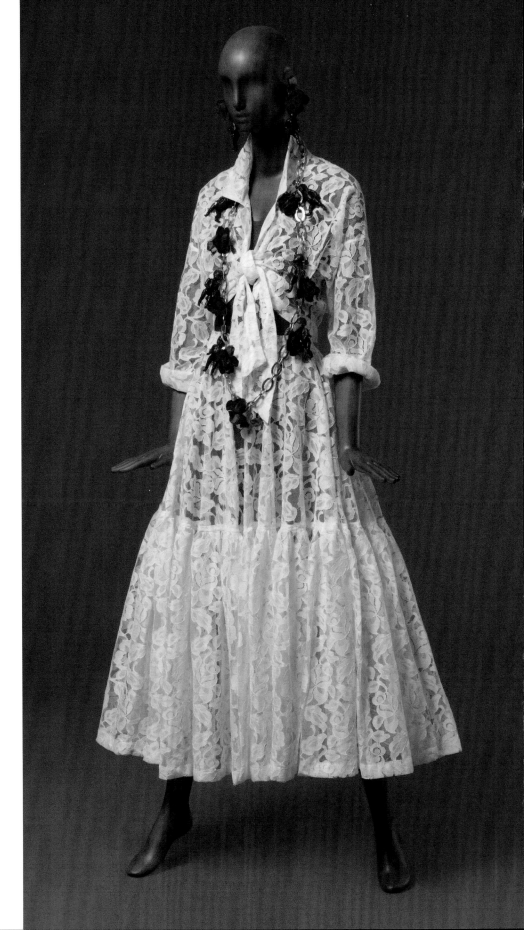

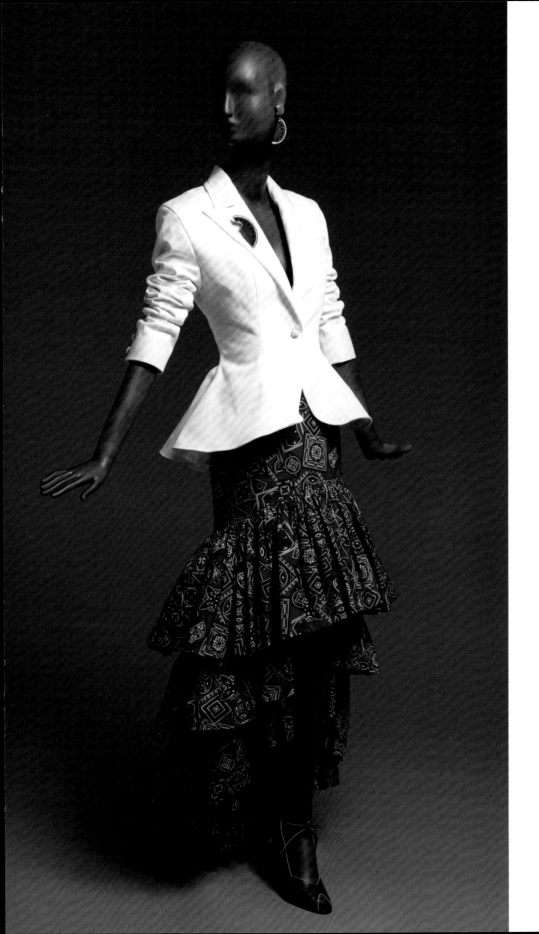

21.

**Jacket, skirt, shoes,
earrings, and pin**

Spring/Summer 1988

Jacket made from Vogue
Individualist Pattern 2077: cotton

Skirt: printed cotton

Shoes by Maud Frizon
(French, est. 1969): leather

Earrings and pin: painted resin clay

Gift of Bjorn Guil Amelan and
Bill T. Jones in honor of Monica
Brown, 2014-207-1a,d,e (skirt and
shoes); 2015-201-176 (earring);
2015-201-175 (pin)

Reproduction jacket made by
Paula M. Sim, Philadelphia
Museum of Art, 30-2014-1

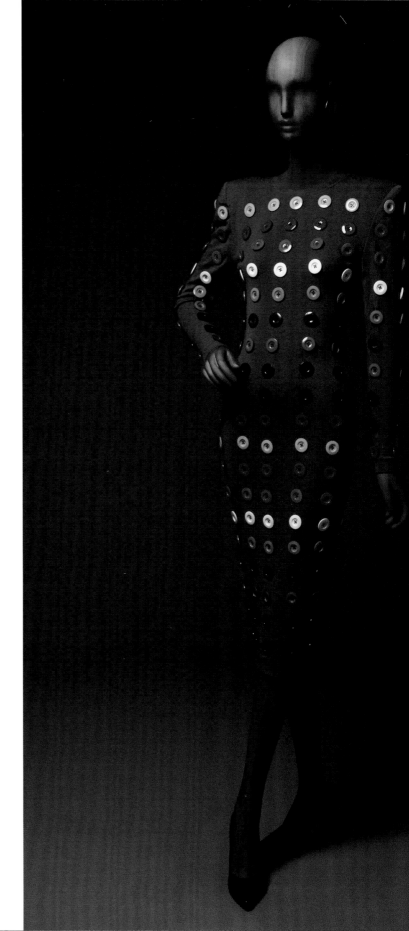

22.
Dress and earrings

Fall/Winter 1986–1987

Chez Patrick Kelly collection

Dress: wool knit with plastic buttons

Earrings by David Spada
(American, 1961–1996): anodized
aluminum

Gift of Bjorn Guil Amelan and
Bill T. Jones in honor of Monica
Brown, 2015-201-22 (dress);
2015-201-229a,b (earrings)

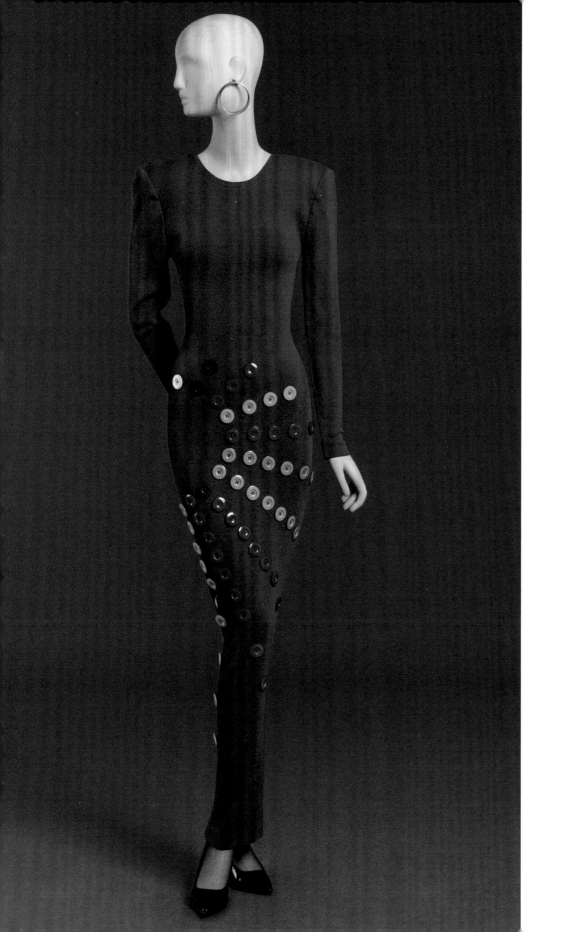

23.

Dress and earrings

Fall/Winter 1986–1987

Chez Patrick Kelly collection

Dress: wool knit with plastic buttons

Earring repurposed from David Spada (American, 1961–1996) pendant: anodized aluminum

Gift of Bjorn Guil Amelan and Bill T. Jones in honor of Monica Brown, 2015-201-23 (dress); 2015-201-228 (earring)

24.

Dress

Fall/Winter 1986–1987

Chez Patrick Kelly collection

Wool knit with plastic buttons

Gift of Bjorn Guil Amelan and Bill
T. Jones in honor of Monica Brown,
2015-201-24

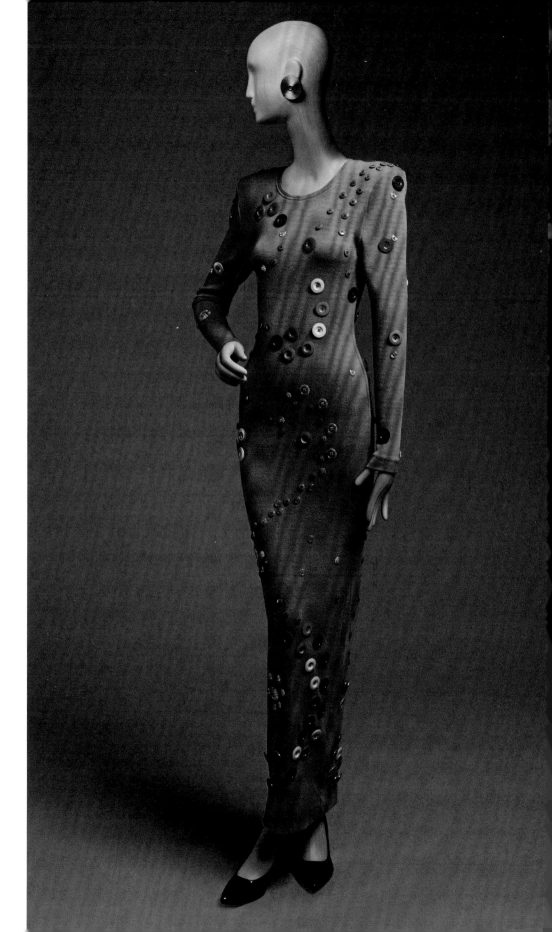

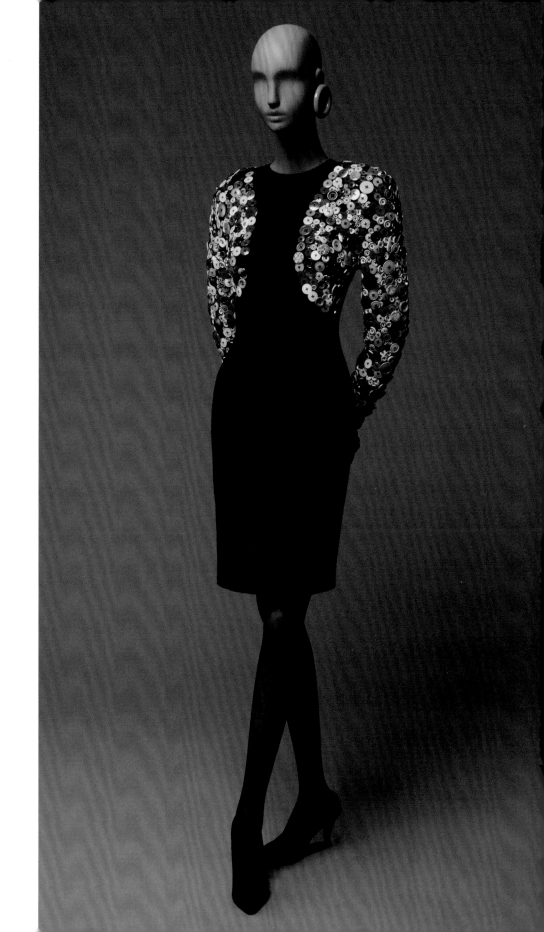

25.

Dress and earrings

Fall/Winter 1987–1988

Dress: wool and spandex knit with plastic buttons

Earring: plastic; repurposed from Patrick Kelly button brooch

Gift of Bjorn Guil Amelan and Bill T. Jones in honor of Monica Brown, 2015-201-63 (dress); gift of Marvin Levitties, 2004-131-1 (earring)

26.

Dress, bodysuit, overskirt, and gloves

Fall/Winter 1987–1988

Custom design for 6th Festival de la Mode, Galeries Lafayette, Paris

Nylon

Gift of Bjorn Guil Amelan and Bill T. Jones in honor of Monica Brown, 2015-201-232a--e

27.

Coat and scarf

Fall/Winter 1986–1987

Chez Patrick Kelly collection

Coat: rayon; printed by Bianchini-Férier (French, est. ca. 1880)

Scarf: silk; printed by Bianchini-Férier (French, est. ca. 1880)

Gift of Bjorn Guil Amelan and Bill T. Jones in honor of Monica Brown, 2015-201-36a (coat); 2015-201-37c (scarf)

28.

Dance costume

Fall/Winter 1986–1987

Chez Patrick Kelly collection

In collaboration with David Spada
(American, 1961–1996)

Skirt: plastic with rubber straps

Bra: anodized aluminum with
rubber straps

Bottom: synthetic fabric

Gift of Bjorn Guil Amelan and Bill
T. Jones in honor of Monica Brown,
2015-201-38a,b (skirt and bra);
2015-201-87b (bottom)

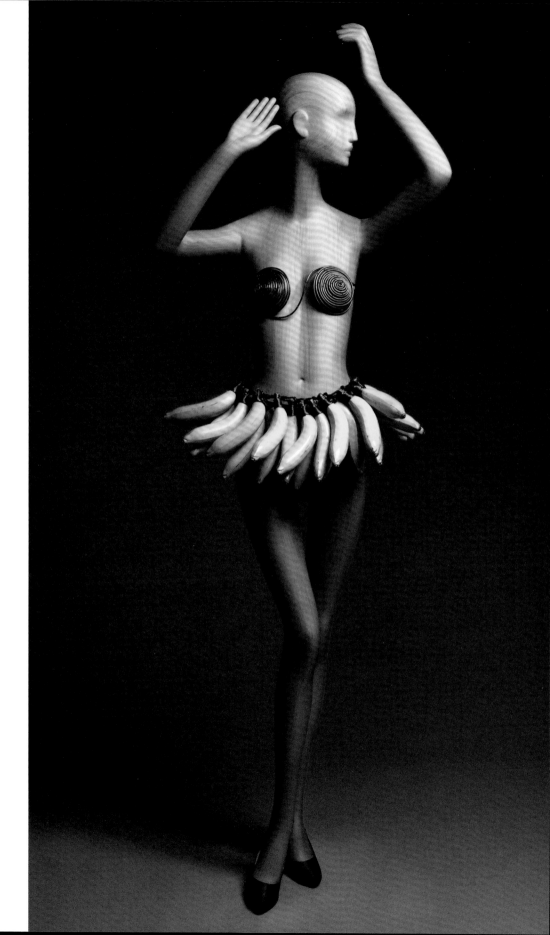

29.

Dress, boots, handbag, and earrings

Fall/Winter 1988–1989

More Love collection

Dress: wool and spandex knit

Boots and handbag by Maud Frizon (French, est. 1969): leather

Earring: plastic; repurposed from Patrick Kelly button

Gift of Bjorn Guil Amelan and Bill T. Jones in honor of Monica Brown, 2015-201-83 (dress); 2015-201-81a--c (boots and handbag); gift of Ellie Wolfe, 2014-68-5a (earring)

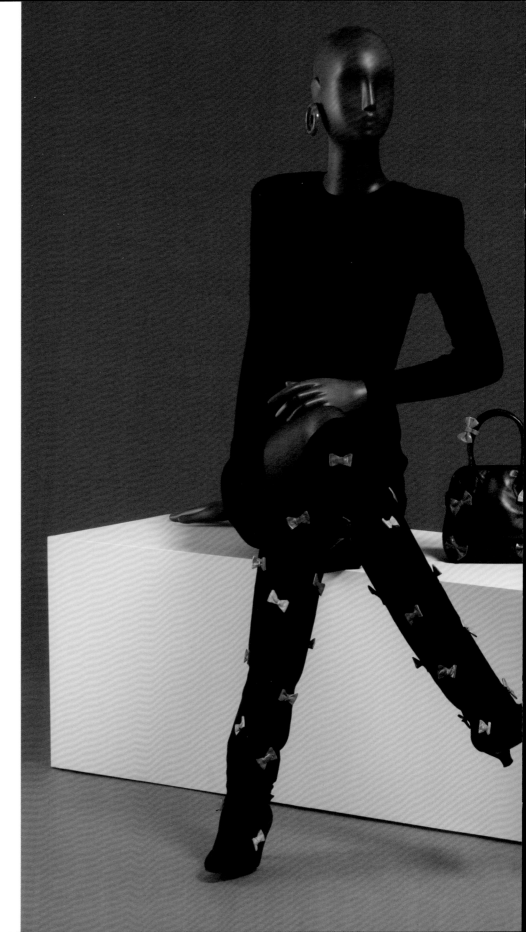

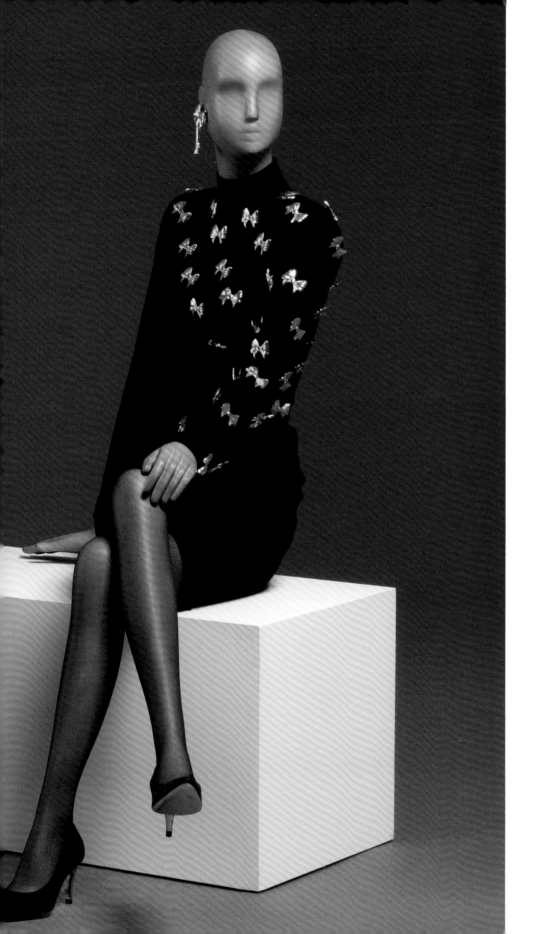

30.

Dress and earrings

Fall/Winter 1988–1989

More Love collection

Dress: wool and spandex knit with metal bows

Earring: metal; repurposed from Patrick Kelly brooch

Gift of Bjorn Guil Amelan and Bill T. Jones in honor of Monica Brown, 2015-201-79 (dress); 2015-201-180 (earring)

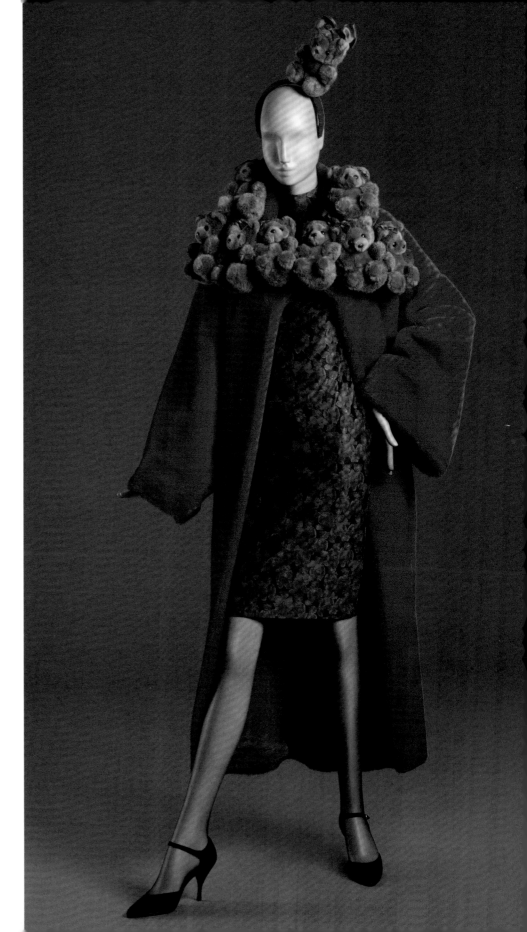

31.

Coat, dress, and headband

Fall/Winter 1988–1989

More Love collection

Coat: synthetic fur

Dress: nylon and Lycra knit

Headband: synthetic fur, satin, and velvet

Gift of Bjorn Guil Amelan and Bill T. Jones in honor of Monica Brown, 2014-207-13a--c

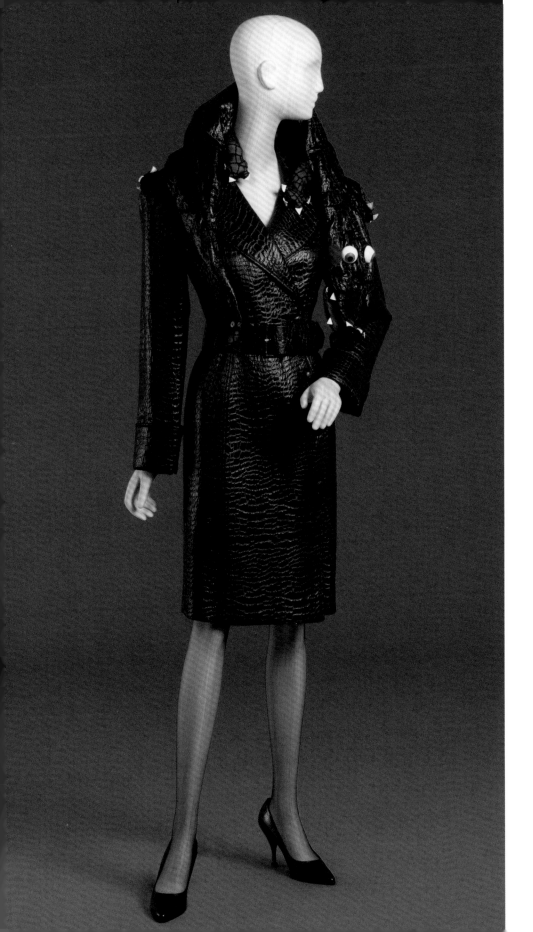

32.

**Convertible coat/dress
and bag/scarf**

Fall/Winter 1987–1988

Acetate and viscose

Gift of Bjorn Guil Amelan and Bill
T. Jones in honor of Monica Brown,
2015-201-65a--c

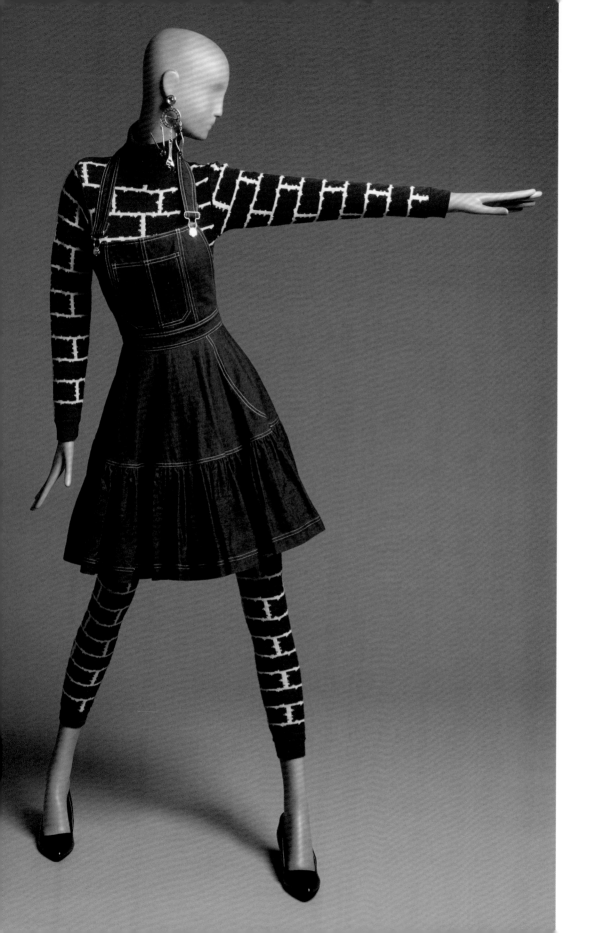

33.

Apron dress, jumpsuit, and earrings

Fall/Winter 1987–1988

Apron dress: cotton

Jumpsuit: wool and acrylic knit

Earring: metal

Gift of Bjorn Guil Amelan and Bill T. Jones in honor of Monica Brown, 2015-201-67b (apron dress); 2015-201-66b (jumpsuit); 2015-201-193a (earring)

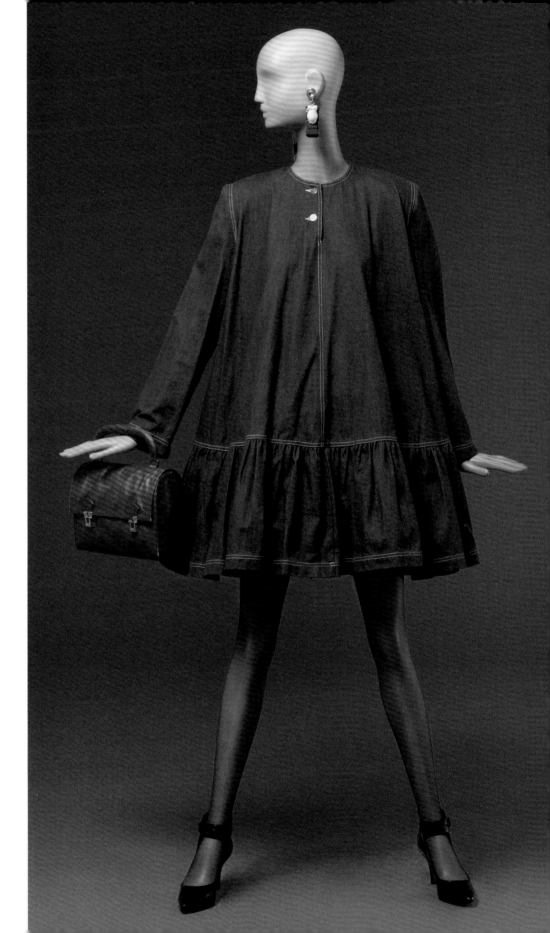

34.

Dress, bag, and earrings

Fall/Winter 1987–1988 and
Spring/Summer 1987

Dress: cotton

Bag: synthetic fabric

Earrings: metal and plastic

Gift of Bjorn Guil Amelan and Bill
T. Jones in honor of Monica Brown,
2015-201-69a,b (dress and bag);
2015-201-181a (cement truck
earring); 2015-201-192 (tools
earring, Spring/Summer 1987)

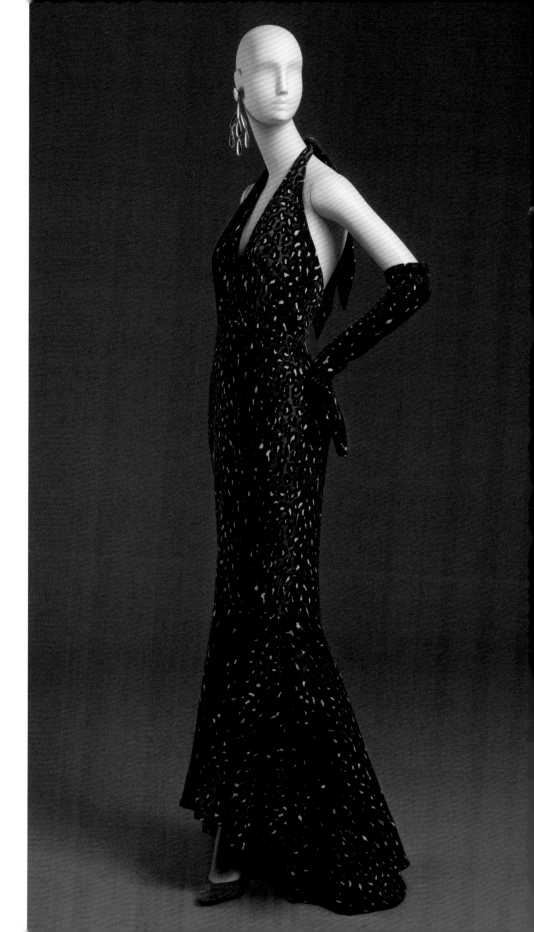

35.

Dress and gloves

Mock-Couture collection

Fall/Winter 1987–1988

Wool and nylon knit

Gift of Bjorn Guil Amelan and Bill T. Jones in honor of Monica Brown, 2015-201-48a--c

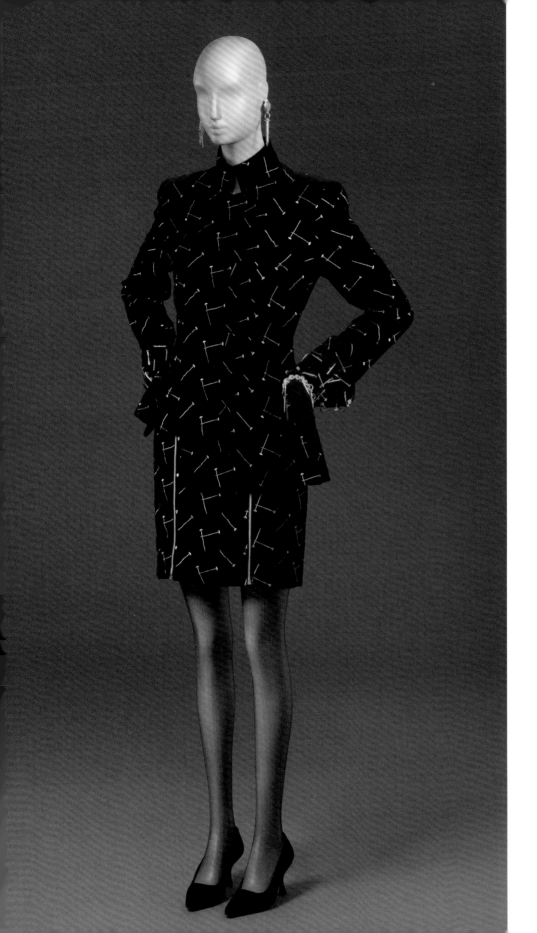

36.

Jacket, skirt, gloves, bracelet, and earrings

Fall/Winter 1988–1989

More Love collection

Jacket, skirt, gloves: cotton velveteen with metal

Bracelet and earrings by Edouard Rambaud Paris (founded 1984, active 1980s–1990s): metal

Gift of Bjorn Guil Amelan and Bill T. Jones in honor of Monica Brown, 2014-207-12a,b,d,e (jacket, skirt, gloves); 2015-201-217 (bracelet); 2015-201-219a (earring); 2015-201-221a (earring)

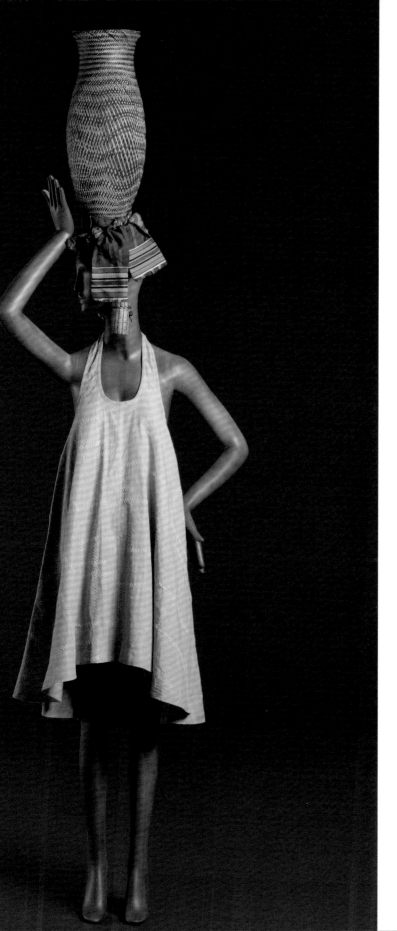

37.

Dress, hat, and earrings

Spring/Summer 1988

Dress: linen with cotton embroidery

Hat: woven straw with printed cotton

Earring: metal

Gift of Bjorn Guil Amelan and Bill T. Jones in honor of Monica Brown, 2014-207-2a,b (dress, hat); 2015-201-227a (earring)

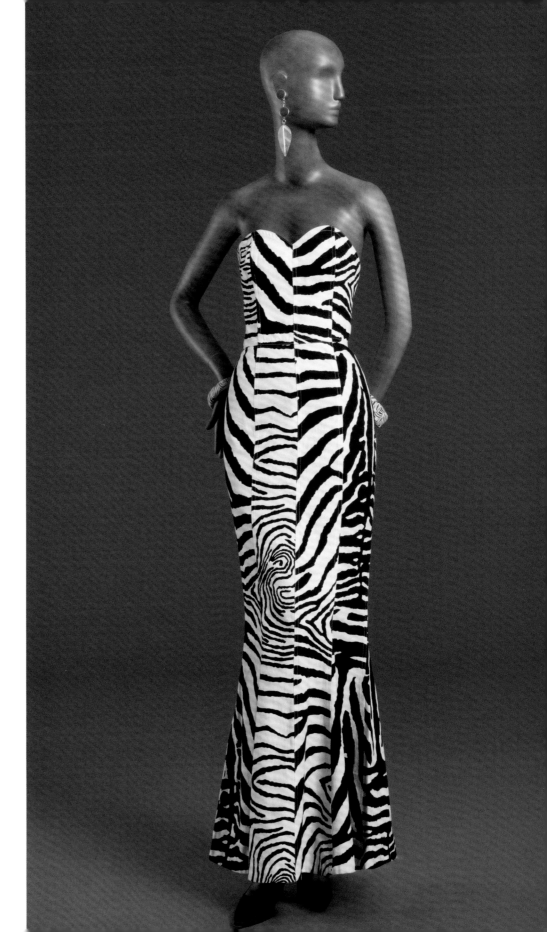

38.

Dress and bracelets

Spring/Summer 1988

Dress: printed cotton

Bracelets: suede leather

Gift of Bjorn Guil Amelan and
Bill T. Jones in honor of Monica
Brown, 2014-207-3b (dress);
2015-201-165a--c (bracelets)

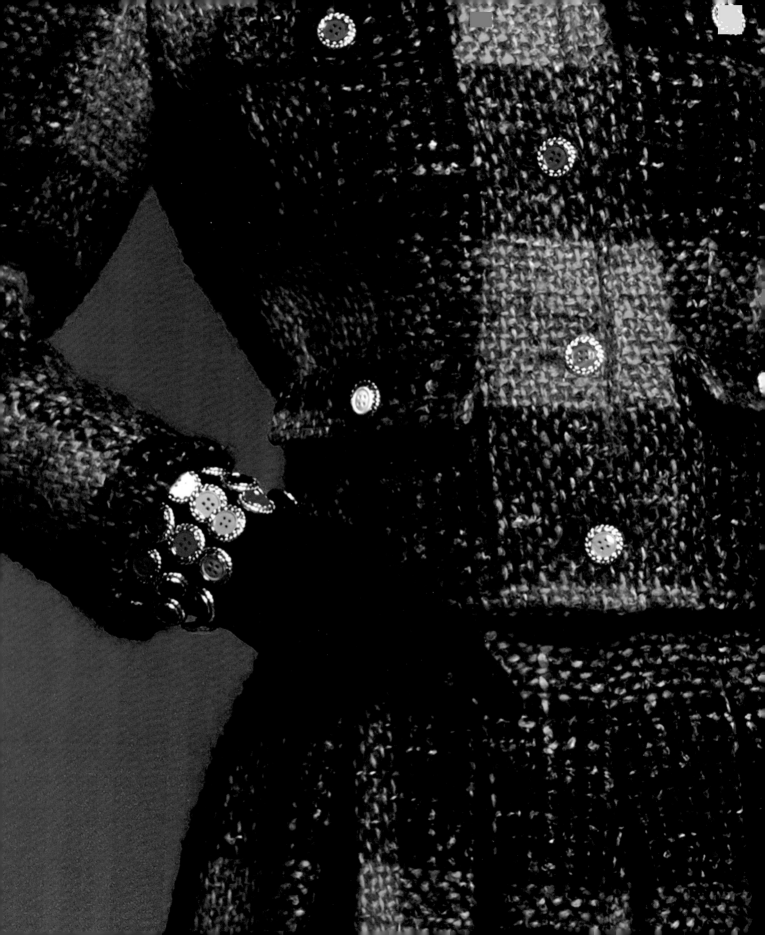

HOT COUTURE

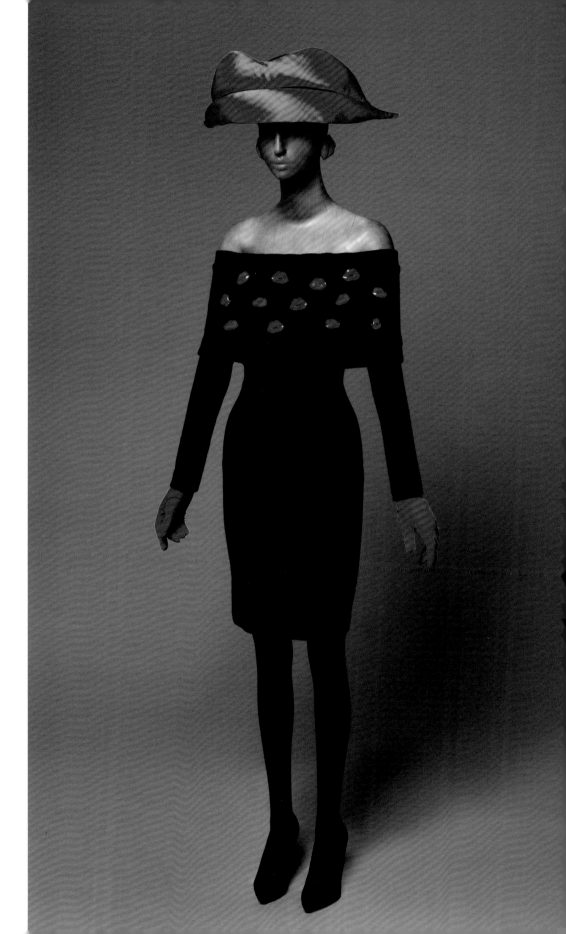

39.

Dress, hat, earrings, and brooches

Fall/Winter 1989–1990

Dress: wool, acrylic, and spandex knit

Hat by Maison Michel (French, est. 1936): wool felt with synthetic satin

Earrings: plastic

Brooches: plastic

Gift of Bjorn Guil Amelan and Bill T. Jones in honor of Monica Brown, 2015-201-123a (dress); 2015-201-138a--d (brooches); 2015-201-106c (hat); 2015-201-139a,b (earrings); Fine Arts Museums of San Francisco, Gift of Elizabeth Goodrum in honor of Patrick Kelly, 2021.7.11a-f (brooches)

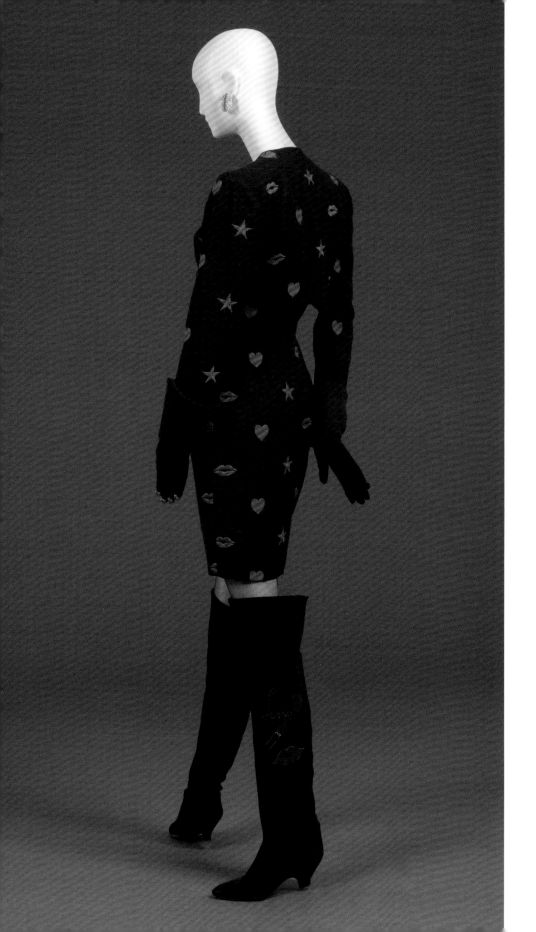

40.

Dress, jacket, boots, gloves, and earrings

Fall/Winter 1988–1989

More Love collection

Dress and jacket: wool with polyester embroidery

Boots by Maud Frizon (French, est. 1969): leather suede with synthetic embroidery

Gloves: wool knit with plastic buttons

Earring: metal with rhinestones

Gift of Bjorn Guil Amelan and Bill T. Jones in honor of Monica Brown, 2014-207-15a,b (dress and jacket); 2014-207-5a,b (boots); Purchased with the Costume and Textiles Revolving Fund, 2012-122-1a,b (gloves); 2015-201-167 (brooch used as earring)

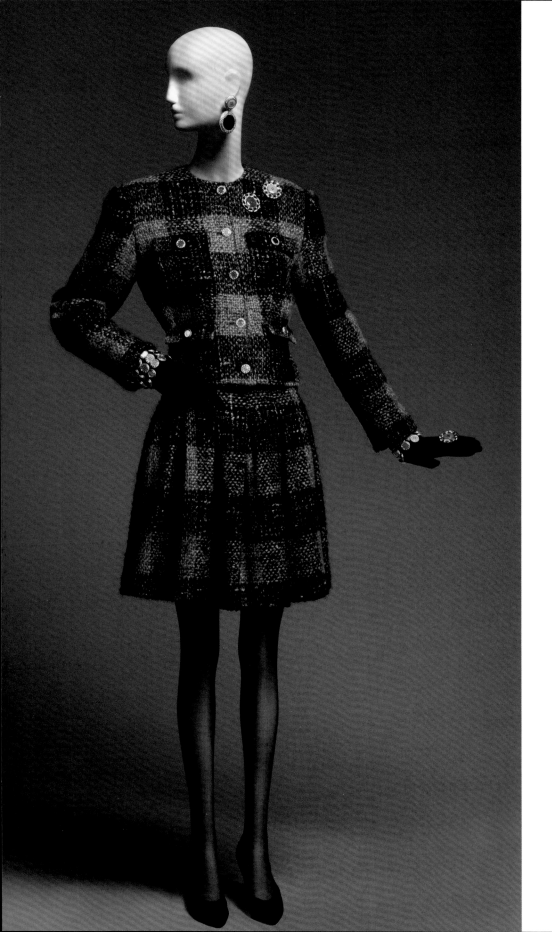

41.

Jacket, skirt, gloves, pins, and earrings

Fall/Winter 1988–1989

More Love collection

Jacket and skirt: wool and acrylic with plastic and metal buttons and rayon ribbon

Gloves: wool knit with metal and plastic buttons

Pins and earrings: metal and plastic

Gift of Bjorn Guil Amelan and Bill T. Jones in honor of Monica Brown, 2014-207-9a,b (jacket and skirt); 2014-207-9d,e (gloves); 2014-207-9f,g (pins); 2015-201-142 (pin); 2015-201-146a,b (earrings)

42.

Jacket, skirt, top, gloves, and earrings

Fall/Winter 1988–1989

More Love collection

Jacket and skirt: wool and acrylic with metal and plastic buttons

Top: wool and spandex knit

Gloves: wool knit with metal and plastic buttons

Earrings: metal and plastic buttons

Gift of Bjorn Guil Amelan and Bill T. Jones in honor of Monica Brown, 2014-207-8a,b,c,e,f (jacket, skirt, top, gloves); 2015-201-147a,b (earrings)

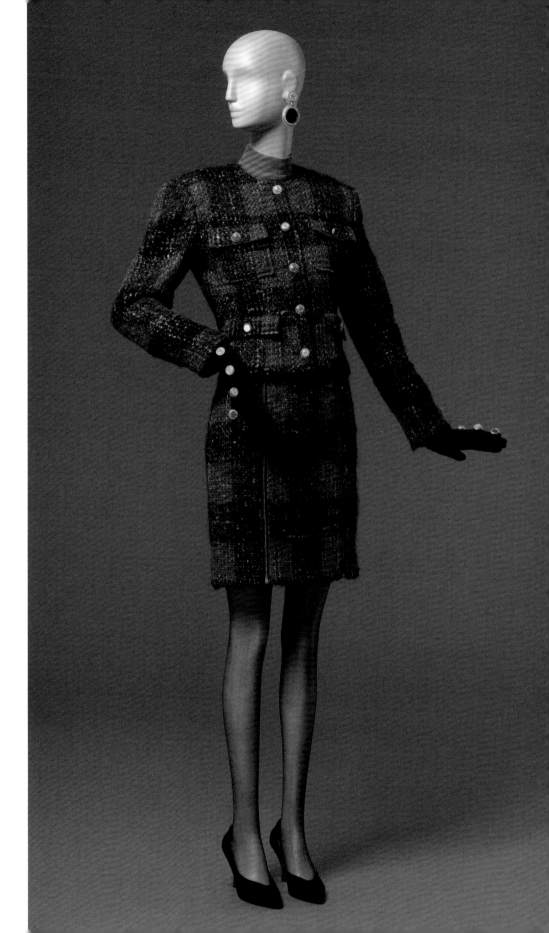

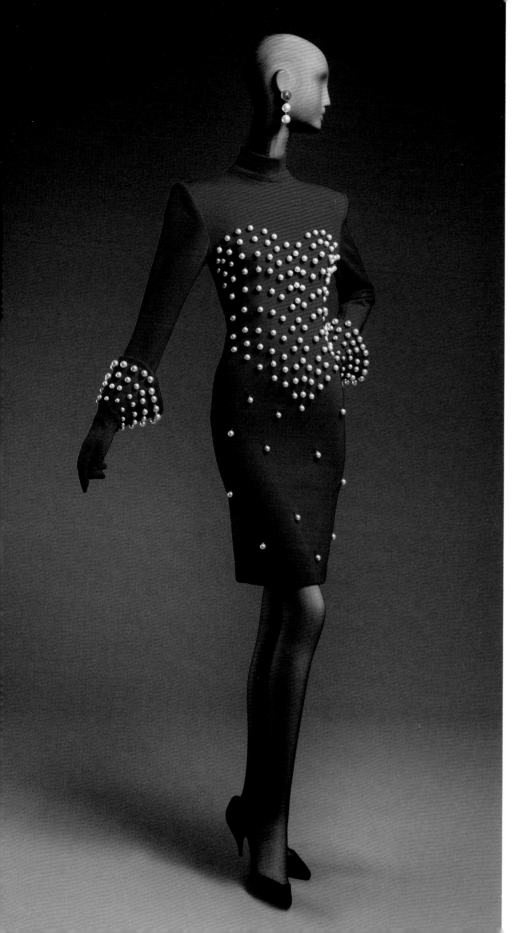

43.

**Dress, gloves,
and earrings**

Fall/Winter 1988–1989

More Love collection

Dress and gloves: wool and
spandex knit with plastic pearls

Earrings: metal and plastic pearls

Gift of Bjorn Guil Amelan and
Bill T. Jones in honor of Monica
Brown, 2014-207-10a--c (dress and
gloves); 2015-201-226a,c (earrings)

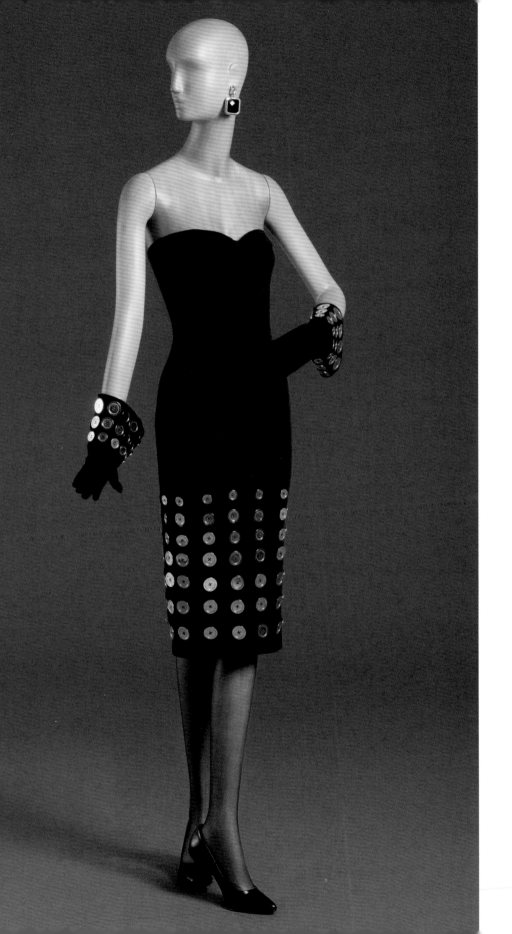

44.

Dress and gloves

Fall/Winter 1987–1988

Wool and spandex knit with metal buttons

Gift of Bjorn Guil Amelan and Bill T. Jones in honor of Monica Brown, 2015-201-64a--c

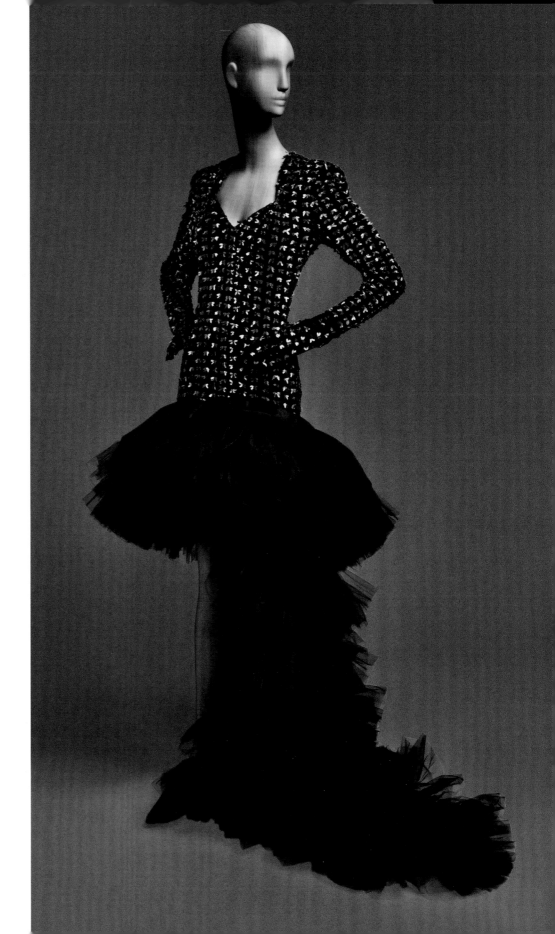

45.

Dress and gloves

Fall/Winter 1988–1989

More Love collection

Dress: nylon knit with machine embroidery and acetate ribbons, nylon taffeta, and tulle

Gloves: nylon knit with machine embroidery and acetate ribbons

Gift of Bjorn Guil Amelan and Bill T. Jones in honor of Monica Brown, 2014-207-4a,d,e

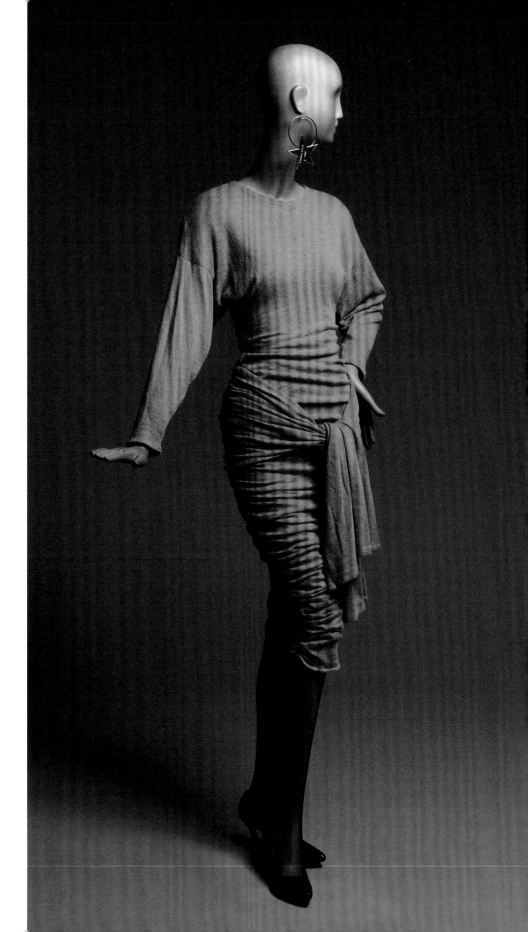

46.

Dress, wrap, and earrings

Fall/Winter 1986–1987

Chez Patrick Kelly collection

Dress and wrap: wool, nylon, and angora knit

Earring: metal

Gift of Bjorn Guil Amelan and Bill T. Jones in honor of Monica Brown, 2015-201-14a,b (dress and wrap); 2015-201-171 (pin made into earring)

47.

Dress

Mock-Couture collection

Spring/Summer 1988

Polyester, acetate, and spandex with printed nylon knit

Gift of Bjorn Guil Amelan and Bill T. Jones in honor of Monica Brown, 2015-201-116

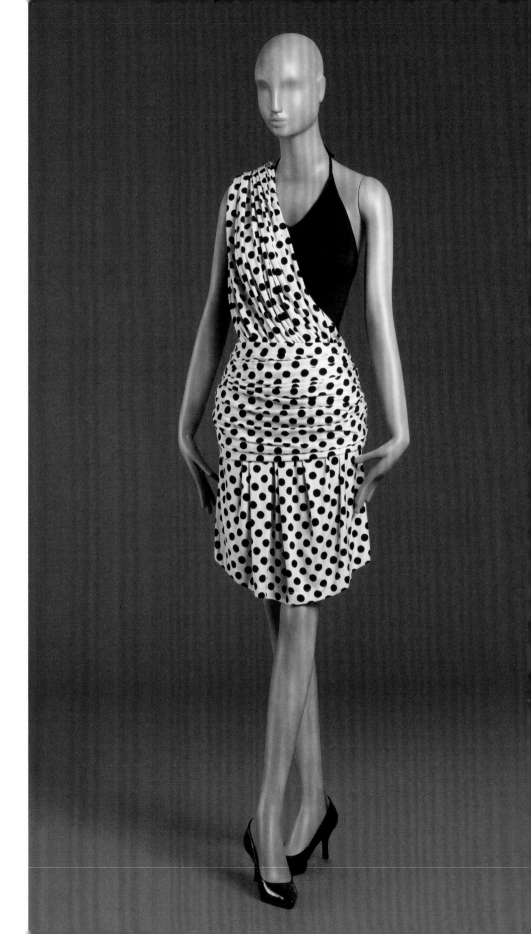

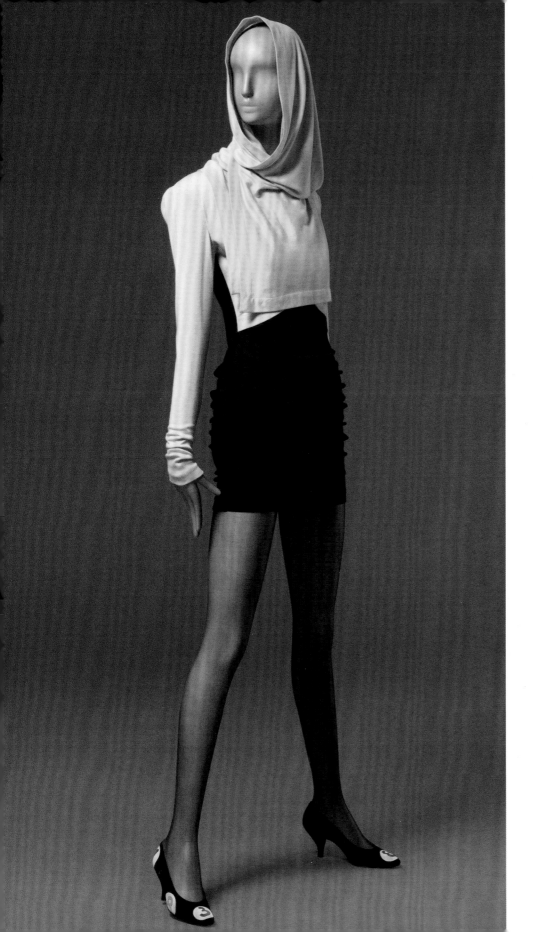

48.

Dress and shoes

Fall/Winter 1988–1989

More Love collection

Dress: wool, acrylic, and Lycra knit

Shoes by Maud Frizon (French, est. 1969): leather with suede appliqué

Gift of Bjorn Guil Amelan and Bill T. Jones in honor of Monica Brown, 2014-207-7 (dress); 2014-207-6a,b (shoes)

LISA LOVES THE LOUVRE

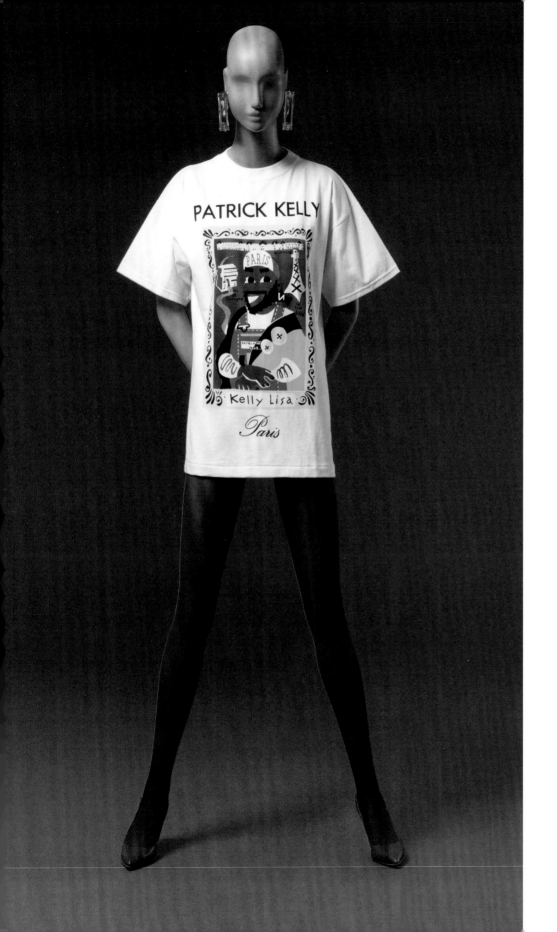

49.

T-shirt and earrings

Spring/Summer 1989

Kelly Lisa group

T-shirt designed by Christopher Hill (American, 1959–1990): printed cotton

Earrings: metal with printed paper

Gift of Bjorn Guil Amelan and Bill T. Jones in honor of Monica Brown, 2014-207-30 (T-shirt); 2015-201-184, 2015-201-185 (brooches repurposed into earrings)

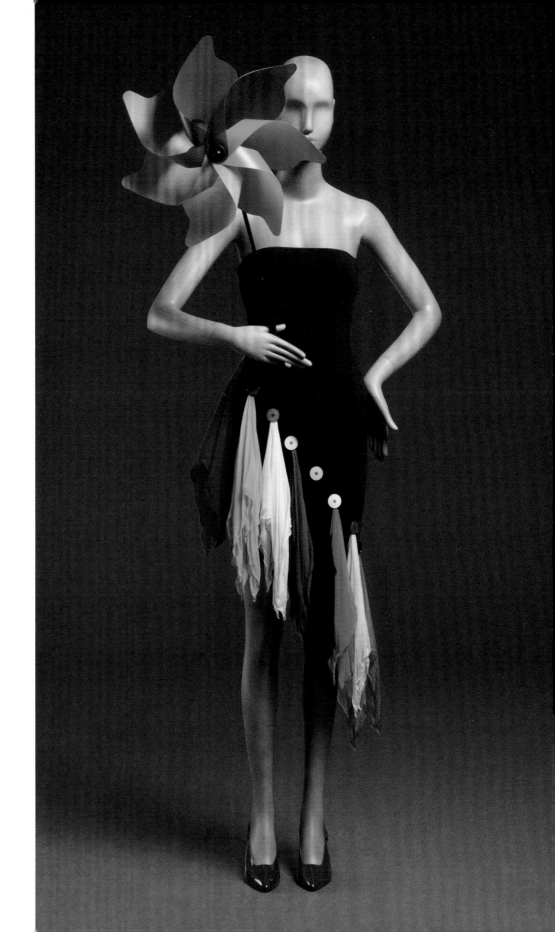

50.

Dress

Spring/Summer 1989

Pinwheel Lisa group

Cotton and spandex knit with silk
and plastic buttons

Gift of Bjorn Guil Amelan and Bill
T. Jones in honor of Monica Brown,
2014-207-18

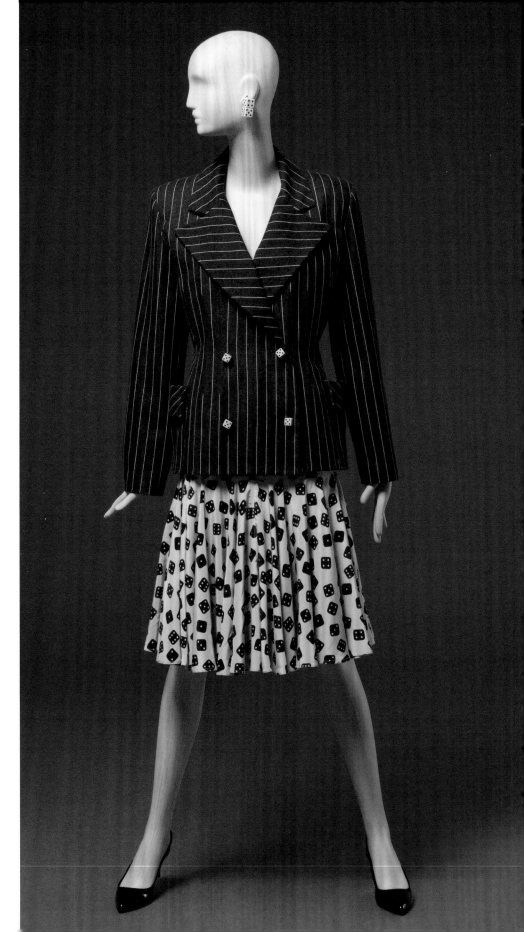

51.

Jacket, skirt, and earrings

Spring/Summer 1989

Mona's Bet group

Jacket: cotton with plastic dice buttons

Skirt: printed silk

Earrings: plastic

Gift of Bjorn Guil Amelan and Bill T. Jones in honor of Monica Brown, 2014-207-22a,b (jacket and skirt); Fine Arts Museums of San Francisco, gift of Elizabeth Goodrum in honor of Patrick Kelly, 2021.7.8a-b (earrings)

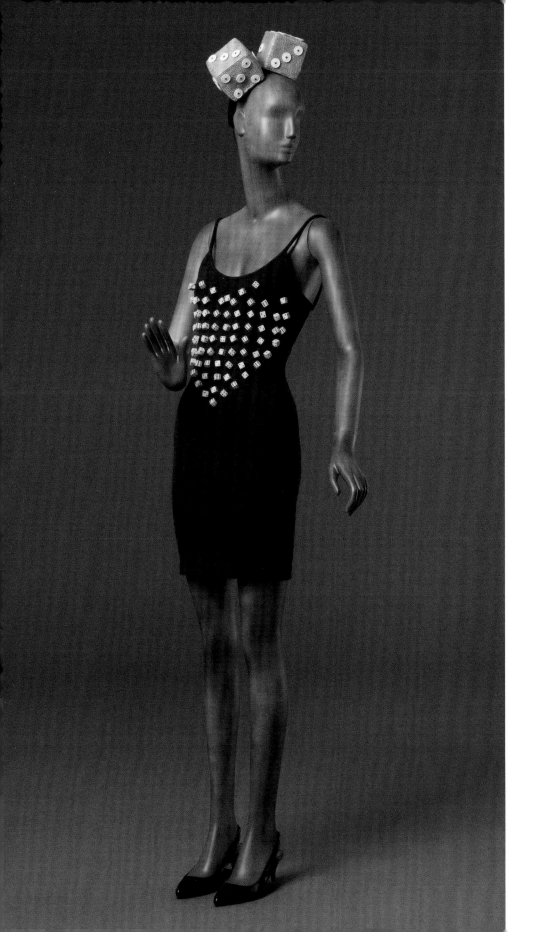

52.

Dress and headpiece

Spring/Summer 1989

Mona's Bet group

Dress: cotton, nylon, and spandex knit with plastic dice buttons

Headpiece: synthetic straw with plastic buttons

Gift of Bjorn Guil Amelan and Bill T. Jones in honor of Monica Brown, 2014-207-23a,b

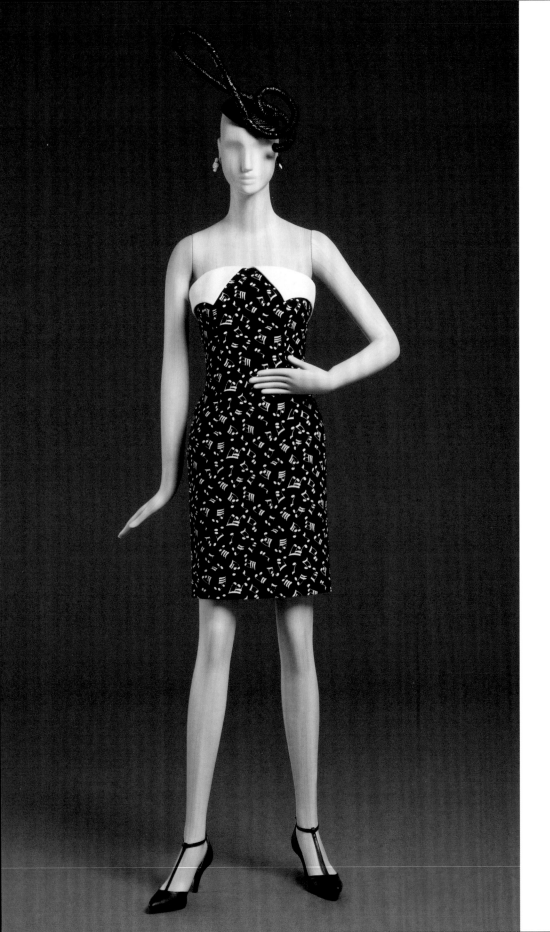

53.

Dress, hat, and earrings

Spring/Summer 1989

Lisa-Josephine group

Dress: cotton

Hat by Maison Michel (French, est. 1936): synthetic straw and plastic

Earrings: plastic; repurposed from Patrick Kelly buttons

Gift of Bjorn Guil Amelan and Bill T. Jones in honor of Monica Brown, 2014-207-25a (dress and hat); gift of Kristina Haugland, 2008-36-1a,c (earrings)

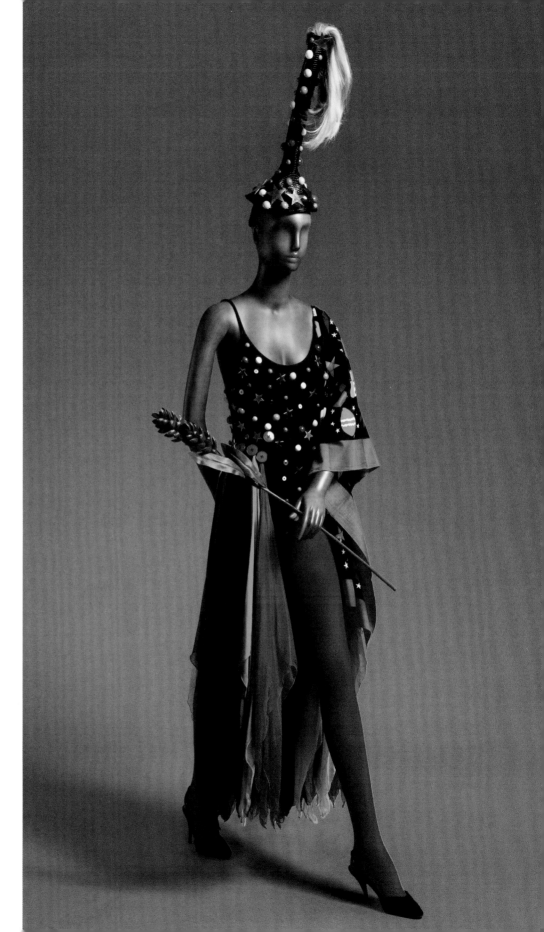

54.

**"The Mona Lisa–La Joconde"
costume**

Spring/Summer 1989

Mona Lisa–La Joconde group

Bodysuit: cotton knit with silk scarves,
plastic buttons, and metal stars

Headpiece by Maison Michel (French,
est. 1936): straw with plastic buttons,
metal stars, and synthetic hair

Scarf: printed cotton

Gift of Bjorn Guil Amelan and Bill
T. Jones in honor of Monica Brown,
2014-207-29a,b,d

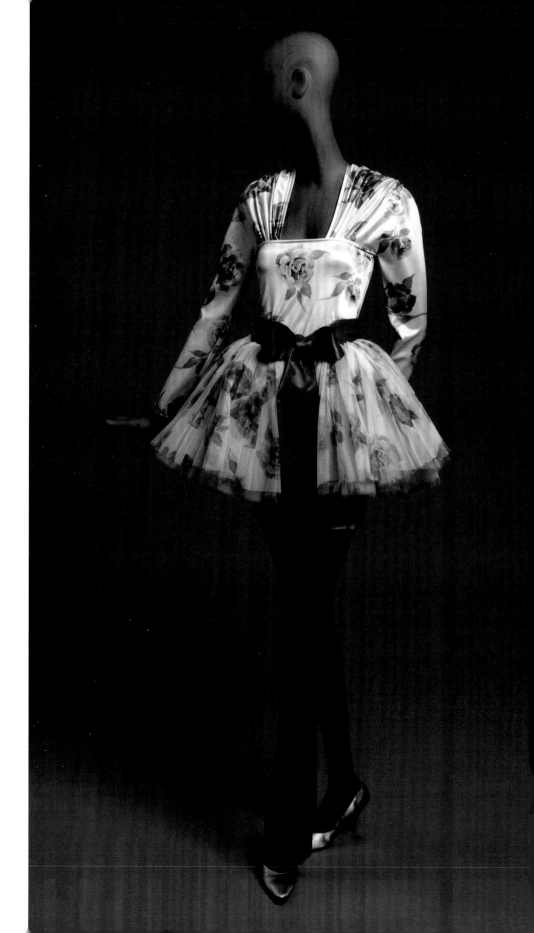

55.

Dress and overskirt

Spring/Summer 1989

Le parfum de la Joconde group

Dress: printed polyester and spandex knit

Overskirt: printed polyester tulle and satin ribbon

Gift of Bjorn Guil Amelan and Bill T. Jones in honor of Monica Brown, 2014-207-24a,b

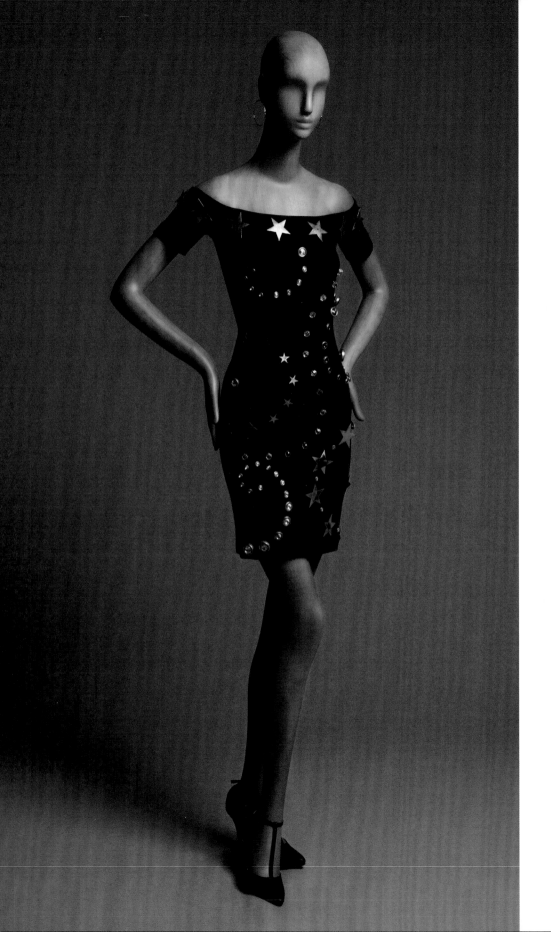

56.

Dress

Spring/Summer 1989

Moona Lisa group

Cotton, polyester, and spandex knit with metal, plastic, and synthetic decoration

Gift of Bjorn Guil Amelan and Bill T. Jones in honor of Monica Brown, 2014-207-28

57.

Dress

Spring/Summer 1989

Moona Lisa group

Nylon and spandex knit with plastic sequins

Gift of Bjorn Guil Amelan and Bill T. Jones in honor of Monica Brown, 2014-207-27

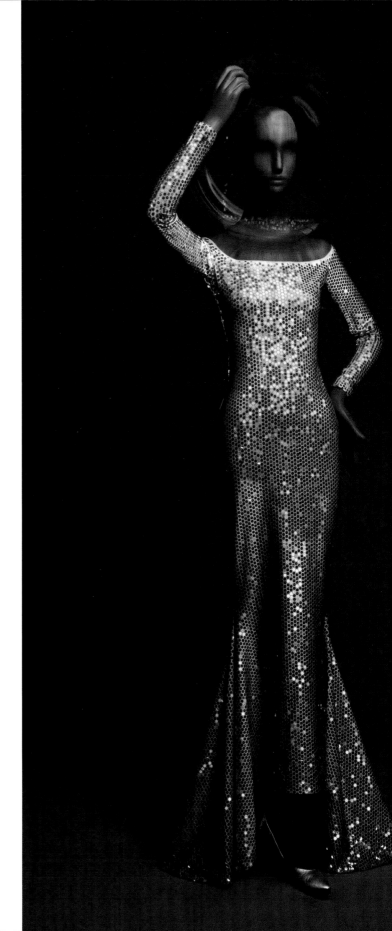

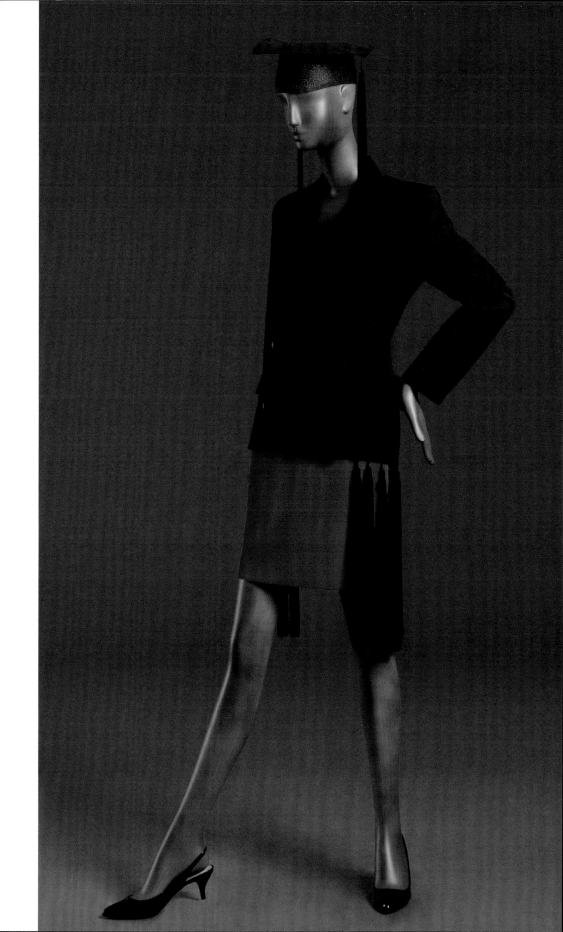

58.

Jacket, skirt, and hat

Spring/Summer 1989

Miss M. Lisa Graduates group

Jacket and skirt: cotton and rayon

Hat by Maison Michel (French, est. 1936): synthetic straw and rayon

Gift of Bjorn Guil Amelan and Bill T. Jones in honor of Monica Brown, 2014-207-26b,c,d

59.

Dress, necklace, bracelet, and earrings

Spring/Summer 1989

Jungle Lisa Loves Tarzan group

Dress: cotton

Necklace, bracelet, and earrings by Mickaël Kra (French, b. 1960): metal

Gift of Bjorn Guil Amelan and Bill T. Jones in honor of Monica Brown, 2014-207-20c (dress); 2015-201-205a--g (necklace; consists of several unconnected parts); 2015-201-194 (bracelet); 2015-201-201a,b (earrings)

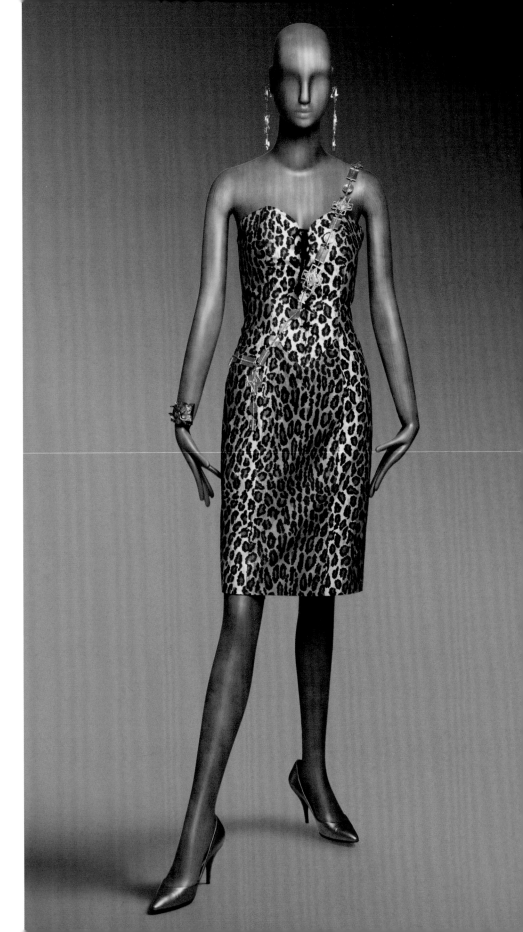

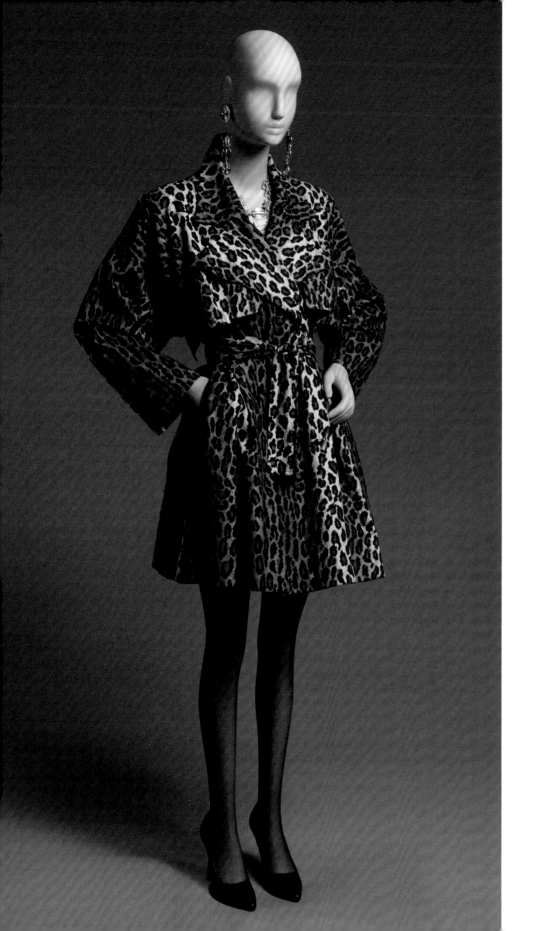

60.

Coat and earrings

Spring/Summer 1989

Jungle Lisa Loves Tarzan group

Coat: printed cotton

Earrings by Mickaël Kra (French, b. 1960): metal

Gift of Bjorn Guil Amelan and Bill T. Jones in honor of Monica Brown, 2014-207-20a,b (coat); 2015-201-195a,b (earrings)

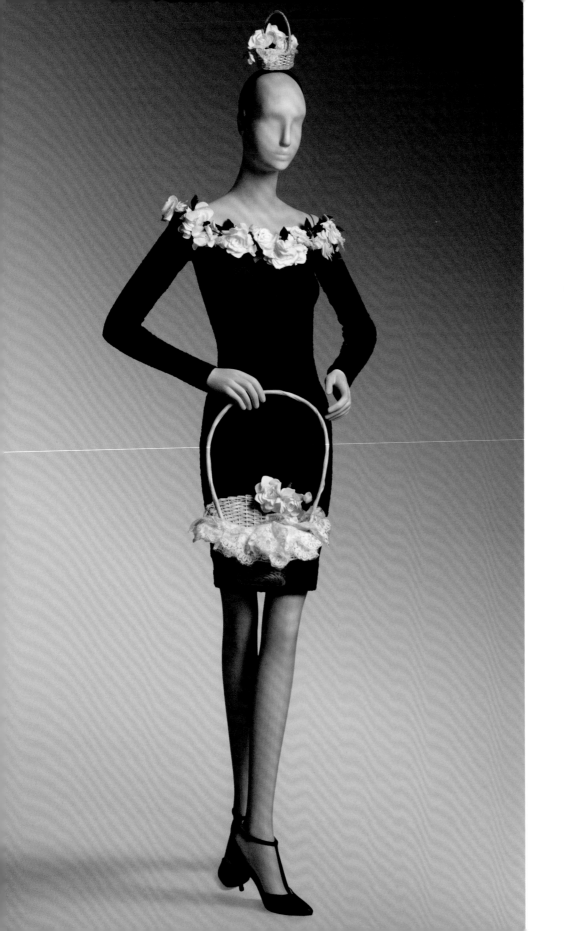

61.

Dress, headpiece, and basket

Spring/Summer 1989

Billie Lisa group

Dress: polyester and spandex knit with cotton flowers

Headpiece: cotton velveteen with straw and cotton flowers

Basket: straw with polyester lace and cotton flowers

Gift of Bjorn Guil Amelan and Bill T. Jones in honor of Monica Brown, 2014-207-19a--c

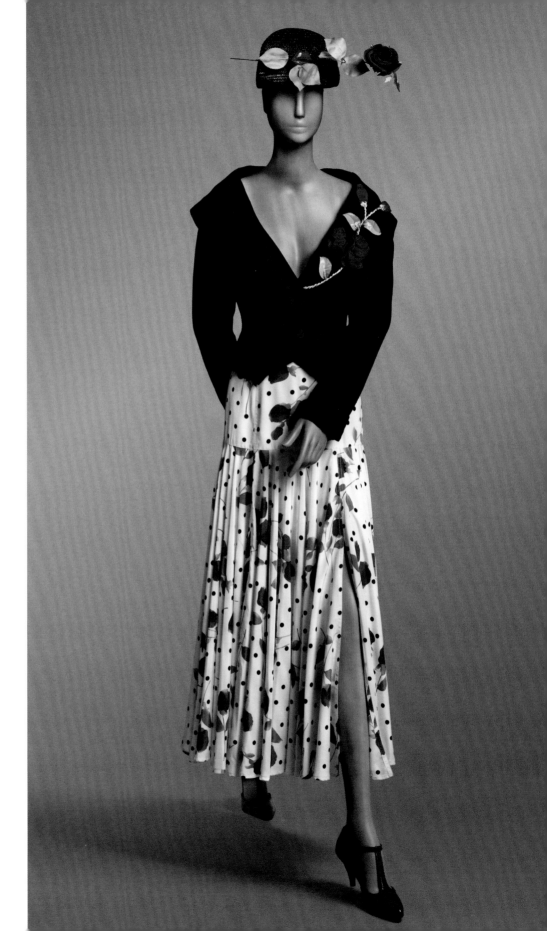

62.

Jacket, skirt, and hat

Spring/Summer 1989

Tango Lisa group

Jacket: cotton and linen with silk

Skirt: printed silk

Hat by Maison Michel (French, est. 1936): synthetic straw with plastic and silk

Gift of Bjorn Guil Amelan and Bill T. Jones in honor of Monica Brown, 2014-207-21a--c

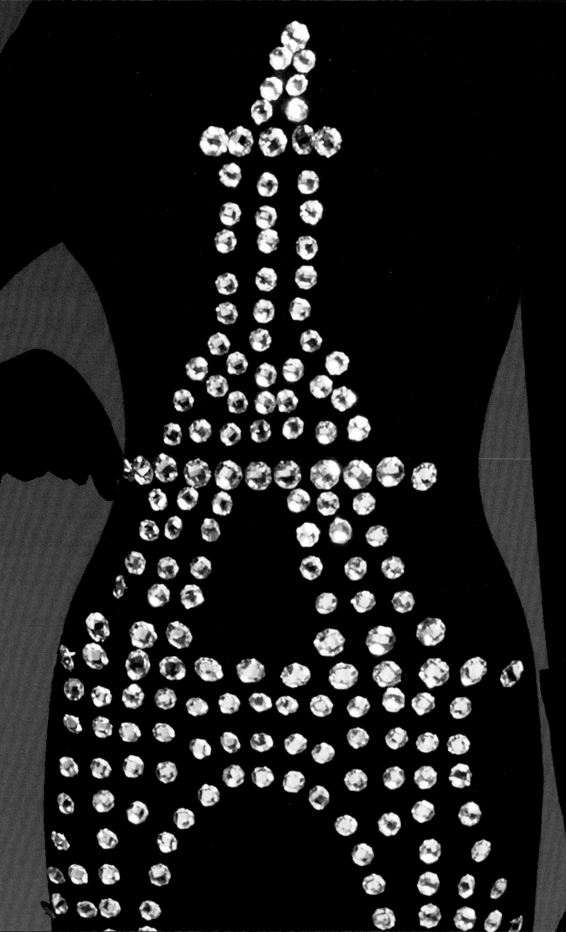

TWO LOVES

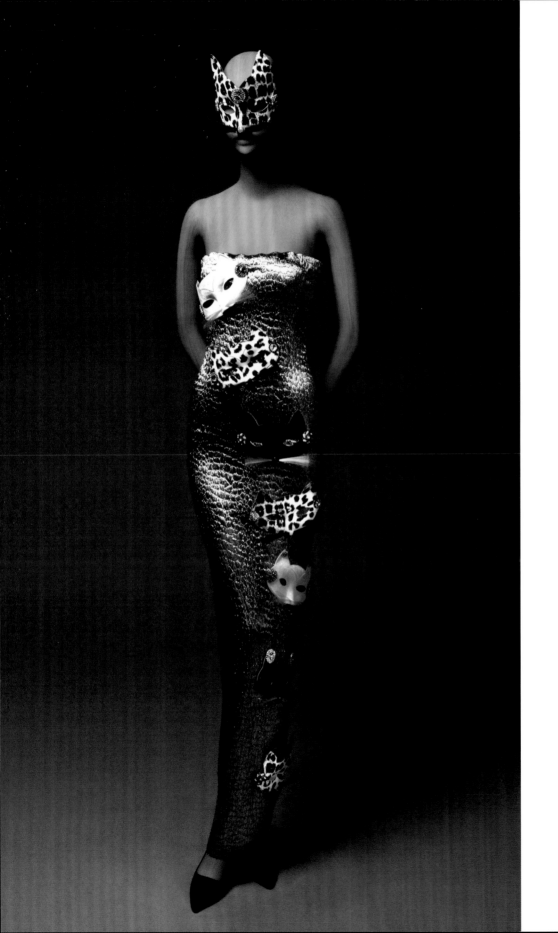

63.

Dress and mask

Mock-Couture

July 1989

Platine collection

Synthetic

Gift of Bjorn Guil Amelan and Bill T. Jones in honor of Monica Brown, 2015-201-115a,c

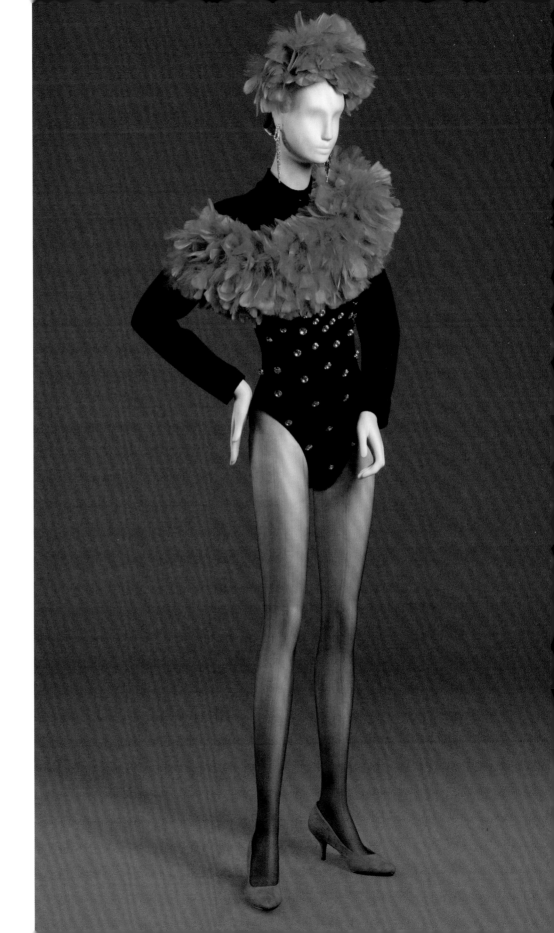

64.

Bodysuit, headdress, and boa

Fall/Winter 1989–1990

Casino de Patrick group

Bodysuit: wool and spandex knit

Headdress and boa: feathers

Gift of Bjorn Guil Amelan and Bill T. Jones in honor of Monica Brown, 2015-201-233 (bodysuit); 2015-201-234 (headdress); 2015-201-235 (boa)

65.

Dress

Fall/Winter 1989–1990

Casino de Patrick group

Acetate and rayon with feathers

Gift of Bjorn Guil Amelan and Bill T. Jones in honor of Monica Brown, 2015-201-109

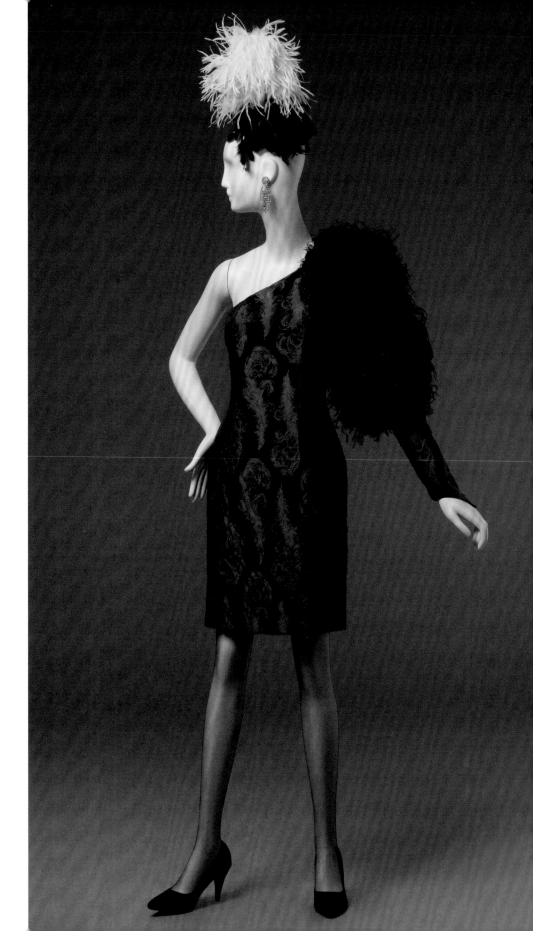

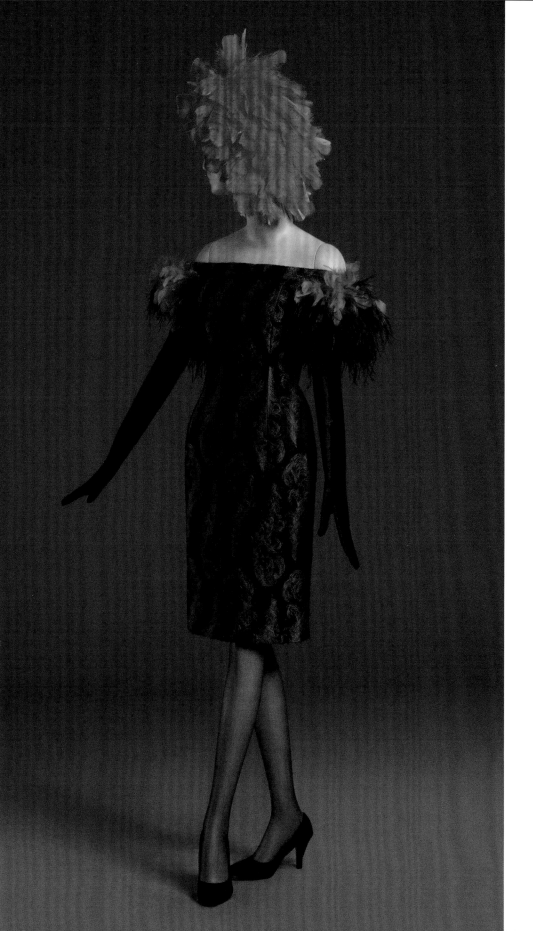

66.

Dress, gloves, and hat

Fall/Winter 1989–1990

Casino de Patrick group

Dress: acetate and rayon

Gloves: polyester knit with feathers

Hat: feathers and synthetic ribbon

Gift of Bjorn Guil Amelan and Bill T. Jones in honor of Monica Brown, 2015-201-110a,c,d (dress and gloves); 2015-201-112 (hat)

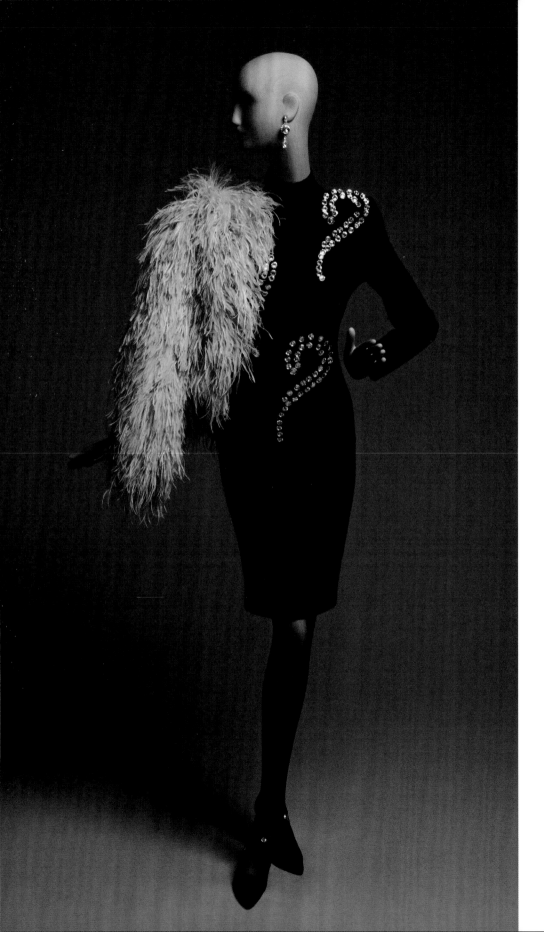

67.

Jacket, dress, and earrings

Fall/Winter 1989–1990

Casino de Patrick group

Jacket: synthetic with feathers

Dress: wool knit with rhinestones

Earrings: metal with rhinestones

Gift of Bjorn Guil Amelan and Bill
T. Jones in honor of Monica Brown,
2015-201-108a,c (jacket and dress);
2015-201-141a,b (earrings)

68.

Dress, hat, and earrings

Fall/Winter 1989-1990

Man Ray's Photograph group

Dress: cotton, nylon, and Lycra lace

Hat by Maison Michel (French, est. 1936): wool felt

Earrings: metal

Gift of Bjorn Guil Amelan and Bill T. Jones in honor of Monica Brown, 2015-201-103a--e (dress and hat); 2015-201-204a,b (earrings)

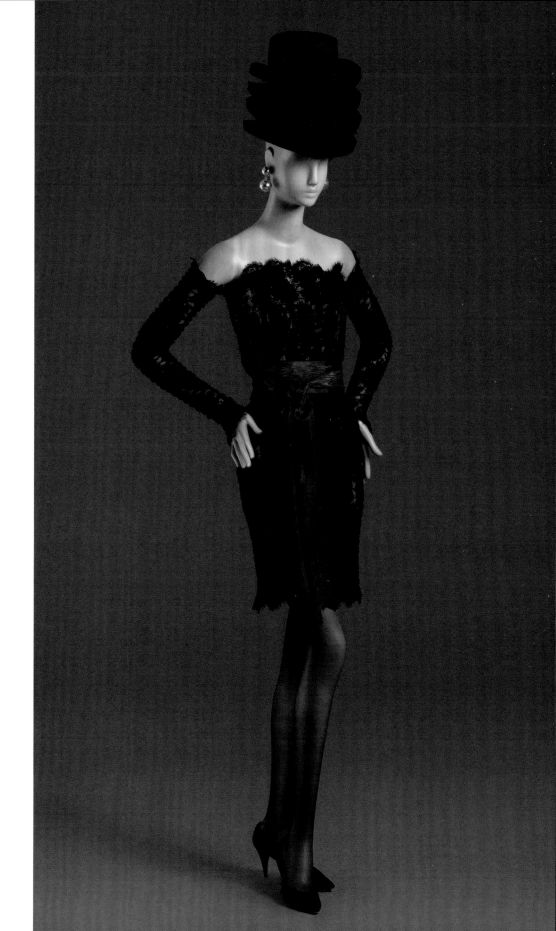

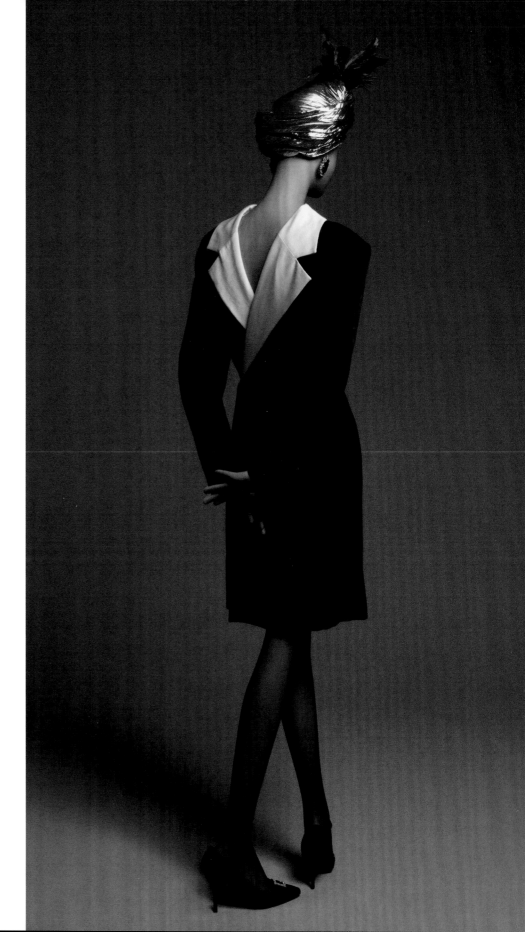

69.

Dress, turban, and earrings

Fall/Winter 1989–1990

Blackamoors group

Dress: wool and acetate

Turban by Maison Michel (French, est. 1936): synthetic lamé

Earrings: synthetic stones and rhinestones

Gift of Bjorn Guil Amelan and Bill T. Jones in honor of Monica Brown, 2015-201-105a,c (dress and turban); 2015-201-156a,b (earrings)

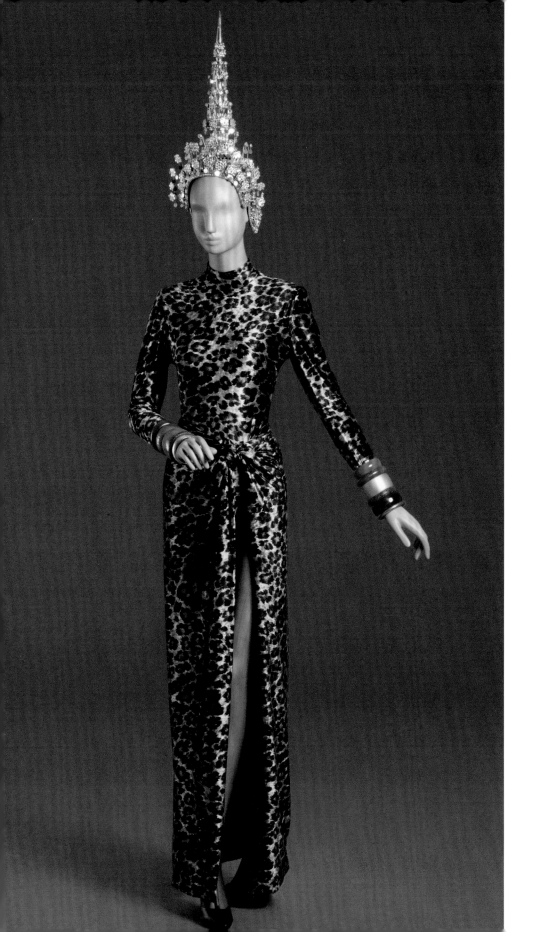

70.

Bodysuit and sarong

Fall/Winter 1989–1990

Man Ray's Photograph group

Synthetic knit

Gift of Bjorn Guil Amelan and Bill T. Jones in honor of Monica Brown, 2015-201-104a,b

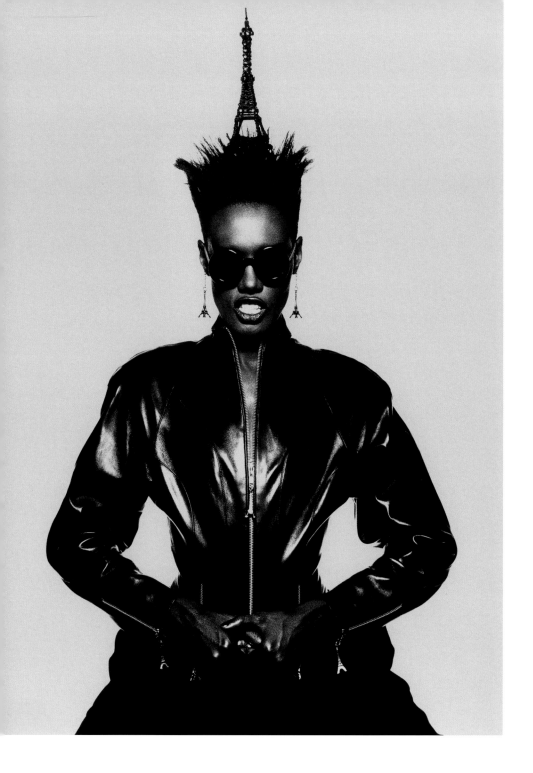

71.

**Grace Jones for
Patrick Kelly**

Gilles Decamps (French, b. ca.
1963)

Grace Jones for Patrick Kelly, 1989

Chromogenic print on Kodak
Endura metallic paper

Gift of Janet and Gary Calderwood
and Gilles Decamps, 2014-42-1

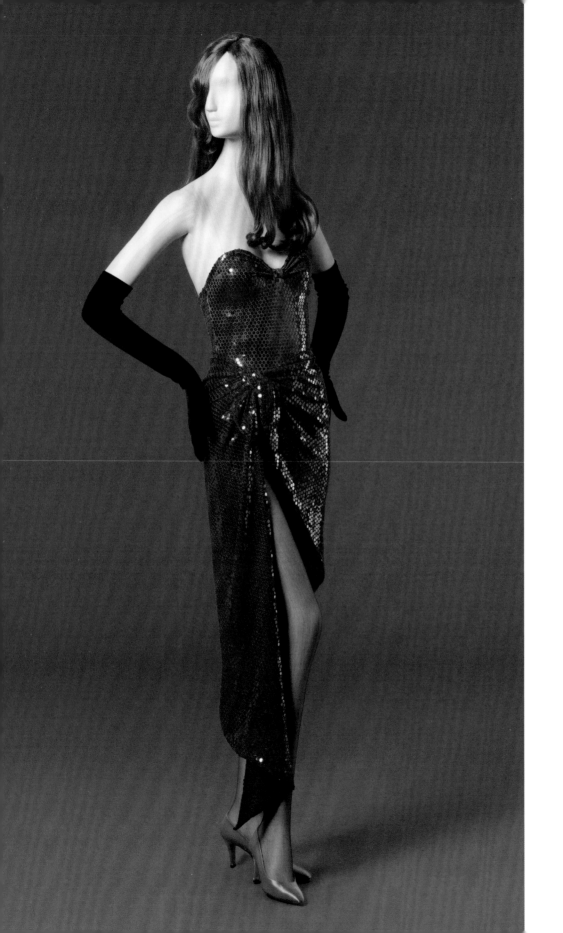

72.

Bodysuit and sarong

Fall/Winter 1989–1990

The Lips of Jessica Rabbit group

Bodysuit: polyester and spandex knit with plastic sequins

Sarong: silk chiffon with plastic sequins

Gift of Bjorn Guil Amelan and Bill T. Jones in honor of Monica Brown, 2015-201-106a,b

73.

Dress and scarf

Fall/Winter 1989–1990

Little Red Riding Hood group

Wool and spandex knit

Purchased with funds contributed
by Marvin Levitties, 2007-141-1
(dress); gift of Bjorn Guil Amelan
and Bill T. Jones in honor of Monica
Brown, 2014-207-32 (scarf)

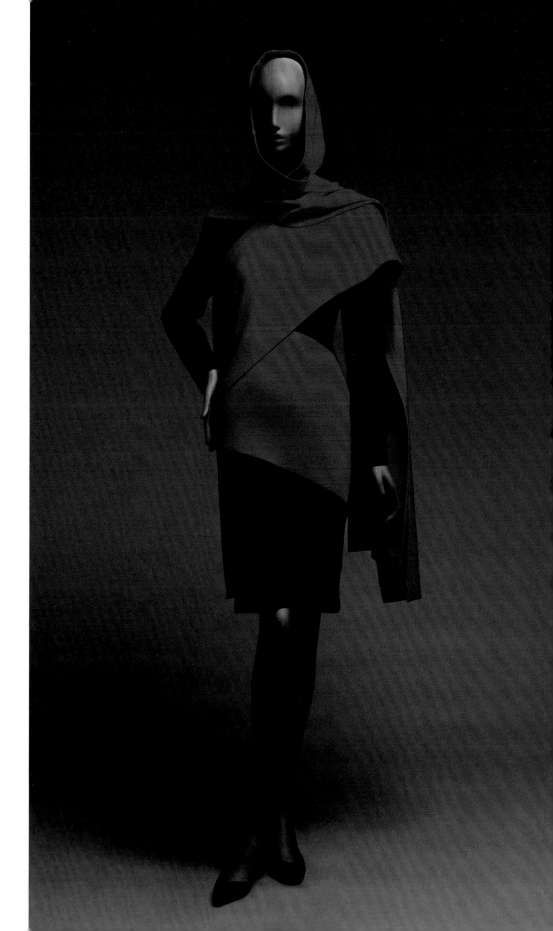

74.

Dress, hat, shoes, and earrings

Fall/Winter 1989–1990

Eiffel Tower group

Dress: wool and spandex knit with rhinestones

Hat by Maison Michel (French, est. 1936): metal wire, plastic, and nylon velvet with rhinestones

Shoes by Maud Frizon (French, est. 1969): leather and suede

Earrings: metal with rhinestones

Gift of Bjorn Guil Amelan and Bill T. Jones in honor of Monica Brown, 2014-207-35a,b,d,e (dress, hat, shoes); 2015-201-190a,b (earrings)

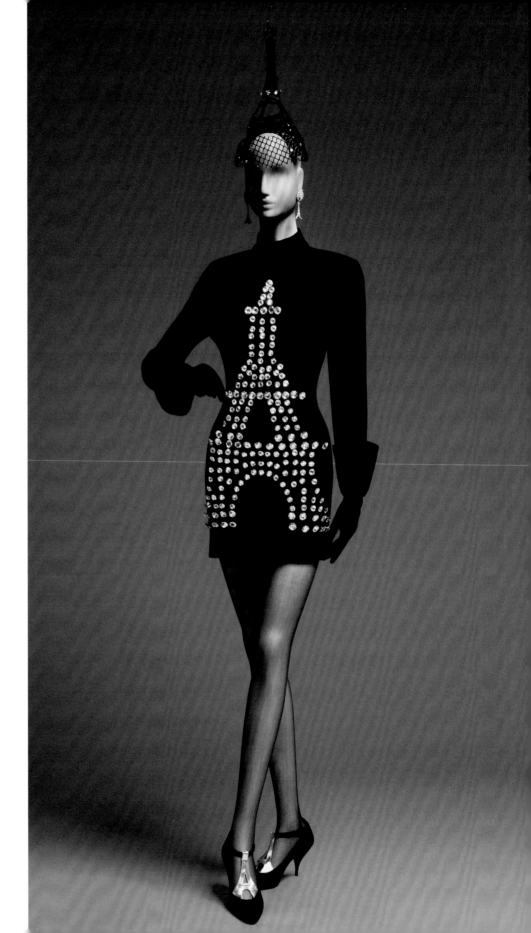

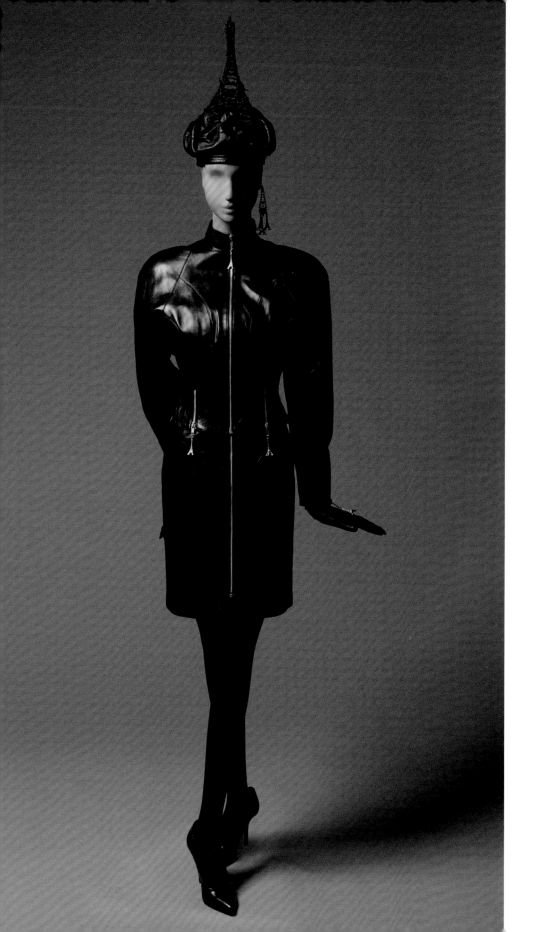

75.

**Dress, jacket, hat,
and earrings**

Fall/Winter 1989–1990

Eiffel Tower group

Dress and jacket: leather with metal

Hat by Maison Michel (French, est.
1936): leather with plastic and
polyester

Earring: metal with rhinestones

Gift of Bjorn Guil Amelan and Bill
T. Jones in honor of Monica Brown,
2014-207-36a--c (dress, jacket, hat);
2015-201-191a (earring)

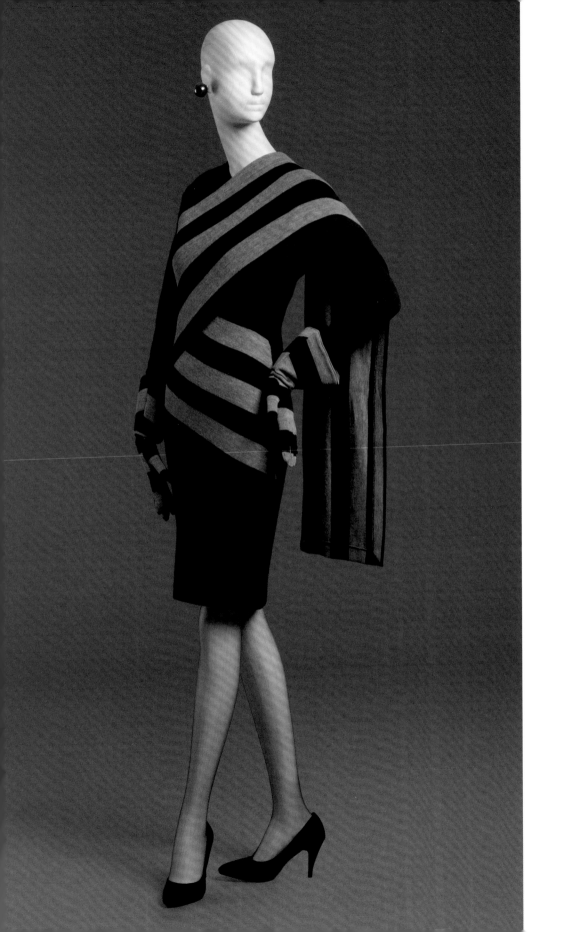

76.

Dress and gloves

Fall/Winter 1989–1990

Jailhouse Rock group

Wool and spandex knit

Fine Arts Museums of San
Francisco, Gift of Elizabeth
Goodrum in honor of Patrick Kelly,
2021.7.4a--c

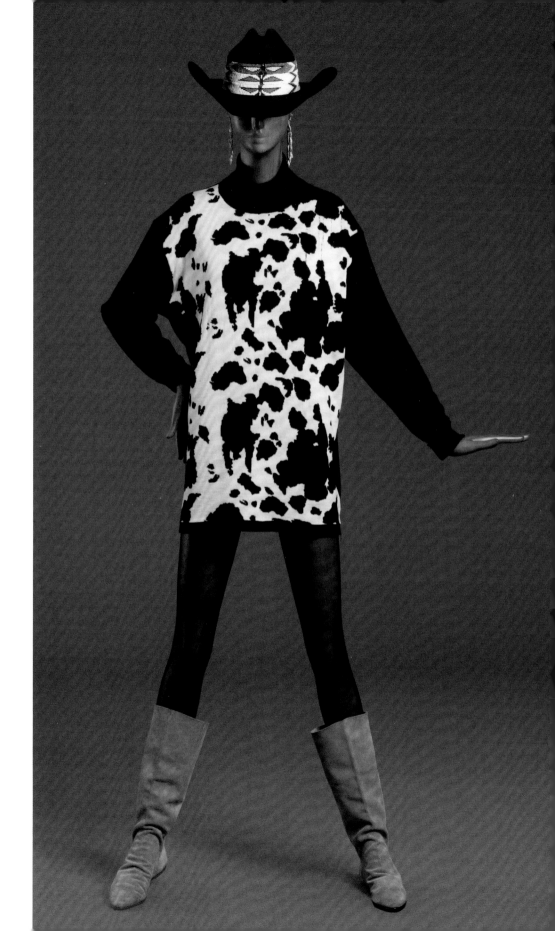

77.

Sweater/dress

Fall/Winter 1989-1990

Cowboys group

Wool knit

Fine Arts Museums of San
Francisco, Gift of Elizabeth
Goodrum in honor of Patrick Kelly,
2021.7.1

78.

Suit

Fall/Winter 1989–1990

The Man in the Gray Flannel Suit group

Wool and mohair with metal buttons

Gift of Bjorn Guil Amelan and Bill T. Jones in honor of Monica Brown, 2014-207-33a,b

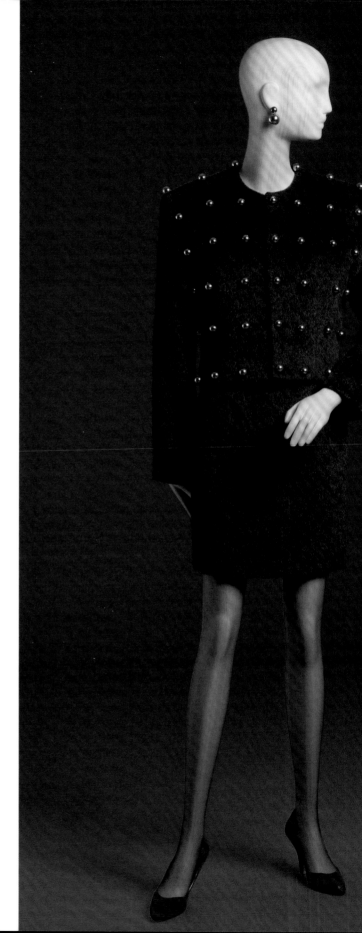

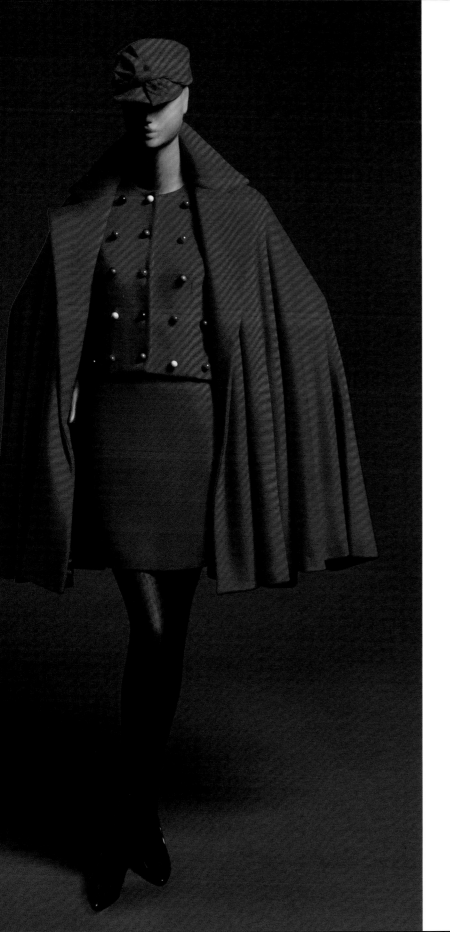

79.

Cape, jacket, skirt, hat, and earrings

Fall/Winter 1989–1990

The Man in the Gray Flannel Suit group

Cape: wool

Jacket: wool with plastic buttons

Skirt and hat: wool

Earring: metal

Gift of Bjorn Guil Amelan and Bill T. Jones in honor of Monica Brown, 2014-207-34a--c,e (cape, jacket, skirt, hat); 2015-201-203a (earring)

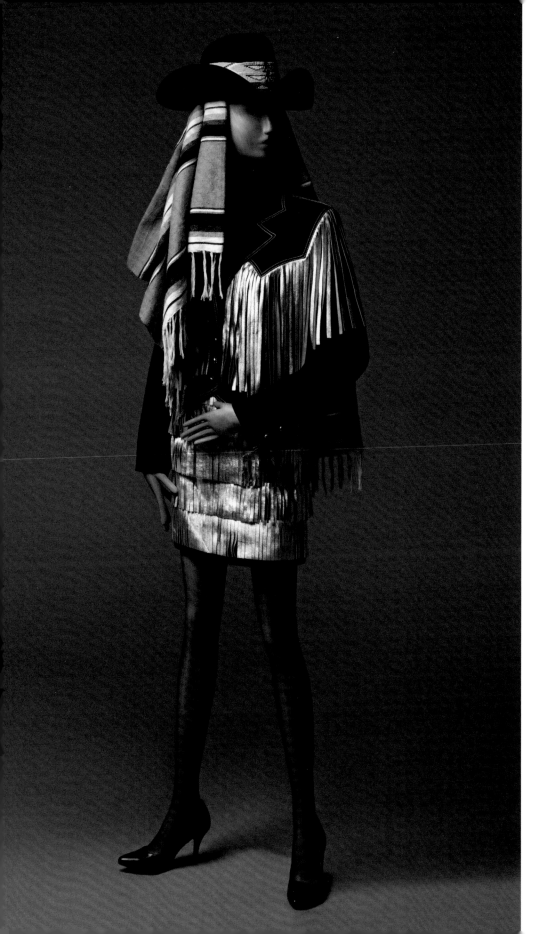

80.

Suit

Fall/Winter 1989–1990

Cowboys group

Rayon and polyester with faux leather

Gift of Bjorn Guil Amelan and Bill T. Jones in honor of Monica Brown, 2014-207-37a,b

81.

Dress and earrings

Fall/Winter 1989–1990

Cowboys group

Dress: wool and spandex knit

Earring: metal with rhinestones

Gift of Bjorn Guil Amelan and
Bill T. Jones in honor of Monica
Brown, 2015-201-101 (dress);
2015-201-173 (earring)

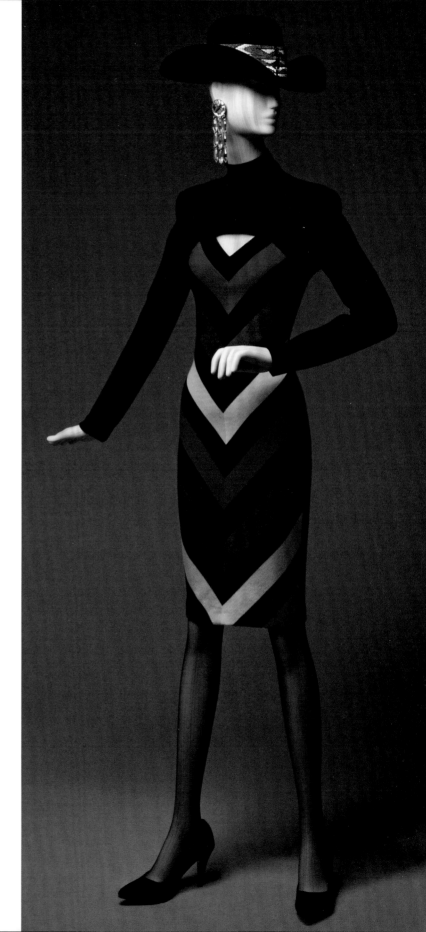

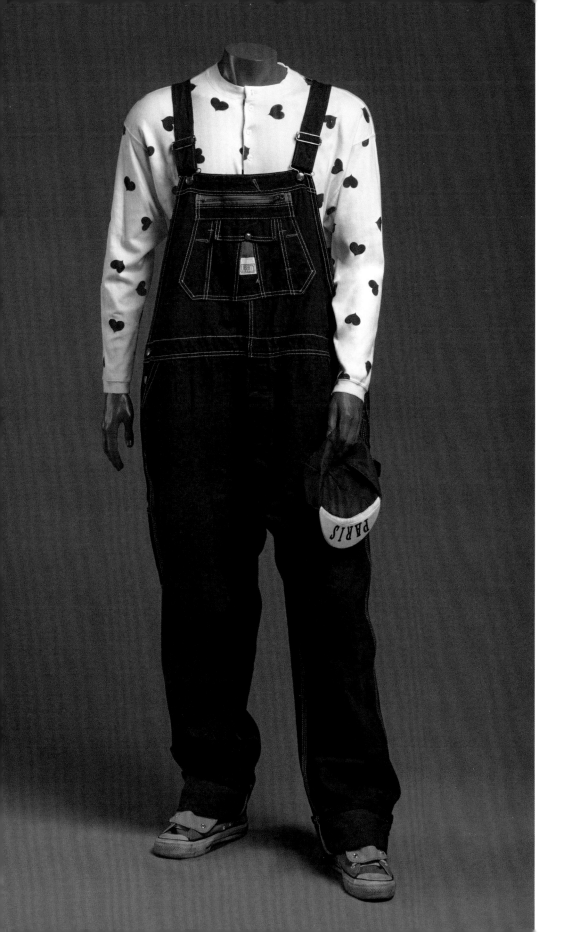

82.

**Outfit worn by
Patrick Kelly at his
final fashion show
(Fall/Winter
1989–1990)**

Overalls by Liberty
(American, est. 1912)

T-shirt by Coup de Coeur
(French, est. 1983)

Cap by Pink Soda
(English, est. 1983)

Sneakers by Converse
(American, est. 1908)

Patrick Kelly logo pin (1985;
not pictured)

Gift of Bjorn Guil Amelan and
Bill T. Jones in honor of Monica
Brown, 2015-201-111-a--c,e,f
(overalls, T-shirt, cap, sneakers);
2015-201-45b (pin)

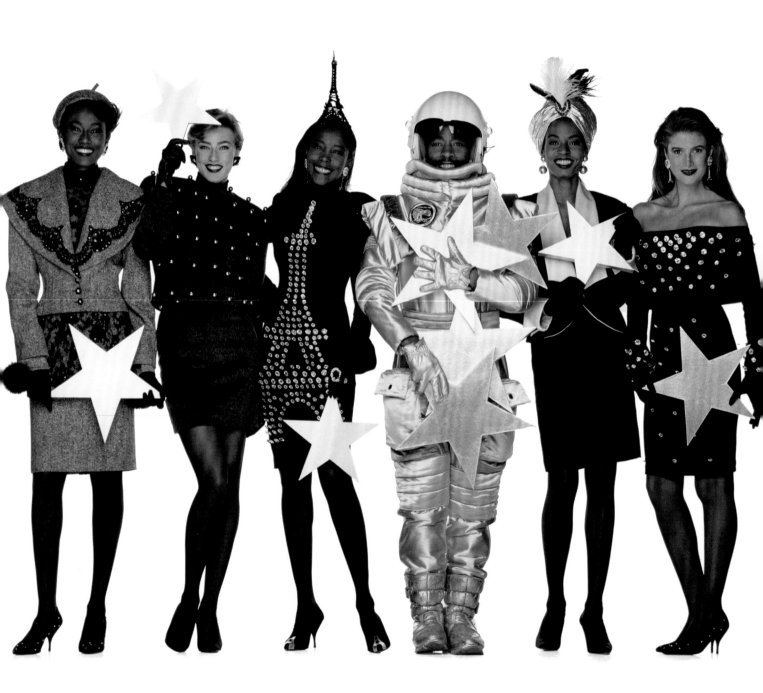

APPENDICES

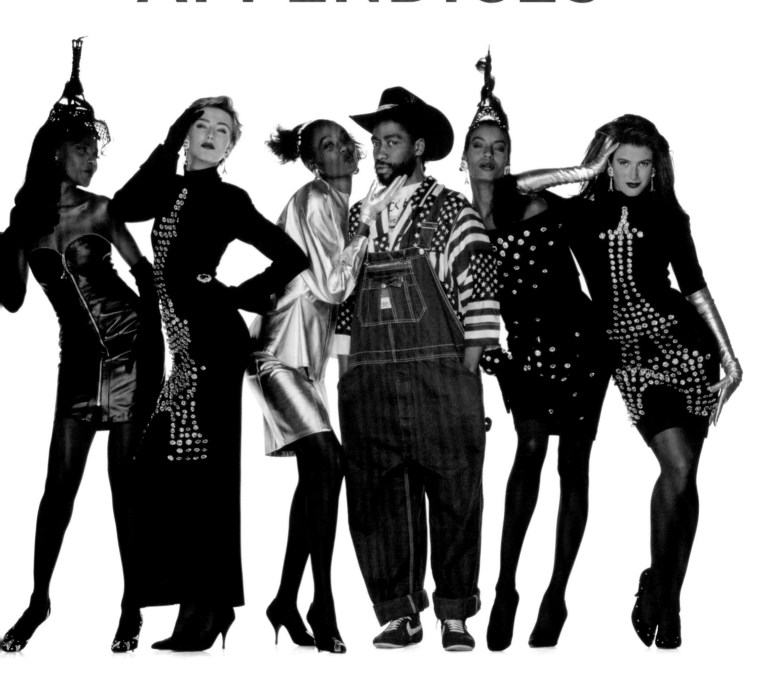

CHRONOLOGY

COMPILED BY **DILYS E. BLUM**

1954

Patrick Leroy Kelly is born on September 24, in Vicksburg, Mississippi, to Letha May Rainey Kelly (1922-2014), a home-economics teacher, and Danie Sylvester Kelly (1921-1969), variously a fishmonger, an insurance agent, and a cabdriver. Patrick is their second son; his older brother, Danie (or Dannie) Sylvester Kelly Jr. (1949-1996), was a hairstylist, model, dancer, and choreographer. His younger brother, William Michael Kelly (1963-2021), studied agriculture at Alcorn State University and was a member of the ASU Braves football team.

1960

Grandmother Ethel Viola Bernard Rainey (1897-1994) brings home copies of *Vogue* and *Harper's Bazaar* given to her by her white employer. She and Kelly notice that no Black women are featured; Kelly vows to design clothes for all women, regardless of their skin color or size. His mother teaches him to draw, and an aunt teaches him to sew.

1970

Attends the thirteenth Ebony Fashion Fair in Atlanta. (Kelly states that it was in Jackson, Mississippi, which would have been in 1974, but Audrey Smaltz remembers meeting him in 1970, at her first show.) Meets Audrey Smaltz, the fair's coordinator and commentator from 1970 to 1977. Smaltz later coordinates Kelly's Paris shows.

1972

Graduates from Vicksburg High School. Voted most popular, friendliest, and best dancer by his classmates. Designs clothes for friends to sew.

1972-1974

Attends Jackson State University on an art scholarship for eighteen months. Studies art history, art education, and African American history. He continues making clothing for friends, and he dresses Miss Jackson State University pageant winner. Acts as fashion coordinator for Miss Black Mississippi in 1973.

1974

Moves to Atlanta.

Works at AMVETS (American Veterans), an organization that provides services to veterans of the American military, sorting used clothing.

Opens a small shop, called Moth Ball Matinee, in the hip hair salon Wizard of Ahs, selling antique and secondhand clothing; remodels clothing and sells his own designs; encourages friends and local models to wear his designs to parties to promote his name.

Volunteers to design window displays for the newly opened Yves Saint Laurent Rive Gauche boutique and is later hired. He eventually meets Connie Uzzo, American market director for Yves Saint Laurent, who becomes a close friend and advocate.

Works as gofer at the Atlanta Apparel Mart and styles trend shows. Meets Ellie Wolfe, owner of an accessories showroom at the Mart, who becomes a lifelong friend and an early client.

Frequents Barbara Weiss's boutique, Snooty Hooty, to sketch and gather design ideas.

1975

One of three local designers, together with New York–based ready-to-wear designer Jack Fuller, an Atlanta native and a graduate of Parsons School of Design, invited to show as guests with the Joseph Schlitz Brewing Company's 1974 *Toast to Fashion*, a traveling fashion show of the Los Angeles student winners of the company's design competition, during the National Urban League's 65th Annual Convention in Atlanta.

1976

Dennis Shortt's fashion production company, Unique with Fashions, presents the show *Headline News* at the Hilton Hotel, featuring models Iman, in her American runway debut, and Pat Cleveland. Ready-to-wear from Yves Saint Laurent Rive Gauche, Emilio Pucci, and Givenchy (courtesy of local boutiques) is featured with, according to the press announcement, designs by "the fabulous Patrick Kelly."

1977

Pat Hill's Theatrical Fashions, Inc.'s *The Dance of Rags and Pieces*, performed at the Peachtree Playhouse, features exclusive designs by Kelly and Gerald Simpson, worn by local models and top New York male model Charles Williamson. The thirteen scenes, choreographed by Ron Frazier and Phillip Griffin of Atlanta Dance Theatre, incorporate modern dance, mime, and skits.

Kelly's designs continue to be featured in other Atlanta fashion shows, including *In the Star Style* at the Harlequin Dinner Theater, with fashions by Bob Mackie, Tahmoo collection by P.N. Fall

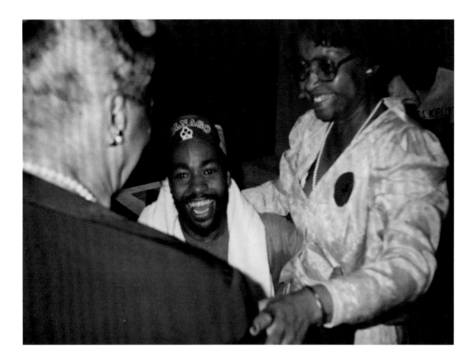

51. Patrick Kelly with his mother, Letha May Rainey Kelly

and Associates of West Africa, and, according to the press announcement, the "debut showing of Atlanta's new designer," Patrick Kelly.

1978
Pat Cleveland encourages Kelly to move to New York to study fashion design at Parsons School of Design. An anonymous benefactor provides $3,000 for tuition. Kelly leaves Parsons after attending for one academic year, from September to May. He is remembered as an indifferent student who spent more time at clubs, particularly at the historic Paradise Garage, than studying. Kelly continues making clothes for friends, models, and entertainers to wear to clubs.

1979
Continues to make the rounds of New York design houses but is unable to find a permanent position. Works briefly with Black ready-to-wear designer Jack Fuller, whom he first met in Atlanta in 1975 and later credits in a 1984 interview with Renée Minus White, of the *New York Amsterdam News*, with helping him "master his trade."

Reconnects with model Pat Cleveland through hairstylist Rudy Townsel (1940–2008), with whom he shares an apartment. Townsel later styles Kelly's Paris shows.

Attends a Columbus Circle hairdressing show with Townsel and Cleveland, who wears the first version of Kelly's Josephine Baker–inspired ensemble consisting of a skirt made of plastic bananas and a bra made of two pink-sequined cups for a dance number.

Kelly is frustrated and depressed. Cleveland suggests he try Paris and anonymously leaves a plane ticket for him with Rudy Townsel at Bergdorf Goodman's hair salon, where Townsel was working. On the flight to Paris he meets Black choreographer Larry Vickers. Vickers offers Kelly a job designing costumes for Fabrice Emaer's nightclub Le Palace.

1979–1982
Works as the costume designer for Le Palace, assisted by Elizabeth Goodrum (known as

"Ms. Liz"), who will later become Kelly's collection design assistant, researching and sourcing fabrics, trimmings, and accessories. Projects include Larry Vickers's ballet for Sony France's launch of the Walkman II in 1981.

Supplements his income by designing and sewing for friends and private clients and catering home-cooked fried-chicken dinners.

Joins Paco Rabanne's haute-couture atelier for Fall/Winter 1981–1982 but is forced to leave when he is hospitalized with Crohn's disease. Rabanne leases a one-room apartment for Kelly at 40 Rue des Saints-Pères. Kelly accompanies Rabanne to Rio de Janeiro.

1982
Meets Bjorn Guil Amelan, an agent for photographers Horst P. Horst, William Klein, and others, in New York at Willi Smith's new WilliWear showroom.

1983
Reconnects with Bjorn Guil Amelan in Paris. Amelan becomes Kelly's life and business partner.

Paco Rabanne establishes Centre 57 as a meeting place and exhibition space for Black diaspora artists. Amelan takes over the Rue des Saints-Pères lease.

Audrey Smaltz introduces Kelly to Italian fashion designer Giuliana Camerino, founder of the fashion house Roberta di Camerino. Kelly's first paid freelance project is a sweater collection for Camerino's licensed Giuliana sportswear line.

Meets Somali-born Italian artist Marco Fattuma Maò in Paris. Kelly collaborates with Maò and architect Loredana Dionigio, partners in Turin's Studio Invenzione, on an experimental project centered on living architecture, which includes fashion. Called *Progetto S-Cambia - Invenzione - Architture e Linguaggio d'Immagine*, it is exhibited at the Franz Paludetto Gallery in Turin.

Amelan's birthday gift of a Black figurative ashtray prompts Kelly to collect Black racist memorabilia.

1984
March: Kelly's Studio Invenzione designs are presented to buyers as a fashion collection and shown in an accompanying video, called *Sveglia la notte bruciando cacao (Wake-up the night-burning cacao)*, during Milan Fashion Week for Fall/

52. Patrick Kelly with friend, hairstylist Rudy Townsel, photographed by Oliviero Toscani

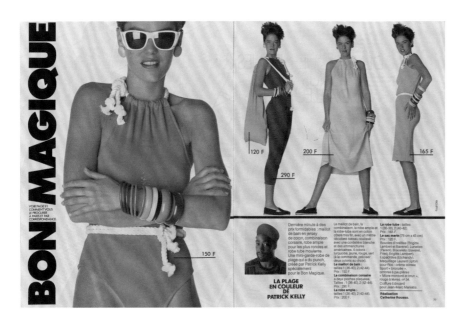

53. Patrick Kelly for
Bon Magique, available
exclusively to French *Elle*
magazine readers, 1986

54. Sketch of a ribbed
knit dress with bows,
1985

Winter 1984–1985. Manufactured by La Maison
Blu, it features knits and decorative elements that
snap on and off. The collection sells to Bergdorf
Goodman, Henri Bendel, and Harrods.

Renée Minus White, fashion and beauty editor
of the *New York Amsterdam News*, is the first
American journalist to interview Kelly in Paris and
report on his Milan collection.

Discovers rolls of tubular cotton knitted fabric
at Marché d'Aligre. Using a borrowed sewing
machine, Kelly sews dresses cut directly from the
roll, leaving the edges unfinished, and decorates
them with buttons and bows.

Sells one-seam cocoon coats, which he designs
and sews himself, on the street near the Church of
Saint-Germain-des-Prés; his model friends wear
them over his tubular knit dresses.

1985

Nina Dorsey, a publicist, introduces Kelly and
Amelan to Françoise Chassagnac (1929–2020),
owner of the fashion boutique Victoire, who
suggests contacting Nicole Crassat (1934–2012),
French *Elle*'s editor in chief. Kelly's designs
are featured in the February issue, in a six-
page spread titled *Les Tubes de Patrick Kelly*,
photographed by United Colors of Benetton's
Oliviero Toscani, creator of Benetton's
controversial ad campaign; he later photographs
Kelly's campaign. In September, Kelly is profiled
in the inaugural issue of American *Elle*.

March: Fall/Winter 1985–1986, Kelly's first
ready-to-wear collection, is presented at 17
Rue du Mail, above the Victoire boutique.
Victoire's fashion director, Gilles Reboux,
provides production facilities, shipping, and a
showroom in an unused space on the second
floor. Simultaneously, Kelly designs an exclusive
winter collection for Victoire. The show invitation
is illustrated with Kelly's lucky number three in
a circle. Renowned lighting designer Thierry
Dreyfus makes his fashion-show debut, using
candles for lighting; he will continue as lighting
director for all of Kelly's future shows. Invitees
include Bergdorf Goodman's Dawn Mello, who
attended the 1984 Milan show.

Bergdorf special orders the dresses featured
in French *Elle*. Kelly sews these himself to meet
the delivery deadline, using tubular cotton
knit fabric purchased from Natacha Lévy's

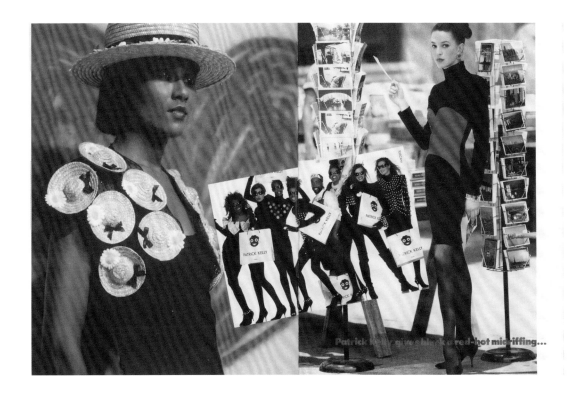

55. Patrick Kelly
Paris press book

La Soie de Paris, a source for knit textiles for future collections. Bergdorf's showcases Kelly's collection in the store's 57th Street windows, which are reserved for new designers.

Designs knit collection on a freelance basis for Italian brand Touche Fall/Winter 1985–1986 collection, following Enrico Coveri's departure. Declines to produce second collection as he does not want to be branded "a jersey person."

Kelly and fellow Black American Peter Kea are included in the exhibition *La Mode en Direct* (June 12–September 23) at the Forum, Centre Georges Pompidou, celebrating young fashion designers working in France.

September: Presents Spring/Summer 1986 collection at 17 Rue du Mail.

The Spring/Summer 1986 collection is the first to feature Kelly's signature golliwog image, notably on Bianchini-Férier printed dresses and Maud Frizon shoes. Frizon will continue to design shoes for future collections. Kelly designs and makes the jewelry in his studio, a practice that continues with future collections; begins controversial tradition of handing out Black "babies" (small Black baby dolls) to clients.

1986
Rachida (Abou El Wafa) Afroukh becomes Kelly's patternmaker and sample maker.

Kelly's tube dresses are modeled in live presentation introducing the new Auror Eyewear collection.

March: Presents his Fall/Winter 1986–1987 collection at the Galerie Colbert. The invitation features a Josephine Baker image from a vintage postcard in Kelly's collection. The show's "Chez Patrick Kelly" theme is inspired by Chez Josephine Baker, Josephine Baker's Paris nightclub. The finale features Pat Cleveland as Baker, wearing a plastic-banana skirt designed by Kelly, and an anodized aluminum bra and accessories designed by David Spada (1961–1996) that photographer Bill Cunningham features on the cover of *Details* magazine for September 1986. The collection also includes Bianchini-Férier printed fabrics based on a Paul Colin lithograph of Josephine Baker; knit dresses with button golliwogs and abstract designs; a Dior fashion-show spoof; and Madame Grès–inspired hip-wrapped knits.

Designs a beaded golliwog dress with the words "I Love Fashion Scandal" exclusively for the 1986–1987 traveling Ebony Fashion Fair show *Fashion Scandal*; the Josephine Baker banana-skirt ensemble is featured in several venues as a finale to the swimsuit section; Kelly's designs are included in Ebony Fashion Fair's annual fashion shows until 1990.

La Soie de Paris offers customers instructions for making a variety of Kelly's knit dresses with the purchase of the store's fabric.

Victoire launches its own Kelly-designed ready-to-wear line.

Attends exhibition opening of *Yves Saint Laurent: 28 années de création* at the new Musée des Arts de la Mode, 111 Rue de Rivoli, where he reconnects with Connie Uzzo. Several journalists note Kelly's admiration for Yves Saint Laurent, and Saint Laurent's influence on his work.

Kelly's designs are included in Bloomingdale's 100th anniversary celebration.

Freelance design projects include Eres luxury bathing suits, 3 Suisses (mail-order catalogue) dresses, and a Bon Magique clothing group offered exclusively to French *Elle* magazine's readers.

Travels to Seychelles; the trip inspires the color palette for Spring/Summer 1987 collection. Kelly's working holidays frequently provide him with collection ideas.

October: Presents the Summer 1987 collection and Patrick Kelly for Victoire at the Grand Hotel, in the Salon Opéra. The invitation features a photograph of Kelly surrounded by Black dolls from his personal collection of more than three thousand dolls; the show is dedicated to Kelly's mother, grandmother, and "Maman."

Kathryn Sermak, Bette Davis's former personal assistant, interns with Kelly and is promoted to press attaché; Davis visits Paris and attends Christmas dinner with Sermak at Kelly's home; she arrives wearing an arm sling pinned with a Kelly Black baby doll.

Victoire announces that it can no longer continue production since they need the space above their offices for plant expansion.

1987
Moves home and workspace to 6 Rue du Parc Royal in the Marais.

Diagnosed with HIV.

Suze Yalof Schwartz, later the fashion editor at *Glamour* magazine, serves as Kelly's personal assistant from 1987 to 1988 during her junior year at the Sorbonne.

March: Presents the Fall/Winter 1987–1988 collection at the Intercontinental Hotel in Paris. The invitation features a vintage image of a small boy dressed in white holding a staff with a fleur-de-lis and an oversize rose, surrounded by a period frame and the word "gallery." The collection's button-covered dresses, denim, bandana, and faux-alligator fabrics reference Kelly's Mississippi roots. One of the models is visibly pregnant, showing that women of any size can wear Kelly's designs. The collection is now produced by Ghinea of Perugia, Italy, for this season only; they announce that they cannot manage future collections due to the large production volume.

56. Sketch for the Spring/Summer 1988 collection, shown in October 1987 at the Grand Hotel. This was the first Patrick Kelly Paris collection backed by Warnaco.

Participates in the 6th Festival de la Mode, hosted by Galeries Lafayette.

Ellie Wolfe of Atlanta introduces Kelly to New York television producer Carla Morgenstern, who introduces him to Gloria Steinem. Steinem visits Kelly's Paris showroom and, during fashion week, introduces him to Linda Wachner, president and CEO of Warnaco.

Interviewed by Gloria Steinem on the *Today* show.

Freelance projects for Fall/Winter 1987–1988 include a fifty-piece collection (woven fabrics and jeans) for Benetton and a second Fall/Winter collection for 3 Suisses.

Willi Smith dies from AIDS-related complications.

Harvey Nichols London promotion features two shows of Kelly's designs and a luncheon in his honor.

Beginning in May, Kelly acts as a design consultant for Warnaco's White Stag Sportswear and Stagsport for their Spring 1988 collections.

People magazine names Kelly "the new king of cling."

Opens the first Patrick Kelly Paris boutique at 6 Rue du Parc Royal. Kelly's mother makes cloth Aunt Jemima dolls to sell in the boutique.

Bette Davis appears on *Late Night with David Letterman* wearing a Patrick Kelly dress; she presents Letterman with Black baby-doll pin and

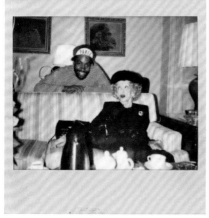

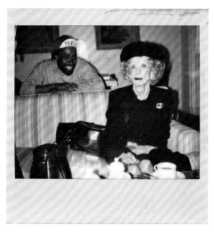

57. Bjorn Guil Amelan, Bette Davis, and Patrick Kelly (top); Patrick Kelly and Bette Davis (middle and bottom)

58. Invitation to the Patrick Kelly Paris Fall/Winter 1988–1989 collection presentation

announces that the designer is looking for financial backers.

In July, Warnaco, under Wachner, signs an exclusive contract with Kelly for ready-to-wear sportswear, dresses, coats, jackets, and sweaters. Mary Ann Wheaton leaves Bidermann Industries to become president of Patrick Kelly Marketing. The first collection is scheduled for Spring/Summer 1988.

July: During the Fall/Winter 1987 haute-couture fashion shows Kelly presents Mock-Couture, his first made-to-order collection for private clients, at 6 Rue du Parc Royal. Known as "Wink of the Eye," the fifty-two looks are ordered by Lynn Manulis of Martha, a luxury boutique on New York's Park Avenue, which has a US exclusive. The looks are presented in New York as Nouvelle Couture at a trunk show and cocktail party and priced from $2,000 to $5,000. Kelly hands out Black baby-doll lapel pins to guests. Harvey Nichols London places a major order prior to the collection's presentation.

Black fashion designer Patrick Robinson interns with Kelly while a student at Parsons Paris.

Nordstrom in Palo Alto, California, hosts an informal modeling of Patrick Kelly Paris.

Good Morning America tapes a visit by Kelly to his family in Vicksburg. The interview airs on October 21, but it does not include the visit to Vicksburg.

Participates, with other designers and artists, in a Halloween Costume Ball auction held at the Puck Building in New York to benefit Living with AIDS.

October: Presents the Summer 1988 collection, Kelly's first ready-to-wear collection with Warnaco, at the Grand Hotel, Salon Garnier, 2 Rue Scribe. The show invitation features Kelly's caricature of himself as a nude cutout paper doll with a beard and a bun. The invitation includes a selection of outfits for the doll, including a top hat and tails, snorkeling gear, angel wings and halo, leopard skin, and a watermelon slice, and his signature denim overalls; use of the same invitation by the luxury boutique Saks Jandel in Chevy Chase, Maryland, for the opening of its Right Stuff shop, causes controversy.

Dresses the Black American hairstyling team, winner of coveted world honors for high fashion and fantasy styles, at the Festival Mondial de la Coiffure, in Cannes, France.

1988
January: Presents Mock-Couture collection at 6 Rue du Parc Royal during the Spring/Summer 1988 haute-couture showings. The three-piece made-to-order collection pays homage to

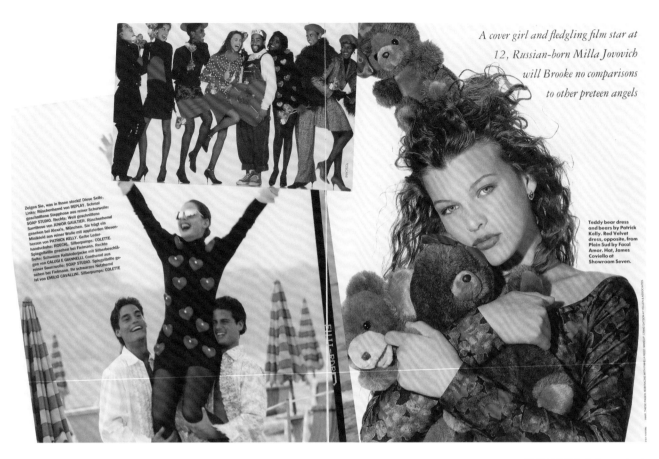

Zeigen Sie, was in Ihnen steckt! Diese Seite. Links: Rüschenhemd von REPLAY. Schmal geschnittene Stepphose aus reiner Schurwolle: SOAP STUDIO. Rechts: Weit geschnittene Samthose von JUNIOR GAULTIER. Rüschenhemd gesehen bei Alexa's, München. Sie trägt ein Minikleid aus reiner Wolle mit applizierten Riesenherzen von PATRICK KELLY. Gelbe Lederhandschuhe: ROECKL. Silberpumps: COLETTE. Spiegelbrille gesehen bei Fielmann. Rechte Seite: Schwarze Kalblederjacke mit Silberbeschlägen von CALUGI E GIANNELLI. Cordhemd aus reiner Baumwolle: SOAP STUDIO. Spiegelbrille gesehen bei Fielmann. Ihr schwarzes Netzhemd ist von EMILIO CAVALLINI. Silberpumps: COLETTE.

Teddy bear dress and bears by Patrick Kelly. Red Velvet dress, opposite, from Plein Sud by Faҫal Amor. Hat, James Coviello at Showroom Seven.

59. Patrick Kelly Paris press book

60. Patrick Kelly Paris sewing pattern by Vogue Patterns, 1988

Madame Grès, Elsa Schiaparelli, and Christian Dior, three of Kelly's muses.

Bette Davis wears a Kelly dress with a button heart while promoting her memoir, *This 'n That.*

March: Presents the Fall/Winter 1988–1989 collection at the La Cigale theater, which had been recently renovated by Philippe Starck. The theme is "More Love." The show invitation is a heart-shaped candy box filled with chocolates including a chocolate pickaninny doll. The looks range from spoofs of Chanel and Schiaparelli to teddy bears in honor of his life partner, Bjorn Guil Amelan.

Kelly introduces packaged buttons and bows for the American market to avoid the 40 percent duty on embellished garments imported into the United States.

Presents the Fall/Winter 1988–1989 collection "More Love" in its entirety at the Atlanta Apparel Mart as "A Fashion Salute to Heart Strings," a benefit for the Design Industries Foundation Fighting AIDS (DIFFA). Kelly premieres a special design for the event, an evening dress embroidered with the "Heart Strings" logo. The logo was originally created by graphic designer Ken Kendrick (1949–1992) for the 1987 poster advertising the DIFFA musical revue of the same name to raise awareness of AIDS. First presented in Atlanta in 1986, it was restaged the following year before touring the United States through the early 1990s.

61. Advertisements for Patrick Kelly Paris at Martha and Macy's, from a Patrick Kelly Paris press book

Thirty-six new retail accounts for Patrick Kelly Paris open in the last two weeks of March; the number of stores in the United States that carry Kelly's designs is 148, with 71 in Europe and accounts in Australia and Asia; the volume sales are at $3 million, up from less than $1 million when Warnaco acquired the licensing agreement; the forecast is for $5 million by fall.

Vogue Patterns launches the first of five licensed sewing patterns for Patrick Kelly designs.

June: Elected to the Chambre Syndicale du Prêt-à-Porter des Couturiers et des Créateurs de Mode. His membership is sponsored by

Pierre Bergé, chairman of Yves Saint Laurent, and fashion designer Sonia Rykiel. He is the first American, and the first Black designer, to be inducted into the prestigious organization.

Produces his first midseason collection for Holiday/Cruise.

July: Presents Mock-Couture Winter 1988 collection at 6 Rue du Parc Royal during the Fall/Winter 1988–1989 haute-couture showings. The small, made-to-order collection is shown on shop mannequins in order to simulate a store window. Kelly pays homage to Chanel with a scoop-neck dress trimmed with huge gardenias.

October: Presents the Spring/Summer 1989 collection at the Salle Perrault, Cour Carrée du Louvre. This is Kelly's first fashion show as a member of the Chambre Syndicale. The collection pays homage to Leonardo da Vinci's *Mona Lisa*, the Louvre's most famous "resident." The collection is grouped as a series of thirteen "alter egos": Pinwheel Lisa; Billie Lisa; Jungle Lisa Loves Tarzan; Tango Lisa; Sunburnt Lisa; Lisa Loves Me? Lisa Loves Me Not; I Won't Talk to Anybody Lisa; Mona's Bet; Le parfum de la Joconde; Lisa-Josephine; Miss M. Lisa Graduates; Moona Lisa; and the Mona Lisa–La Joconde. The playing card–inspired invitation and portrait T-shirts are designed by American illustrator Christopher Hill. The Jungle Lisa Loves Tarzan group includes

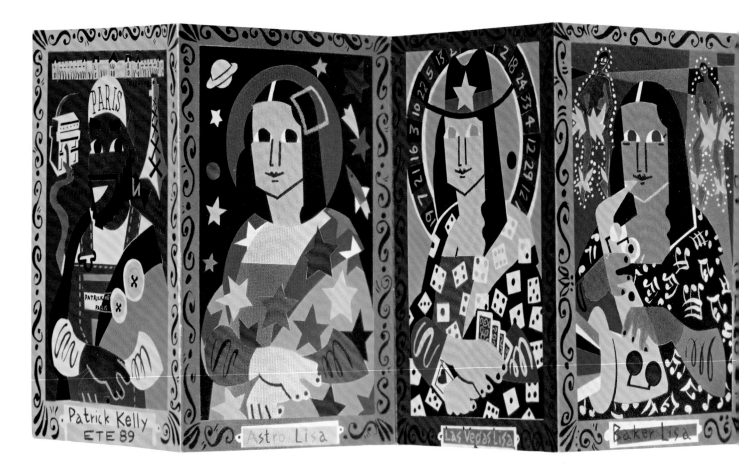

62. Invitation to the Patrick Kelly Paris Spring/Summer 1989 collection presentation, designed by Christopher Hill

Ashanti-inspired jewelry designed by Mickaël Kra for Reine Pokou.

Participates in a fashion show in Moscow, held at the October Cinema House, organized by Owen Breslin Associates to promote Western fashion.

Thirty-six Paris fashion designers create a heart-themed AIDS Memorial Quilt for a benefit auction during the Spring/Summer 1989–1990 collections in October 1988; Kelly dedicates a button-filled heart to Willi Smith.

The November issue of *Paris Match* features a six-page spread titled *Vive la Mode Américaine à Paris* with Grace Jones wearing selections from Kelly's Spring/Summer 1989 collection.

Creates special knitwear designs for the Australian Bicentennial Wool Collection fashion show at the Sydney Opera House, honoring the Australian wool industry.

1989

January: Robin Leach interviews Kelly for the television show *Lifestyles of the Rich and Famous*.

Signs independent (non-Warnaco) licensing agreement with Auror Eyewear, which will later be distributed in the United States by Avalon Eyewear; the first collection is to be presented in October with Grace Jones as the spokesperson and Gilles Decamps shooting the advertising campaign. Other licensing agreements include Franco-Anglaise furs and Streamline buttons.

Reported that over the past eighteen months ending in March, earnings shot up from $795,000 to $5.2 million.

March: Presents the Fall/Winter 1989–1990 collection at the Salle Perrault, Cour Carrée du Louvre. The invitation features a Pierre et Gilles hand-painted photograph with Kelly as turbaned blackamoor. The collection celebrates Kelly's two loves: France and America. Themes include Little Red Riding Hood; Jailhouse Rock; The Man in the Gray Flannel Suit; Eiffel Tower; Cowboys; Plaid Gone Mad; Caviar and Diamonds; The Lips of Jessica Rabbit; Man Ray's Photograph.

May: *Bob Hope's Birthday Spectacular* televised from Paris features an eight-minute fashion show of

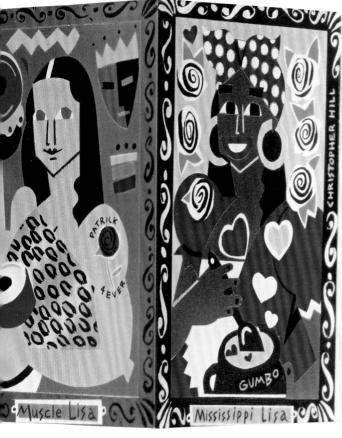

Muscle Lisa Mississippi Lisa

PATRICK KELLY

PRIE M..

DE LUI FAIRE L'HONNEUR D'ASSISTER
A SON DEFILE
ETE 89

MERCREDI 19 OCTOBRE 1988
A 16 HEURES (4 PM)

SALLE PERRAULT
COUR CARREE DU LOUVRE
PALAIS DU LOUVRE - 75001 PARIS
TEL. 48.04.97.64

ENTREE PORTE MARENGO (RUE DE RIVOLI)

ENTRE :................

BLOC :.........PLACE :............

R.S.V.P. AVANT
LE 16 OCTOBRE 1988

M..

❏ ASSISTERA / WILL ATTEND
❏ N'ASSISTERA PAS / WILL NOT ATTEND

AU DEFILE

PATRICK KELLY
ETE 89

a selection of Kelly's designs from his Fall/Winter 1989–1990 collection, narrated by Hope and Brooke Shields.

The Kelly boutique at Bergdorf Goodman sells $20,000 worth of merchandise on its opening weekend. Kelly appears at the boutique; it is his first appearance there since the store showed his collection five years previously.

Announces plan to launch a Patrick Kelly Loves You line aimed at the bridge market.

Mary Ann Wheaton resigns as president of Patrick Kelly Inc. over a disagreement with Warnaco about outside licensing arrangements.

Listed as one of the sponsors of the Voguing for AIDS "Love Ball" benefit at held at New York's Roseland Ballroom.

Carrie Donovan's June 4 *New York Times* review, in which she asserts that Kelly "seems to be moving nowhere," deeply upsets Kelly.

July: Presents Mock-Couture collection at 6 Rue du Parc Royal during the Fall/Winter 1989–1990 haute-couture showings. The small collection, called Platine, marks a plan for a full-fledged entry into haute couture. It features a jungle theme, with leopard-spotted chiffon dresses, metallic brocades, and black-and-white plaid pants. Grace Jones purchases "What's New, Pussycat?" platinum stretch minidress decorated

with cat masks. To ensure the line's exclusivity, Kelly will produce no more than three examples of each style.

Admitted to a hospital in Paris on August 23.

Architectural Digest features Michael Gross's article on Kelly and Amelan's Paris home in its September issue.

Bette Davis dies on October 6. She is buried in a Patrick Kelly dress.

Kelly's designs are included in San Francisco's Rock Against AIDS benefit performance at Pier 3.

Warnaco announces that Kelly's Spring/Summer 1990 ready-to-wear collection is canceled due to his illness. They note that prior to Kelly's affiliation with Warnaco, Patrick Kelly Paris reached $900,000 in sales but never turned a profit; under Warnaco the line had grown substantially in sales but was still not profitable due to start-up costs; Warnaco expected the line to turn a profit in 1990.

Warnaco breaks their contract with Kelly for non-performance.

The Los Angeles NAACP honors eight "Great Black Fashion Designers," including Kelly in a charity fashion show.

1990
Kelly succumbs to AIDS-related complications on January 1. According to his wishes, he is buried at Père Lachaise Cemetery. His tombstone includes his signature golliwog and a button heart. It reads:
Patrick Kelly
24.9.19??–1.1.1990
Nothing is impossible
The question marks respect Kelly's wish to keep the exact year of his birth a secret. A memorial service is held at the American Church in Paris.

3iéme Nuit de la Mode pays homage to Kelly with a presentation of fourteen looks.

Arles International Photography Festival (Les Rencontres d'Arles) and *Camera International* magazine 26 pay homage to Kelly; Dominique Issermann's article in *Camera International* 26 features photos of Kelly by Horst P. Horst, Annie Leibovitz, Pierre et Gilles, and William Klein.

Memorial service for Kelly is held at the Fashion Institute of Technology in New York; it is attended by more than five hundred people. Audrey Smaltz, Gloria Steinem, Rudy Townsel, and Toukie A. Smith lead the eulogies.

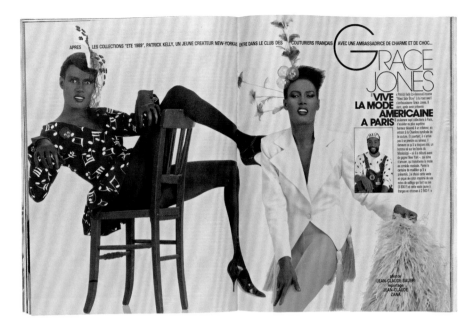

63. Grace Jones wearing Patrick Kelly Paris, *Paris Match*, November 10, 1988

64. Patrick Kelly's atelier in the Marais district of Paris, *Architectural Digest*, September 1989

65. Madonna wearing Patrick Kelly Paris, photographed by Patrick Demarchelier, from "Madonna Holds Court," *Vogue*, May 1989

REMEMBERING PATRICK KELLY

INTERVIEWS CONDUCTED AND COMPILED BY
LAURA L. CAMERLENGO

Patrick Kelly fostered communities of loving friends and talented colleagues and collaborators throughout his life. Between 2012 and 2014, many individuals who once knew Kelly, including childhood friends; former staffers; fashion models and muses; authors, writers, editors, and journalists; photographers; media personalities; fashion, runway, and set designers; and many loved ones, shared memories of their time with the artist, fondly remembering Kelly for his natural intellect, innate creativity, ebullient personality, and generous spirit. This selection of oral histories, drawn from those interviews and edited, form a timeline of personal narratives that poignantly frame Kelly's life and legacy.

Cheryl Ann Wadlington,
style director, Evoluer Image Consultants

"I met Patrick in the mid-1970s. I was in Atlanta in Bauder College. . . . I met Patrick with a group of my girlfriends. We were super dressed up in avant-garde attire— I mean really extreme, blue eye shadow up to our hairlines—and Patrick had his group of fashion people. When you see your own kind somewhere, something instantly connects. We were friends for life. . . . He loved adornment and embellishments even then. He always had lots of jeweled cords, belts, and piles of beautiful brocaded and metallic fabrics on hand. . . . We played dress-up nearly every day at my apartment or his place. My roommate and I were his muses. One of our fun pastimes was Patrick dressing us up to go to the popular dance clubs. Patrick would style us to the hilt to be the stars of the nightclub scene. He dressed us in Marilyn Monroe-style dresses. And lots of Egypt[ian]-and Arabian-inspired kooky-cool outfits. We were the red carpet before it became a big deal. No one could outdo the way Patrick dressed us.

"After Atlanta we stayed connected. We were both in the fashion industry. If you are in that industry and not wealthy, you have to keep your alliances. . . . I went to New York when he went. I went to the Fashion Institute of Technology and he went to Parsons.

"He was in the South at a time when it was so tumultuous. Blacks were being beaten, being lynched. . . . Black men were perceived as threats and were subjected to violence. Those are Patrick's roots growing up. He would mention his mom, his sister, his grandmother Mrs. Rainey, and they influenced his aesthetic with his buttons and golliwog images. Those come from life in the South. The patchwork dresses—those referenced what he saw his grandmother do. He grew up in the Delta of Mississippi. He was with churchgoing women. These women were aware of hand-me-downs, of scraps—and aware of how to use hand-me-downs and fabric remnants to create 'Sunday best' outfits for themselves, family, and friends. Many of them worked for whites, and they would take their hand-me-downs from them and make them into other things.

"It was part of the aesthetic and part of the Black experience in America. It dates all the way back to slavery. He was very inspired by American slavery in his dress. He grew up with the idea of 'Sunday best'—that comes from his heritage. That was something that dated back to the era of American slavery to present. And he was unapologetic about his background. His culture and identity—being a gay Black man from the Bible Belt meant everything to him.

66. A spontaneous photograph of Patrick Kelly, his models, and local children at a sandbox near the Patrick Kelly Paris showroom on the Rue du Parc Royal, 1988

67. Pat Cleveland in a Patrick Kelly–designed Josephine Baker ensemble, ca. 1978

"I remember Patrick showing his designs at different galas—at the Congressional Black Caucus fashion show—and the women there did not want to face a few of his designs, and they hated Patrick's golliwog logo on his shopping bags and the Black baby-doll pin. To add that much culture to his collections—with the watermelons hat, the mismatched buttons, for example—these very ethnic inspirations from his life and the women he grew up around and loved. He lived them. Patrick's style point of view was revolutionary, like no other designer of his time. He designed clothes that did not solely appeal to a mainstream customer base. He kept the soul in his aesthetic and maintained an unapologetic, culturally relevant and connected, design point of view."

Pat Cleveland,
superstar

"You know there was no internet back then. If you knew anyone, you knew them through someone else. A hairdresser friend [Rudy Townsel] had called and asked if I would like to meet his friend Patrick Kelly. 'He's a young designer from Georgia and makes beautiful clothes,' he said. So I invited them to come over. Patrick was this sweet, shy guy, so cute and nice. Patrick cheered me up and asked if I'd like to go have some fun. He just so happened to have brought with him a banana skirt made with plastic bananas on it, a modern version of the one Josephine Baker wore in Paris. He knew I loved Josephine Baker, he loved Josephine too. At Columbus Circle [in New York], before they built the Time Warner building, they used to have hairdressing shows there. So I put on the costume Patrick made for me—the banana skirt with the little top made of paper water cups covered in sequins. I felt like Josephine myself; Patrick and I were channeling her for sure. I ended up that night having a ball with Patrick, pretending to be Josephine.

"I even sang onstage 'La Petite Tonkinoise' wearing that costume at that hairdressing show. Our number was a hit with the audience. After that evening Patrick and I became friends. We sometimes talked on the phone about what he was making for ladies to wear, and we would brainstorm for fun about 'Buttons and Bows,' which was one of our songs. One time Patrick called and told me he was heading back to Georgia—he said fashion life in New

York was not working for him, there were no open doors. I was shocked and a little angry; he was so talented and he was so dedicated, and deserved a chance. 'Patrick,' I said, 'You have to go to Paris. It's where you belong.' He didn't have money to buy a ticket, so I said, 'Don't worry, I'll get you the ticket, pack up, you're going.' So I got a first-class ticket for him and within that very week he got his passport and he went to Paris. . . . He stuck to his word—he worked with his talents and integrity to make his dreams come true. . . . People helped me, I thought—that's why I gave him the ticket—so why not help each other make our dreams come true? We just need one person to believe in us, and Patrick kept that dream alive for many more years to come. He was such a giving person. This was in 1978, 1979."

68. Profile of Patrick Kelly by Carol Mongo, *Accent*, Spring/Summer 1987, no. 2

Mel West,
adjunct professor, footwear design, Parsons School of Design, The New School; former footwear and accessories designer for Givenchy S.A.

"I met Patrick Kelly in New York in about 1977 or 1978. I was in advertising at the time and met Patrick in the city's clubs I didn't know he was in fashion at the time. We would just go out to the clubs, Paradise Garage, places like that. . . . I wanted to design shoes, so I decided to move to Europe. Patrick and I moved to Paris the same week, unknown to either of us. . . . It must have been 1979 or 1980. I was walking along Saint Germain when I saw Patrick. It was like, 'Oh my God! What are you doing here?' We both agreed that we couldn't get off the ground in the United States. Paris at the time was like being back in 1925—a Josephine Baker revival. Blacks had a second chance there.

"Patrick had nothing when he got to Paris. . . . He was starting his own thing. He called me one day because he was moving to the Rue des Saints-Pères and asked if I could help him. . . . It was this one-room apartment in a very expensive area of Paris; how would he survive? I asked him that. He said that he was going to put his clothes on girls and put them on Saint Germain, and he wanted to be close by to watch them. Pat Cleveland, Toukie Smith were among the models who wore his clothes. People would ask who made them, and the models would say, 'Patrick Kelly. He's new in town.' Patrick was fascinating and brilliant. He stuck to his guns, and he persevered. I never saw anything like it."

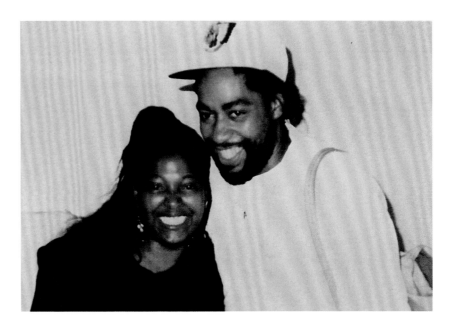

69. Elizabeth "Ms. Liz" Goodrum and Patrick Kelly at his initial fashion show in his first studio, located at 17 Rue du Mail, Paris, 1985

Carol Mongo,
former fashion-design department head and former director of Parsons Paris

"I met Patrick Kelly about six months after he had arrived in Paris, the end of 1979 I think it was through the model Kathy Belmont. She was a successful runway model, and I met her walking along the Champs-Elysées. She just came over to me and introduced herself. Kathy and Patrick were tight. Patrick was really good at finding out who was who in Paris and meeting them.

"Before he launched his label, he would make groups of clothes. Patrick would buy cheap fabrics from the Marché Saint-Pierre. He would get on his hands and knees on the floor and cut out shapes and make you a garbage bag full of clothes. . . . He did a lot of fashion shows before he launched his label that were just over-the-top—great big hats, furs to the floor, really spectacular.

"He didn't know much about pattern adapting. Elizabeth Goodrum had worked on Seventh Avenue in New York and really helped him with pattern drafting. He had a funny way of doing things. In his early days, when he would make custom clothes, he would show you a million different ways the garment could be worn or styled as he was working with it. He had excellent sewing skills—hand sewing—[and] made that work for him."

Elizabeth "Ms. Liz" Goodrum,
designer

"I met Patrick while working on a show for Théâtre Le Palace under the direction of Larry Vickers. This was in 1981, 1982. Patrick had been hired as the production's costume designer, but [he] did not produce any costumes after about a week of work. Mr. Vickers brought me on to work with him and help move him along.

70. Sharon "Magic" Jordan-Roach modeling Patrick Kelly's collections, ca. 1986

. . . While working together, he told me that he wanted to be a big designer, but if I hit it big first, he would work for me, and if he became a success, I would work for him. The rest is history. . . . [At Patrick Kelly Inc.] I was his 'right hand,' researching collections as well as sourcing raw materials, like fabrics, and finding talent to help execute Patrick's ideas. . . . Many of these ideas were personal to him, but he also studied *Vogue* and other fashion magazines, making sure he knew who all of the key players were and what other designers and design houses were producing. He wanted to make a

statement by taking these established designer's works and re-creating them to show that he was just as good, if not better, than them."

Sharon "Magic" Jordan-Roach,
model and Patrick Kelly fit model and muse

"I met Patrick in Atlanta. I was in fashion school at that time; it had to be about 1978, 1979. . . . Patrick was a local designer there and a window dresser for great stores. I modeled for a brother design team [CB2 by Charles and Carl Bogen] who were his rivals. I met Patrick

at a bus stop in Atlanta, and he invited me to do one of his shows. We became friends. . . . He was a very energetic guy. He never met a stranger; he could talk to anyone. He had an uncanny sense of humor, very funny. He had a special thing for models; he knew how to walk, how to do makeup, everything. We worked very closely once his label launched; we were like brother and sister.

"He lived on St. Germain in Paris. It [Kelly's apartment] was like the model hangout. There would be fried chicken and potato salad, and he hooked us into Paris nightlife. We would go to Le Palace, the clubs, always in Patrick Kelly clothes And he was in his overalls! If it was a black-tie occasion, he would put a black jacket over his overalls.

"He was a real night, night, night owl. I didn't see him much in the day when I was around. He worked at night. He would keep us up all night with him. Before the show we would be trying on every single piece of clothing. He wanted to see how everything looked before rehearsal the next day. Everyone would be exhausted. It would be two a.m. or three a.m. and he would be like, 'I need Iman here now!' We didn't really talk then. When we were working his mind-set was different, but he was always upbeat, a lot of humor, and just a fun guy. He was really detailed. Now I understand that his mind was always going all of the time.

"His runway shows had the best vignettes ever. He would set it up so people could understand the story. There would be music to match. . . . Like the space show— he had the girls come out with these big Lucite domes on their heads. Then

71. Patrick Kelly and Audrey Smaltz at the Fashion Group International Gala, Waldorf Astoria, New York, 1988

they moved them to their shoulders; the showing was very strategic. No one showed like that! All of the models were great. They could walk really great. . . . Each set of girls would come out and do their thing. We would come out in groups to overwhelm everyone in the audience. It was so wonderful."

Audrey Smaltz,
fashion-show producer and Patrick Kelly
runway-show coordinator

"I served as the commentator for the Ebony Fashion Fair and Show from 1970 until 1977. I met Patrick backstage after my first show in Atlanta in 1970. Published reports say that Patrick was about twelve years old when he met me, but he was probably about eighteen years old at the time. He had an infectious personality and was incredibly talented, even when he was very young.

"I came to know Patrick well in 1980. At the time, I was in business for myself as a fashion-show producer and was coordinating a show at Lincoln Center [in New York]. An array of designers had donated outfits to the show, and I hired

Patrick to style their clothes. He did a marvelous job styling an outfit lent by Bill Blass in particular. I said to myself, 'This boy is so talented.'

"[When I worked with Patrick as his fashion-show coordinator] Patrick would cast the models and pick the outfits for each model. As he would pick the outfits and put them in order, it was my job to say, 'Well, the girl in outfit number one can't be in outfit number four.' Patrick would send the girls out in groups, so that just wasn't possible. Patrick could be very stubborn but he listened to me. We devised a system of an A-team and a B-team. No team was better than the other, but this system of teams would allow us to rotate the models in groups on the runway. It gave Patrick a system to use. We usually had about thirteen looks per team. There was a French guy who would stay in the front of the runway with headphones, and I would be in the back, also with headphones, sending models out. He spoke enough English and I spoke enough French that we could make sure everything went smoothly.

"You worked 24/7 with Patrick leading up to a show, because he would often change his mind. He would often want things to be his way, but he would listen to me because he knew that I was right and that things wouldn't work in the way he had hoped. . . . The girls [models] loved doing the shows and did it for free. Nobody got paid. Sometimes people got clothes and buttons. I always got two dozen of the most beautiful red roses and a bottle of Cristal champagne from Patrick. I never had Cristal champagne before that! I really loved working for him and didn't mind working all night. It was a joy."

72. Mary Ann Wheaton and Patrick Kelly at the designer's Fall/Winter 1988–1989 show

Mary Ann Wheaton,
former CEO and president, Patrick Kelly Inc.

"In 1987, I was working for Bidermann Industries in New York, managing their fashion licenses. Patrick was desperate for a backer for his company. . . . Later that year, Patrick met Gloria Steinem, who introduced him to Linda Wachner of Warnaco. I gave Patrick tips for his meeting with Linda. Linda met with Patrick and was willing to sign him, but she did not specialize in European couture. She stipulated that she would back Patrick only if I came on board as the company's president. . . . So I became the CEO and president of Patrick Kelly Inc.

"It was my first foray into launching an unknown designer. . . . Patrick had a clear vision of what he wanted to do. For example, it was Patrick's idea to put six models in his ad campaigns. He was averse to showing any one model in the advertisements. He wanted them spread out, looking wild and having fun. The advertisements were picked up by tons of press outlets—even though the company did not have a marketing budget—because their look was so fresh and different. It was ingenious of him.

"The same was true of Patrick's runway shows. They cost about $100,000 to produce when most designer's shows cost $500,000. He always got incredible press, because the shows were held in interesting locations and were always very lively. . . . The press loved the idea of the 'American in Paris'—coming out of

the tradition of people like Josephine Baker. . . . Patrick marketed himself and his designs in a new way.

"As the company's CEO, it was my challenge not just to launch the Patrick Kelly label in one market, but globally. I had to do it in a way that would not take the label away from Patrick. He had very close relationships with his assistants, and the house had its own way of operating that was generated by him and his energy. He was a creative, artistic person, as were the members of his team, and I had to make them fit into this major corporation. I told Warnaco early on that they couldn't touch the small stuff—the things that made Patrick's house unique—and that everything, from the atelier to the production, had to remain in France because the label was 'Patrick Kelly Paris.'

"When I first started working for Patrick, I wanted to wear his clothing head to toe, as I had traditionally done for other designers I represented. But, as I told Patrick, he only designed dresses when he first started and did not offer designs that women could wear to the office. I asked him to try his hand at suits and he did, creating fun, flirty suits that became the brand's biggest sellers, along with coats. No one else at the time was designing suits in Patrick's style. By his second season of designing coats and suits, these designs were leading the way. Like many things for Patrick, the suits and coats were in the right place, at the right time, and had a bit of

73. House model Janet Chandler and Patrick Kelly, photographed by Gilles Decamps, 1989

rebellion in them, which people really liked. . . . In stores, I demanded that Patrick's designs be on the same floor as other European designers; his clothes sold out quickly because they were so much less expensive than designs by his peers.

"Patrick really wanted to learn all aspects of managing his company, and really wanted to understand the financial side of his business. He learned very quickly; he had the fastest brain on the planet."

Gilles Decamps,
photographer

"In late 1988 or early 1989, Iman was a guest fashion editor for *Ebony* magazine. We were friends at the time, and she invited me to shoot a story on Patrick Kelly. That was my first real introduction to Patrick. . . . We shot at Patrick's studio on Rue du Parc Royal in Paris with Janet Chandler until about three in the morning. He was an incredible human

being—his energy and creativity were infectious. This shoot led to friendship, him imposing me [on] *Time* magazine to shoot his portrait, and ultimately to our last shoot with Grace Jones, [of] which photographs were published only long after his death.

"The most amazing thing Patrick taught me was at his funeral. In France, when people die, you go to the church, the temple, and you weep. It's a sad occasion. It's not fun at all. When Patrick passed there was a ceremony in the American cathedral on the Left Bank in Paris. . . . The cathedral was packed. I was shocked—I had never experienced an American, nor African American, let alone Southern service. For the uneducated French [person] that I was, this was a place and occasion where people were supposed to be crying, and here they were clapping and laughing and sharing stories celebrating Patrick. This was a culture shock for me. I never experienced that before. On that day, I guess Patrick made me see the death of a loved one in a different way, a better way.

"He is buried in the Père Lachaise Cemetery, where the most famous French people are buried—and Jim Morrison! Patrick loved Paris and was embraced by Paris in return. Where he was put to rest was a long way from where he came from."

Bjorn Guil Amelan,
former business and life partner of
Patrick Kelly
In conversation with Dilys E. Blum, Monica E. Brown, Laura L. Camerlengo, and Debra Sitner; interview condensed by Laura L. Camerlengo

"I think Patrick was painfully branded by his youth in Mississippi and all forms of categorization; as a result, he had a visceral rejection to [categorization]. . . . For him, the worst thing I could tell him was, 'Oh, it's four o'clock in the morning, we have to leave the showroom because we have a nine a.m. appointment.' He would get very upset if I said that, because he said, 'If I know what time it is and how little sleep I shall get, I will be tired tomorrow. If I don't know it, I won't be tired.' His attitude was the same with age: 'If I know that I'm fifty I'll be uncomfortable with people of sixteen; if I know I'm sixteen I'll be uncomfortable with people who are sixty.' So he refused any form of categorization.

"At the time, I was unaware of the politics—the social politics of America. . . . Patrick's birthday was September 24. Nineteen eighty-three was the first birthday of his that we were together. I went to the flea market and found a 'cute'—that's how I thought it [but] in retrospect an outrageous—artifact of Black memorabilia, which was one of those porcelain ashtrays [of blackface]. Unbeknownst to me, or without any other thought than the cuteness of the object, I bought it as a birthday gift for Patrick. Patrick was smart enough to understand that I was in no way doing that [with a] motive [connected] to the object's origin—and he decreed, 'Oh, we're going to start collecting Black memorabilia.' [Black memorabilia] was something I didn't even know of at the time. He didn't explain to me what might have been offensive about it. . . . We started collecting Black memorabilia enthusiastically and made a very large collection of hundreds of pieces, from the kitschy to the relatively rare. Patrick later decided to use the memorabilia as inspiration for his collection.

"I think a burden was taken away for him when he was in Paris. And I think his not learning to speak French for a long time had to do with his conscious desire to isolate himself from what may be said. He only learned French really in order to be able to collaborate . . . with Rachida Abou El Wafa Afroukh, who became the head of the atelier.

"Patrick used to say that however much he loved—and he really loved—French couture, the Saint Laurent and the Madame Grès and so on of the world, there was more fashion to be seen in one pew on a Sunday in the church in Mississippi than there was in any of those fashion shows of the grande dames of Paris."

74. Bjorn Guil Amelan and Patrick Kelly attending a fashion show, ca. 1989

SELECTED BIBLIOGRAPHY

Abad, Mario. "250 Black Creatives Push for Change in Fashion." *Paper*, June 15, 2020.

"All Decked Out, Ready to Shine." *Sunday Capital*, October 2, 1988, E4.

Amelan, Bjorn Guil. Patrick Kelly collection of personal belongings, memorabilia, and ephemera.

Archer-Straw, Perrine. *Negrophilia: Avant-Garde Paris and Black Culture in the 1920s*. New York: Thames & Hudson, 2000.

Baker, Stacey Menzel, Carol M. Motley, and Geraldine R. Henderson. "From Despicable to Collectible: The Evolution of Collective Memories for and the Value of Black Advertising Memorabilia." *Journal of Advertising* 33, no. 3 (Fall 2004): 37–50.

Barnes, Sequoia. "'If You Don't Bring No Grits, Don't Come': Critiquing a Critique of Patrick Kelly, Golliwogs, and Camp as a Technique of Black Queer Expression." *Open Cultural Studies* 1, no. 1 (2017), https://www.degruyter.com/document/doi/10.1515/culture-2017-0062/html.

——. "Patrick Kelly's 'Mississippi Lisa': Subverting Racial Kitsch with a T-Shirt." *Kalfou: A Journal of Comparative and Relational Ethnic Studies* 7, no. 1 (November 2020), https://tupjournals.temple.edu/index.php/kalfou/article/view/304.

Bay, Mia, and Ann Fabian, eds. *Race and Retail: Consumption across the Color Line*. New Brunswick, NJ: Rutgers University Press, 2015.

Bernstein, Robin. *Racial Innocence: Performing American Childhood from Slavery to Civil Rights*. New York: New York University Press, 2011.

Bhabha, Homi. "Of Mimicry and Man: The Ambivalence of Colonial Discourse." *October* 28 (Spring 1984): 125–133.

Bivins, Joy L., and Rosemary K. Adams. *Inspiring Beauty: 50 Years of Ebony Fashion Fair*. Chicago: Chicago Historical Society, 2013.

Bowles, Hamish. "Queering Culture." October 30, 2020, in *In Vogue: The 1990s*, podcast, https://open.spotify.com/episode/2KEljNspvwgkNCCrkLm9rd?si=bO1Eyt92QlWvoWYrDEOhgA.

Braun, Annette, and Francine Vormese. *Mickaël Kra: Jewellery between Paris Glamour and African Tradition*. Stuttgart: Arnoldsche, 2006.

Byrd, Rikki. "Easter Sunday Is Peak Black Church Fashion: An Appreciation." *Zora*, April 10, 2020, https://zora.medium.com/easter-sunday-is-peak-black-churchfashion-an-appreciation-de84ef2a12cf?gi=sd.

Cabral, Angelica. "Antique Dealers See Controversial African-American Memorabilia as Part of History." *Cronkite News*, October 23, 2017.

Cameron, Alexandra Cunningham, ed. *Willi Smith: Street Couture*. New York: Cooper Hewitt, Smithsonian Design Museum/Rizzoli Electa, 2020.

Campbell, Jason, and Henrietta Gallina. "Op-Ed: Fashion Is Part of the Race Problem." *Business of Fashion*, June 3, 2020.

Casmier-Paz, Lynn. "Heritage, not Hate? Collecting Black Memorabilia." *Southern Cultures* 9, no. 1 (2003). doi.org/10.1353/scu.2003.0009.

Cleto, Fabio, ed. *Camp: Queer Aesthetics and the Performing Subject; A Reader*. Edinburgh: Edinburgh University Press, 1999.

CNN. Patrick Kelly interview, "Runway Club," *CNN Style*, 1988.

Dallow, Jessica. *Family Legacies: The Art of Betye, Lezley, and Alison Saar*. Chapel Hill, NC: Ackland Art Museum; Seattle: University of Washington Press, 2005.

"Designer Patrick Kelly Dies at 35 in Paris." *San Francisco Chronicle*, January 3, 1990.

Diagne, Souleymane Bachir. "Négritude." *Stanford Encyclopedia of Philosophy*, 2010, updated 2018, https://plato.stanford.edu/entries/negritude/.

Dickel, Simon. *Black/Gay: The Harlem Renaissance, The Protest Era, and Constructions of Black Gay Identity in the 1980s and 90s*. East Lansing: Michigan State University Press, 2011.

Dissly, Meggan. "An American in Paris: The Southern Accent of Designer Patrick Kelly." *Christian Science Monitor*, August 25, 1988.

Donnally, Trish. "Is His Pin the Lawn Jockey of the Fashion World?" *San Francisco Chronicle*, August 10, 1987.

——. "Kelly's Such a Comedian." *San Francisco Chronicle*, September 26, 1988.

——. "Paris Plays It Safe for Fall." *San Francisco Chronicle*, March 20, 1989.

——. "Paris Sizzles in the Spring." *San Francisco Chronicle*, October 21, 1988.

——. "Sexy Shades of the Basics." *San Francisco Chronicle*, May 4, 1989.

——. "Winking at Couture: Patrick Kelly's High-Fashion High Jinks." *San Francisco Chronicle*, July 29, 1988.

Drummond, Tammerlin. "Adieu, Utopia: Paris Seemed a Refuge from Bias to African-Americans. Now Rising Ethnic Tensions Threaten the Myth." *Los Angeles Times*, March 22, 1993.

Evans, Caroline. *The Mechanical Smile: Modernism and the First Fashion Shows in France and America, 1900–1929*. New Haven, CT: Yale University Press, 2013.

Fabre, Michel. *From Harlem to Paris: Black American Writers in France, 1840–1980*. Urbana: University of Illinois Press, 1991.

Fashion and Race Database, fashionandrace.org.

Fernandez, Chantal. "Black Professionals Petition CFDA Over 'Hasty Attempt' to Counter Racism." *Business of Fashion*, June 15, 2020.

Fleetwood, Nicole R. *Troubling Vision: Performance, Visuality, and Blackness*. Chicago: University of Chicago Press, 2011.

Ford, Tanisha C. *Liberated Threads: Black Women, Style, and the Global Politics of Soul*. Chapel Hill: University of North Carolina Press, 2015.

——. "SNCC Women, Denim, and the Politics of Dress." *Journal of Southern History* 79, no. 3 (August 2013): 625–658.

Fouché, Rayvon. "Say It Loud, I'm Black and I'm Proud: African Americans, American Artifactual Culture, and Black Vernacular Technological Creativity." *American Quarterly* 58, no. 3 (2006): 641. doi.org/10.1353/aq.2006.0059.

Gammon, Mitzi. "Dolling for Dollars." *Atlanta Constitution*, March 13, 1988.

Gates, Henry Louis, Jr. "Should Blacks Collect Racist Memorabilia?" PBS, https://www.pbs.org/wnet/african-americans-many-rivers-to-cross/history/should-blacks-collect-racist-memorabilia.

——. *The Signifying Monkey: A Theory of African American Literary Criticism*. New York: Oxford University Press, 1988.

"Getting It Together." *Women's Wear Daily*, October 31, 1988, 16.

Givhan, Robin. "Patrick Kelly's Radical Cheek." *Washington Post*, May 31, 2004.

Goodrum, Elizabeth. Patrick Kelly press archive.

Gross, Michael. "Notes on Fashion." *New York Times*, April 1, 1986.

——. "Patrick Kelly: Exuberant Style Animates the American Designer's Paris Atelier." *Architectural Digest*, September 1989, https://archive.architecturaldigest.com/article/1989/9/patrick-kelly.

Harte, Amadeus. "Becoming a Racialized Subject: The Subjectifying Power of Stereotypes in Popular Visual Culture." *Social & Political Review* XXVI (2016): 74–99.

"Heart Couture: Anatomy of the Latest Trend." *San Francisco Chronicle*, April 29, 1990.

Hine, Darlene Clark. "Rape and the Inner Lives of Black Women in the Middle West: Preliminary Thoughts on the Culture of Dissemblance." *Signs* 24, no. 4 (Summer 1989): 912–920.

Holt, Steven. *Manufractured: The Conspicuous Transformation of Everyday Objects*. San Francisco: Chronicle Books, 2008.

hooks, bell. *We Real Cool: Black Men and Masculinity*. New York: Routledge, 2004.

Hornblower, Margot. "An Original American in Paris: Patrick Kelly." *Time*, April 3, 1989.

Hyde, Nina. "From Pauper to the Prints of Paris." *Washington Post*, November 9, 1986.

Jackson, Lauren Michele. *White Negroes: When Cornrows Were in Vogue . . . and Other Thoughts on Cultural Appropriation*. Boston: Beacon Press, 2019.

Jim Crow Museum of Racist Memorabilia, Ferris State University, Big Rapids, Michigan, https://www.ferris.edu/HTMLS/news/jimcrow/links/collections/carson.htm.

Johnson, Bonnie. "In Paris, His Slinky Dresses Have Made Mississippi-Born Designer Patrick Kelly the New King of Cling." *People*, June 15, 1987.

Johnson, Marilyn. "Fashionata 1988 Will Go Straight for the Heart Strings." *Atlanta Journal-Constitution*, August 28, 1988, https://www.newspapers.com/image/400277188.

Jules-Rosette, Bennetta. *Black Paris: The African Writers' Landscape*. Urbana: University of Illinois Press, 1998.

Keaton, Tricia Danielle, T. Denean Sharpley-Whiting, and Tyler Stovall, eds. *Black France/France Noire: The History and Politics of Blackness*. Durham, NC: Duke University Press, 2012.

Kelly, Patrick, with Dorothy Hanenberg. "Faces and Places in Fashion: Patrick Kelly." Fashion Institute of Technology, New York, April 24, 1989, https://archiveondemand.fitnyc.edu/items/show/1410.

Kern-Foxworth, Marilyn. *Aunt Jemima, Uncle Ben, and Rastus: Blacks in Advertising, Yesterday, Today, and Tomorrow*. Westport, CT: Praeger, 1994.

Keyes, Allison. "Collecting Our History: How Black Memorabilia Shapes the Present through the Past." *The Root*, November 28, 2016.

Kliest, Nicole. "Patrick Kelly Dressed Everyone from Princess Diana to Grace Jones—and His Work Is Still Relevant Today." *Fashionista.com*, February 28, 2020.

Komar, Marien. "What the Civil Rights Movement Has to Do with Denim." *Racked*, October 30, 2017.

Kuznets, Lois Rostow. *When Toys Come Alive: Narratives of Animation, Metamorphosis, and Development*. New Haven, CT: Yale University Press, 1994.

Lewis, Van Dyk, and Keith A. Fraley. "Patrick Kelly: Fashion's Great Black Hope." *Fashion, Style & Popular Culture* 2, no. 3 (2015): 333–350.

Livingstone, David. "Reasonable Approach to Prices." *Globe and Mail*, January 7, 1986.

Lott, Eric. *Love & Theft: Blackface Minstrelsy and the American Working Class*. 2nd ed. Oxford: Oxford University Press, 2013.

Mahder, William, ed. *Paris Arts on Seine*. Paris: Editions Autrement, 1985.

Mandell, Hinda, ed. *Crafting Dissent: Handicraft as Protest from the American Revolution to the Pussyhats*. Lanham, MD: Rowman & Littlefield, 2019.

Manring, M. M. *Slave in a Box: The Strange Career of Aunt Jemima*. Charlottesville: University of Virginia Press, 1998.

Martin, Anthony. "Toys with Professions: Racialized Black Dolls, 1850–1940." *Journal of African Diaspora Archaeology and Heritage* 3, no. 2 (November 2014): 137–158.

McCollom, Michael. *The Way We Wore: Black Style Then*. New York: Glitterati, 2006.

McElya, Micki. *Clinging to Mammy: The Faithful Slave in Twentieth-Century America*. Cambridge: Harvard University Press, 2007.

McManus, Kevin. "Collections from a Painful Past." *Washington Post*, February 1, 1991.

Meyer, Moe, ed. *The Politics and Poetics of Camp*. London: Routledge, 1994.

Miller, Monica L. *Slaves to Fashion: Black Dandyism and the Styling of Black Diasporic Identity*. Durham, NC: Duke University Press, 2009.

moore, madison. *Fabulous: The Rise of the Beautiful Eccentric*. New Haven, CT: Yale University Press, 2018.

Morrison, Toni. "A Knowing So Deep." *Essence*, May 1985, 230.

———. "Rediscovering Black History." *New York Times*, August 11, 1974.

Motley, Carol M., Geraldine R. Henderson, and Stacey Menzel Baker. "Exploring Collective Memories Associated with African-American Advertising Memorabilia." *Journal of Advertising* 32, no. 1 (Spring 2003): 47–57.

Muñoz, José Esteban. *Disidentifications: Queers of Color and the Performance of Politics*. Minneapolis: University of Minnesota Press, 1999.

Murray, Derek Conrad. "Mickalene Thomas: Afro-Kitsch and the Queering of Blackness." *American Art* 28, no. 1 (Spring 2014): 9–15.

———. *Queering Post-Black Art: Artists Transforming African-American Identity After Civil Rights*. London: I.B. Tauris, 2016.

Naer, Danielle. "The Kelly Initiative Is Demanding Accountability and Equity in the Fashion Industry." *The Zoe Report*, June 24, 2020.

Nelson, Stanley. *Devils Walking: Klan Murders along the Mississippi in the 1960s*. Baton Rouge: Louisiana State University Press, 2016.

Nicols, Alice. *Hot Stuff: Disco and the Remaking of American Culture*. New York: W.W. Norton & Company, 2010.

Nunno, George. Christopher Hill sketchbooks.

Nyong'o, Tavia. "Racial Kitsch and Black Performance." *Yale Journal of Criticism* 15, no. 2 (Fall 2002): 371–391.

O'Neal, Alexander. "Fake." 1986, track 8 on *Hearsay*, Tabu, 1987, compact disc.

Palmer, Gladys Perint. "The Big Hype." *San Francisco Chronicle*, October 30, 1988.

———. "Finishing Touches for the Woman Who'll Wear Anything." *San Francisco Chronicle*, December 13, 1987.

———. "Wild Things." *San Francisco Chronicle*, July 23, 1989.

"Paris Splits into 2 Camps." *Women's Wear Daily*, July 31, 1986.

"Patrick Kelly." *Amis et Passionés du Père-Lachaise*, June 12, 2013.

"Patrick Kelly: A Retrospective." Brooklyn Museum, 2004, curated by Thelma Golden, https://web.archive.org/web/20160821035300/https://www.brooklynmuseum.org/opencollection/exhibitions/626.

Patrick Kelly archive, Costume and Textiles department, Philadelphia Museum of Art.

Patrick Kelly archive, 1980–1994, Sc MG 631, Schomburg Center for Research in Black Culture, Manuscripts, Archives and Rare Books Division, The New York Public Library.

Patrick Kelly collection of audio-visual recordings, Schomburg Center for Research in Black Culture, Moving Image and Recorded Sound Division, The New York Public Library.

"Patrick Kelly's Fashion Line to Live on After All." *San Francisco Chronicle*, March 30, 1990.

"Patrick Kelly's Love List." Philadelphia Museum of Art: Exhibitions, 2014, accessed January 4, 2021. https://www.philamuseum.org/exhibitions/799.html?page=3.

Petrarca, Emilia. "A Major New Initiative to Fight Systemic Racism in Fashion." *The Cut*, June 17, 2020.

Phelgyal, Jangchup. "Aunt Jemima, a Sambo, and a Tube of 'Darkie' Toothpaste: The Black Memory Market." *San Diego Reader*, May 9, 2002.

Phelps, Emilia. "The Kelly Initiative Is a Fashion Industry Call to Action against Systemic Racism." *Vogue.com*, June 18, 2020, https://www.vogue.com/article/kelly-initiative-call-to-action-against-systemic-racism.

Picardi, Phillip. "An Oral History of Fashion's Response to the AIDS Epidemic." *Vogue*, accessed December 17, 2020, https://www.vogue.com/aids-epidemic-oral-history.

Pieterse, Jan Nederveen. *White on Black: Images of Africa and Blacks in Western Popular Culture*. New Haven, CT: Yale University Press, 1992.

Pritchard, Eric Darnell. "Black Supernovas: Black Gay Designers as Critical Resource for Contemporary Black Fashion Studies." *International Journal of Fashion Studies* 4, no. 1 (2017): 107–110.

——. "Overalls: On Identity and Aspiration from Patrick Kelly's Fashion to Hip Hop." *The Funambulist* 15 (January–February 2018): 32–37.

Program of the James Kirk Bernard Foundation. "Ken Kendrick." *POBA: A Program of the James Kirk Bernard Foundation*, accessed March 9, 2021, https://poba.org/poba_artists/ken-kendrick/.

Reed, Julia. "Talking Fashion: Patrick Kelly." *Vogue*, September 1989.

Renée, Rashida. "The Legacy of Patrick Kelly." *Office*, March 10, 2019.

Reynolds, Marcellas. *Supreme Models: Iconic Black Women Who Revolutionized Fashion*. New York: Abrams, 2019.

Robertson, Pamela. "Mae West's Maids: Race, 'Authenticity,' and the Discourse of Camp." In *Camp: Queer Aesthetics and the Performing Subject; A Reader*, edited by Fabio Cleto. Ann Arbor: University of Michigan Press, 2002.

Rush, Erik. *Negrophilia: From Slave Block to Pedestal–America's Racial Obsession*. Washington, D.C.: WND Books, 2010.

Saar, Betye. *Call and Response*. Los Angeles: Los Angeles County Museum of Art; Munich: DelMonico Books, Prestel, 2019.

Sargent, Antwaun. "Patrick Kelly Was the Jackie Robinson of High Fashion." *Vice*, September 25, 2017.

Segran, Elizabeth. "Rediscovering Patrick Kelly, the Designer Who Made Blackface His Brand." *Fast Company*, February 13, 2019.

Sermak, Kathryn, with Danielle Morton. "Cool Couple: Bette Davis and Designer Patrick Kelly Made Oddly Perfect Pals." *Daily Beast*, September 17, 2017.

Sessums, Kevin. "Pat Cleveland Remembers Patrick Kelly." *Sessums Magazine*, February 1, 2019, https://sessumsmagazine.com/2019/02/01/pat-cleveland-remembers-patrick-kelly/.

Sharpley-Whiting, T. Denean. *Black Venus: Sexualized Savages, Primal Fears, and Primitive Narratives in French*. Durham, NC: Duke University Press, 1999.

Shaw, Madelyn. "Slave Cloth and Clothing Slaves: Craftsmanship, Commerce, and Industry." *Journal of Early Southern Decorative Arts*, 33 (2012), https://www.mesdajournal.org/2012/slave-cloth-clothing-slaves-craftsmanship-commerce-industry/.

Shilts, Randy. *And the Band Played On: Politics, People, and the AIDS Epidemic*. New York: St. Martin's Griffin, 1988.

Shirley, Thelma H. *Success Guide to Exciting Fashion Shows*. Chicago: Fashion Imprints, 1978.

Shohat, Ella. "The Specter of the Blackamoor." *The Comparatist* 42 (October 2018): 158–188.

Silva, Horacio. "Delta Force." *New York Times Magazine*, February 22, 2004.

Singh, Rajat. "Fashion Flashback: Patrick Kelly." Council of Fashion Designers of America, February 24, 2017, cfda.com.

Smedley, Audrey, and Brian D. Smedley. *Race in North America: Origin and Evolution of a Worldview*. New York: Routledge, 2012.

Sojourner, Sue [Lorenzi], with Cheryl Reitan. *Thunder of Freedom: Black Leadership and the Transformation of 1960s Mississippi*. Lexington: University Press of Kentucky, 2013.

Sontag, Susan. *Notes on Camp*. London: Penguin Books Limited, 2018 [1964].

Sorman, Guy. "Black Lives Matter in Paris: An American Movement in France/Black Lives Matter à Paris: la France à l'heure américaine." *France-Amérique*, September 10, 2020, 12–14.

Stanfill, Sonnet, ed. *80s Fashion: From Club to Catwalk*. London: V&A Publishing, 2013.

Stovall, Tyler Edward. *Paris Noir: African Americans in the City of Light*. Boston: Houghton Mifflin, 1996.

Sulmers, Claire. "Black History Month on Fashion Bomb Daily: Designer Patrick Kelly." *Fashion Bomb Daily*, February 9, 2019.

Summers, Barbara. *Skin Deep: Inside the World of Black Fashion Models*. New York: Amistad, 1998.

Strings, Sabrina. *Fearing the Black Body: The Racial Origins of Fat Phobia*. New York: New York University Press, 2019.

Talley, André Leon. *A.L.T. 365+*. New York: Powerhouse Books, 2005.

Tulloch, Carol, ed. *Black Style*. London: V&A Publishing, 2004.

Van Deburg, William L. *Black Camelot: African-American Culture Heroes in Their Times, 1960–1980*. Chicago: University of Chicago Press, 1997.

Washington, Zoey. "The History of Denim and Black Activism: America's Uncredited Fashion Revolution." *The Zoe Report*, August 10, 2020.

White, Renée Minus. "Patrick Kelly's Spring '84 Fashions." *New York Amsterdam News*, April 21, 1984.

Williams, Lena. "Black Memorabilia: The Pride and the Pain." *New York Times*, December 8, 1988.

ACKNOWLEDGMENTS

Laura L. Camerlengo, associate curator of costume and textile arts, Fine Arts Museums of San Francisco

Dilys E. Blum, the Jack M. and Annette Y. Friedland Senior Curator of Costume and Textiles, Philadelphia Museum of Art

This catalogue, *Patrick Kelly: Runway of Love*, celebrates the exhibition of the same name, first organized and presented at the Philadelphia Museum of Art in 2014, and revised by the Fine Arts Museums of San Francisco in 2021. We thank Timothy Rub, the George D. Widener Director and Chief Executive Officer at the Philadelphia Museum of Art, for his support of the original exhibition, and Thomas P. Campbell, director and chief executive officer at the Fine Arts Museums of San Francisco, for his vision to bring this presentation to the West Coast.

The Fine Arts Museums' program would not have been possible without the full support of our presenting sponsor, Diane B. Wilsey. Additional support is provided by the Textiles Arts Council of the Fine Arts Museums of San Francisco and Mr. Hanley T. Leung. The exhibition and catalogue showcase the remarkable archive of Patrick Kelly's designs now in the collection of the Philadelphia Museum of Art, generously given by Bjorn Guil Amelan, Patrick Kelly's former business and life partner, and Bill T. Jones. We thank them for their exceptional gift to the Philadelphia Museum of Art, and for their unerring support over the past decade, which has contributed immensely to the new exhibition and this catalogue, the first monograph on the artist. The Fine Arts Museums' presentation is uniquely enriched by gracious loans of Patrick Kelly's sketches by the Schomburg Center for Research in Black Culture, The New York Public Library. We thank Kevin Young, director, and Cheryl Beredo, curator of the Manuscripts, Archives and Rare Books Division, for sharing these works with the Museums. We are also immensely grateful for recent gifts to the Fine Arts Museums' collection by Kelly's dear friends and colleagues Elizabeth "Ms. Liz" Goodrum and Audrey Smaltz, which further enhance the Museums' holdings.

For more than a decade, the exhibition and catalogue narratives have benefited tremendously from the generosity of many people who graciously shared their time, knowledge, and memories of Patrick Kelly with the curatorial team. We deeply thank Rachida (Abou El Wafa) Afroukh, Richard E. Allen, Preston Bailey, Pat Cleveland and Paul Van Ravenstein, Gilles Decamps, Louis Dell'Olio, Maud Frizon de Marco, Dianne deWitt, Julio Donoso, Thierry Dreyfus, Mayor George Flaggs Jr., Elizabeth "Ms. Liz" Goodrum, Kate Greenfield, Michael Gross, Larry Hashbarger, Beverly Johnson, Sharon "Magic" Jordan-Roach, Eddie Kuligowski, Marco Fattuma Maò, David Martin, Betté McKenzie, Andrea Mergentime, Michael Merrill, Coco Mitchell, Carol Mongo, Josie Natori, George Nunno, Veronica Pearman, Gilles Riboud, Patrick Robinson, Anne Rohart, Suze Yalof Schwartz, Kathryn Sermak, Tara Shannon, Lu Sierra, Audrey Smaltz, Toukie A. Smith, Gloria Steinem, André Leon Talley, Oliviero Toscani, Connie Uzzo, Mel West, Mary Ann Wheaton, Roshumba Williams, Travis Winkey, and Vicente Wolf. We extend our appreciation to Sequoia Barnes, advising scholar for *Patrick Kelly: Runway of Love* at the Fine Arts Museums, whose detailed knowledge of the designer, and thoughtful guidance, helped shape the updated presentation and related public programming in San Francisco. For their support of Dr. Barnes's work, we also thank Saaqib Ilyaas Bahktawar, founder of D/ecology; Zoë Charlery, writer, producer, and scholar; and Sabrina Henry, curator at the Centre for Contemporary Arts, Glasgow.

This catalogue was meticulously produced by the Publications department at the Fine Arts Museums of San Francisco and thoughtfully and

creatively overseen by Leslie Dutcher, director of publications, whose passion for this project made the realization of this volume a true pleasure. We also thank José Jovel, publications assistant, who managed the catalogue's spirited image program. Lesley Bruynesteyn sensitively edited this volume, and Yolanda de Montijo crafted its vibrant design. The color separations, printing, and binding were managed by the exceptional team at Conti Tipocolor, including Roberto Conti, Marta Conti, Lucia Conti, Laura Cuccoli, and Alfredo Zanellato. At Yale University Press we thank Patricia Fidler, Katherine Boller, and Raychel Rapazza for their wonderful partnership. This publication was greatly enhanced due to the tremendous efforts of the photo services team, in particular Robert Carswell, digital asset and rights manager, and especially Randy Dodson, head photographer, under the leadership of Sue Grinols, director of photo services and imaging. External catalogue essayists Darnell-Jamal Lisby, Eric Darnell Pritchard, madison moore, and Sequoia Barnes provided additional scholarly perspectives on Patrick Kelly's life, career, and legacy, and we thank them for their exceptional contributions. We extend our heartfelt thanks to Patrick Kelly's dear friends and colleagues, including Cheryl Ann Wadlington, Pat Cleveland, Mel West, Carol Mongo, Elizabeth "Ms. Liz" Goodrum, Sharon "Magic" Jordan-Roach, Audrey Smaltz, Mary Ann Wheaton, Gilles Decamps, and most especially André Leon Talley and Bjorn Guil Amelan, for sharing their fond memories and unique insights on Kelly in this book. We also give thanks to Jonathan M. Square, scholar of fashion and visual culture in the African Diaspora at Harvard University, for his review of the catalogue. His critical feedback greatly enriched the volume's essays. We further offer a special note of appreciation to Anna Wintour for her enthusiasm for the project. This catalogue is published with the assistance of the Andrew W. Mellon Foundation Endowment for Publications.

At the Fine Arts Museums, we further thank our Board of Trustees, led by Jason Moment, president, and Diane B. Wilsey, chair emerita, for their support. We acknowledge the Fine Arts Museums' exhibitions division, led by Krista Brugnara, director of exhibitions, and including Caroline McCune, senior exhibitions coordinator, who dutifully oversaw all aspects of this project's realization by the Museums; Ryan Butterfield, director of preparation and installation, and his staff of talented technicians; and Alejandro Stein, director of exhibition design, and Tristan Telander, exhibition designer, who realized the exhibition's remarkable design. In Registration and Collections Management, we are grateful to Kimberley Montgomery, chief registrar, and her team, especially Amy Andersson, museum registrar, who swiftly and strategically coordinated private and institutional loans. In Education, we thank Sheila Pressley, director of education, alongside her staff, including Francesca D'Alessio, senior manager of public programs; Renee Villasenor, assistant manager of education and public programs; and Maria Egoavil, education and public programs coordinator. We thank Abram Jackson, adjunct lecturer, Race and Resistance Studies, San Francisco State University, for his thoughtful feedback on the exhibition's gallery texts. We are appreciative of Linda Butler, director of marketing and communications, and her staff, including Miriam Newcomer, director of communications; Helena Nordström, associate director of communications; Francisco Rosas, internal communications and content project manager; and particularly Shaquille Heath, manager of communications, for her heartfelt promotion of this project to press and the broader public. In Development, Amanda Riley, director of development,

is acknowledged, alongside Christine Chiang, director of foundation and government giving; Helen Hatch, director of individual and major giving; Karen Huang, senior director of individual and major giving; Megan McCauley, director of membership; Carrie Montgomery, director of special events; Christa Sundell, director of corporate giving; Lindsey Stoll, events manager; Cheyenne Tang, assistant events manager; Matthew Sussman, grants manager; and Rosie Williams, individual giving officer. We further recognize the contributions of Patricia Buffa, director of digital strategy; Courtney Fallow, digital production manager; Andrew Fox, senior web and interactive developer; Simone Polgar, digital product manager; and Meenal Tyagi, digital production coordinator. We are grateful to Rich Rice, director of event and exhibition technology.

In the Art Division at the Museums, we thank Melissa E. Buron, director; Abigail Dansiger, head of library and archives; and Natasha Becker, curator of African art, for their generous support of this endeavor. We are grateful to Jill D'Alessandro, curator in charge of costume and textile arts, for her tireless advocacy at all levels of the conception and realization of this book and exhibition. We also thank Furio Rinaldi, Curator, Achenbach Foundation for Graphic Arts. We acknowledge the many conservators who have led the preparation of art for the exhibition, including, in textiles conservation, Sarah Gates, head of textiles conservation; Anne Getts, associate textiles conservator; and Laura Garcia Vedrenne, Andrew W. Mellon Fellow in Textiles Conservation. In paper conservation, we recognize Victoria Binder, head of paper conservation, and Allison Brewer, assistant paper conservator; and, in objects conservation, we salute Jane Williams, director of conservation, and Colleen O'Shea, Andrew W. Mellon Assistant Objects Conservator.

Furthermore, we acknowledge many individuals and their teams who work dedicatedly behind the scenes to realize our many programs, including Megan Bourne, chief of staff; Jason Seifer, chief financial officer; Susan McConkey, chief administrative officer; Patty Lacson, director of facilities; Paul Peterson, director of information technology; Lindsay Ganter, special projects manager; and Jenny Sonnenschein, executive assistant to the director and CEO. We also extend our gratitude to Stuart Hata, director of retail operations; Rose Burke, merchandise manager; and Tim Niedert, book and media manager.

At the Philadelphia Museum of Art, the original exhibition was supported in part by the Arlin and Neysa Adams Endowment. Additional funding was provided by Barbara B. and Theodore R. Aronson, Arthur M. Kaplan and R. Duane Perry, Nordstrom, and by members of Les Amis de Patrick Kelly, a group of generous supporters chaired by Bjorn Guil Amelan and Bill T. Jones. In Philadelphia, we further thank Alice Beamesderfer, former Zoë and Dean Pappas Deputy Director for Collections and Programs, and Gail Harrity, former president and chief operating officer, for their support of the acquisition of the Patrick Kelly archive and realization of the exhibition in 2014. We acknowledge the efforts of Yana Balson, director of exhibition planning; Nicole Stribling, exhibition project manager; Suzanne Wells, former director of special exhibition planning; Irene Taurins, former director of registration; Morgan Webb, director of registration; Hannah Kauffman, associate registrar for outgoing loans; and Kara Furman, associate registrar for exhibitions, for helping organize the exhibition and coordinating its travel to venues in 2021. For their beautiful design of the 2014 exhibition, we are grateful to Jack Schlechter, the Park Family Director of Installation Design; Jeffrey Sitton,

former installation designer; and Andy Slavinskas, lighting designer. In the Costume and Textiles department, we acknowledge the tremendous efforts of Kristina Haugland, the Le Vine Associate Curator of Costume and Textiles and Supervising Curator for the Study Room; Cathy Coho, collections assistant; Shen Shellenberger, administrative assistant; Barbara Darlin, former collections assistant; Stephanie Feaster, former department assistant; Paula M. Sim, former intern; Joanna Fulginiti, former administrative assistant; Sara Reiter, the Penny and Bob Fox Senior Conservator of Costume and Textiles; Bernice Morris, associate conservator of costume and textiles; Lisa Stockebrand, former conservation technician; and Debra Sitner, the late Nancy Bergman, Catherine Hineline, and other departmental volunteers.

For their careful editing of exhibition materials and graceful graphic designs, we thank Amy Hewitt, editor and project coordinator; Jacqui Baldridge, former graphic designer; and Barb Barnett, former senior graphic designer; and others in the Editorial and Graphic Design department. We also express our deep appreciation to Jason Wierzbicki, conservation photographer and former museum photographer, as well as others in the Photography Studio, for their elegant photographs of Patrick Kelly's designs, which appear throughout this publication. We express our thanks as well to Jane Allsopp, former director of major gifts, and others in Development; Steve Keever, audio-visual services manager, and others in Information and Interpretive Technologies. In Curatorial, we thank Innis Shoemaker, curator emerita of prints, drawings, and photographs; Louis Marchesano, the Audrey and William H. Helfand Senior Curator of Prints, Drawings, and Photographs; Peter Barberie, the Brodsky Curator of Photographs, Alfred Stieglitz Center; and Sharon Hildebrand, head preparator for the Prints, Drawings, and Photographs department. Our deepest appreciation is also given to the many other individuals who made the original exhibition in Philadelphia possible, including members of the departments of Facilities and Operations, Finance, Installations and Packing, Marketing and Communications, Membership and Visitor Services, and Education.

We are pleased that after its presentation at the Fine Arts Museums, the show will travel to the Peabody Essex Museum in Salem, Massachusetts. We extend our great thanks to our esteemed colleagues at the Peabody Essex, including Lynda Roscoe Hartigan, Rose-Marie and Eijk van Otterloo Executive Director and CEO; Petra Slinkard, Director of Curatorial Affairs, the Nancy B. Putnam Curator of Fashion and Textiles; Theo Thyson, advising scholar; Priscilla Danforth, director of exhibition planning; and Hannah Silbert, exhibition project manager.

We dedicate this publication to the loving memory of our dear friend and colleague Monica E. Brown. As senior collections assistant for costume and textiles with the Philadelphia Museum of Art, Brown championed and facilitated the acquisition of the Patrick Kelly archive, and provided unmatched curatorial support throughout its acquisition and the research and development of the 2014 exhibition. Her contributions reverberate throughout this book, which benefits especially from her "magic touch"—her innate sense of style and remarkable skill for costume mounting.

Last, but not least, we honor the remarkable spirit and legacy of Patrick Kelly, who lives on through his fashion designs and in the hearts and minds of all who knew him.

PICTURE CREDITS

Front cover: Patrick Kelly's Fall/Winter 1988–1989 advertising campaign. Photograph by Oliviero Toscani. Courtesy of the Estate of Patrick Kelly. Scan by Randy Dodson / Fine Arts Museums of San Francisco

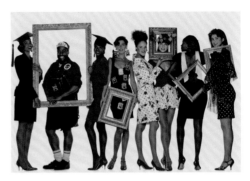

Back cover: Patrick Kelly's Spring/Summer 1989 advertising campaign. Photograph by Oliviero Toscani. Courtesy of the Estate of Patrick Kelly. Scan by Randy Dodson / Fine Arts Museums of San Francisco

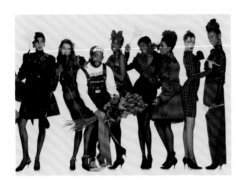

p. 2: Patrick Kelly's Fall/Winter 1988–1989 advertising campaign. Photograph by Oliviero Toscani. Courtesy of the Estate of Patrick Kelly. Scan by Randy Dodson / Fine Arts Museums of San Francisco

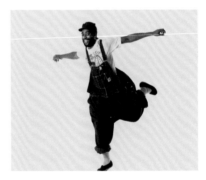

p. 4: Portrait of Patrick Kelly. Photograph by Oliviero Toscani. Courtesy of the Estate of Patrick Kelly. Scan by Randy Dodson / Fine Arts Museums of San Francisco

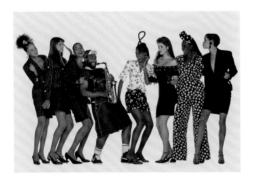

p. 6: Patrick Kelly's Spring/Summer 1989 advertising campaign. Photograph by Oliviero Toscani. Courtesy of the Estate of Patrick Kelly. Scan by Randy Dodson / Fine Arts Museums of San Francisco

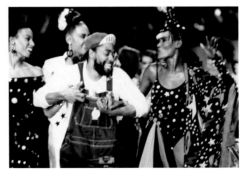

p. 8: Patrick Kelly and model Grace Jones at the finale of the designer's Spring/Summer 1989 collection presentation. Courtesy of the Estate of Patrick Kelly. Scan by Randy Dodson / Fine Arts Museums of San Francisco. Photograph © Therme

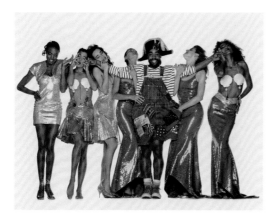

p. 12: Patrick Kelly's Spring/Summer 1988 advertising campaign. Photograph by Oliviero Toscani. Courtesy of the Estate of Patrick Kelly. Scan by Randy Dodson / Fine Arts Museums of San Francisco

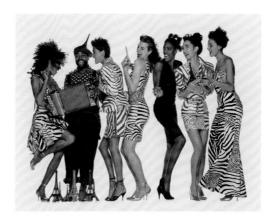

p. 13: Patrick Kelly's Spring/Summer 1988 advertising campaign. Photograph by Oliviero Toscani. Courtesy of the Estate of Patrick Kelly. Scan by Randy Dodson / Fine Arts Museums of San Francisco

p. 14: Patrick Kelly, 1988. Courtesy of the Estate of Patrick Kelly. Scan by Randy Dodson / Fine Arts Museums of San Francisco. Photograph by Steve Ueckert, © Houston Chronicle. Used with permission

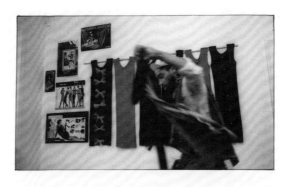

p. 28: Patrick Kelly in his studio at 17 Rue du Mail, Paris, preparing the Spring/Summer 1986 collection. Courtesy of the Estate of Patrick Kelly. Scan by Randy Dodson / Fine Arts Museums of San Francisco

p. 36: Patrick Kelly as seen on *America's Black Forum*, November 5–6, 1988. Courtesy of the Estate of Patrick Kelly. Scan by Randy Dodson / Fine Arts Museums of San Francisco

p. 44: Photograph from the Patrick Kelly Paris Spring/Summer 1987 collection presentation invitation. Courtesy of the Estate of Patrick Kelly. Scan by Randy Dodson / Fine Arts Museums of San Francisco

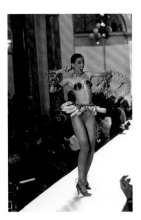

p. 50: Pat Cleveland performs as Josephine Baker at the Patrick Kelly Paris Fall/Winter 1986–1987 fashion show. Courtesy of the Pat Cleveland Archive

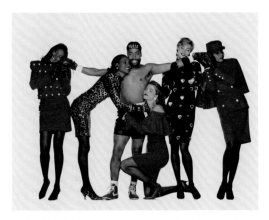

p. 58: Patrick Kelly's Fall/Winter 1989–1990 advertising campaign. Photograph by Oliviero Toscani. Courtesy of the Estate of Patrick Kelly. Scan by Randy Dodson / Fine Arts Museums of San Francisco

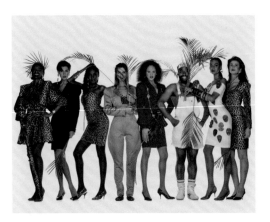

p. 59: Patrick Kelly's Spring/Summer 1989 advertising campaign. Photograph by Oliviero Toscani. Courtesy of the Estate of Patrick Kelly. Scan by Randy Dodson / Fine Arts Museums of San Francisco

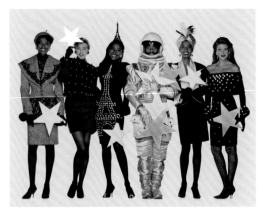

p. 160: Patrick Kelly's Fall/Winter 1989–1990 advertising campaign. Photograph by Oliviero Toscani. Courtesy of the Estate of Patrick Kelly. Scan by Randy Dodson / Fine Arts Museums of San Francisco.

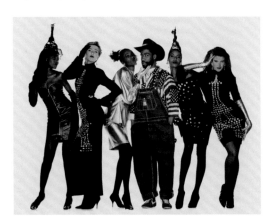

p. 161: Patrick Kelly's Fall/Winter 1989–1990 advertising campaign. Photograph by Oliviero Toscani. Courtesy of the Estate of Patrick Kelly. Scan by Randy Dodson / Fine Arts Museums of San Francisco

p. 199: Patrick Kelly with model and friend Toukie Smith at the finale of the Fall/Winter 1989–1990 collection presentation. Photograph by PL Gould / IMAGES / Getty Images

CATALOGUE ILLUSTRATIONS All photographs are courtesy of the Philadelphia Museum of Art.

FIGURE ILLUSTRATIONS 1, 3, 5, 9, 19, 51: Photographs and Prints Division, Schomburg Center for Research in Black Culture, The New York Public Library. 2, 18, 20–21, 34–35, 37, 50, 55, 57-63, 66, 71, 74: Courtesy of the Estate of Patrick Kelly. Scan by Randy Dodson / Fine Arts Museums of San Francisco. 4: Photograph by Eddie Kuligowski. Courtesy of the Eddie Kuligowski Estate. 6, 12: Gamma-Rapho via Getty Images. 7: Horst P. Horst. © Condé Nast. Courtesy of the Estate of Patrick Kelly. Scan by Randy Dodson / Fine Arts Museums of San Francisco. 8: Horst P. Horst, photograph in *Vogue*, 1937. © Condé Nast. Shutterstock. 10, 54, 56: Patrick Kelly Archive. Manuscripts, Archives and Rare Books Division, Schomburg Center for Research in Black Culture, The New York Public Library. 11: Gysembergh Benoît / Contributor. *Paris Match* Archive via Getty Images. 13: Progretto S-Cambia of Marco Fattuma Maò, Collection Autumn/Winter 1984–1985, Patrick Kelly for Invenzione. From *MAÒmage Re Patrick Kelly* (Sfogliami). Used with permission from Marco Fattuma Maò. 14–15: From *Sveglia la notte bruciando cacao*, directed by Marco Fattuma Maò. Used with permission from Marco Fattuma Maò. 16–17: Courtesy of the Philadelphia Museum of Art. Scan by Margaret Huang / Philadelphia Museum of Art. 22: Victor Virgile / Gamma-Rapho via Getty Images. 23: Photograph by Rev. Henry Clay Anderson. © Smithsonian National Museum of African American History and Culture, Washington, DC. 24: Photograph by Wayne Maser in *Vogue*, 1988. © Condé Nast. 25: Photograph by PL Gould / IMAGES / Getty Images. 26: Photograph by *Afro-American Newspapers* / Gado / Getty Images. 27, 31-32, 53: Courtesy of the Philadelphia Museum of Art. 28-29: Courtesy of the Philadelphia Museum of Art. Stills by Rich Rice / Fine Arts Museums of San Francisco. 30: Canovas Alvaro / Contributor. *Paris Match* Archive via Getty Images. 33, 73: Photograph by Gilles Decamps. Courtesy of the Estate of Patrick Kelly. Scan by Randy Dodson / Fine Arts Museums of San Francisco. 36, 52: Photograph by Oliviero Toscani. Courtesy of the Estate of Patrick Kelly. Scan by Randy Dodson / Fine Arts Museums of San Francisco. 38: Photograph by Anthony Barboza / Getty Images. 39-40: Photograph © The Bill Cunningham Foundation. *Details* magazine, September 1986. Courtesy of Condé Nast. Scan by Randy Dodson / Fine Arts Museums of San Francisco. 41: Ian Dagnall Computing / Alamy Stock Photo. 42-49: Courtesy of the Estate of Patrick Kelly. Stills by Rich Rice / Fine Arts Museums of San Francisco. 64: Photographs by Simon Brown for *Architectural Digest*, 1989. © Condé Nast. 65: Photograph by Patrick Demarchelier for *Vogue*, 1989. © Condé Nast. 67: Courtesy of the Pat Cleveland Archive. 68: Courtesy of Carol Mongo. 69: Courtesy of Elizabeth "Ms. Liz" Goodrum. 70: Courtesy of Sharon "Magic" Jordan-Roach. Scan by Randy Dodson / Fine Arts Museums of San Francisco. 72: Courtesy of Mary Ann Wheaton. Scan by Randy Dodson / Fine Arts Museums of San Francisco.

CONTRIBUTORS

Sequoia Barnes is an artist and scholar who received her PhD from Edinburgh College of Art at the University of Edinburgh. Her thesis, "Radical Cheek: Black Camp, Racist Kitsch, and Patrick Kelly's Subversive Fashions," explores Kelly's appropriation of racist imagery in his designs. She is the author of the journal articles *"If You Don't Bring No Grits, Don't Come": Critiquing a Critique of Patrick Kelly, Golliwogs, And Camp as A Technique of Black Queer Expression* (2017) and *Patrick Kelly's "Mississippi Lisa": Subverting Racial Kitsch with a T-shirt* (2020).

Dilys E. Blum is the Jack M. and Annette Y. Friedland Senior Curator of Costume and Textiles at the Philadelphia Museum of Art. She has organized many groundbreaking exhibitions including *Shocking: The Art and Fashion of Elsa Schiaparelli* (2003-2004), *Roberto Capucci: Art into Fashion* (2011), *Patrick Kelly: Runway of Love* (2014), and, most recently, *Off the Wall: American Art to Wear* (2020).

Laura L. Camerlengo is associate curator of costume and textile arts at the Fine Arts Museums of San Francisco. She was the co-curator of the critically acclaimed exhibition *Contemporary Muslim Fashions* (2018), and has been a contributor to several Museums' publications, including *Degas, Impressionism, and the Paris Millinery Trade* (2017) and *Contemporary Muslim Fashions* (2018).

Darnell-Jamal Lisby is a fashion historian and independent curator who recently contributed to the *Willi Smith: Street Couture* exhibition at Cooper Hewitt, Smithsonian Design Museum, New York, where he also currently serves as an education coordinator. He writes regularly for mainstream and academic publications such as *Teen Vogue, Cultured Magazine,* and the Fashion and Race Database.

madison moore is assistant professor of queer studies in the Department of Gender, Sexuality and Women's Studies at Virginia Commonwealth University. He is the author of *Fabulous: The Rise of the Beautiful Eccentric* (2018).

Eric Darnell Pritchard's biography of Patrick Kelly, *Abundant Black Joy: The Life and Work of Patrick Kelly*, is forthcoming from Amistad/HarperCollins. They are the Brown Chair in English Literacy and associate professor at the University of Arkansas.

André Leon Talley is a Chevalier of the Ordre des Arts et des Lettres and the former creative director at *Vogue* magazine. He is the author, most recently, of *The Chiffon Trenches* (2020), and he organized the exhibition *Oscar de la Renta* at the Fine Arts Museums of San Francisco and coedited its catalogue (2016).

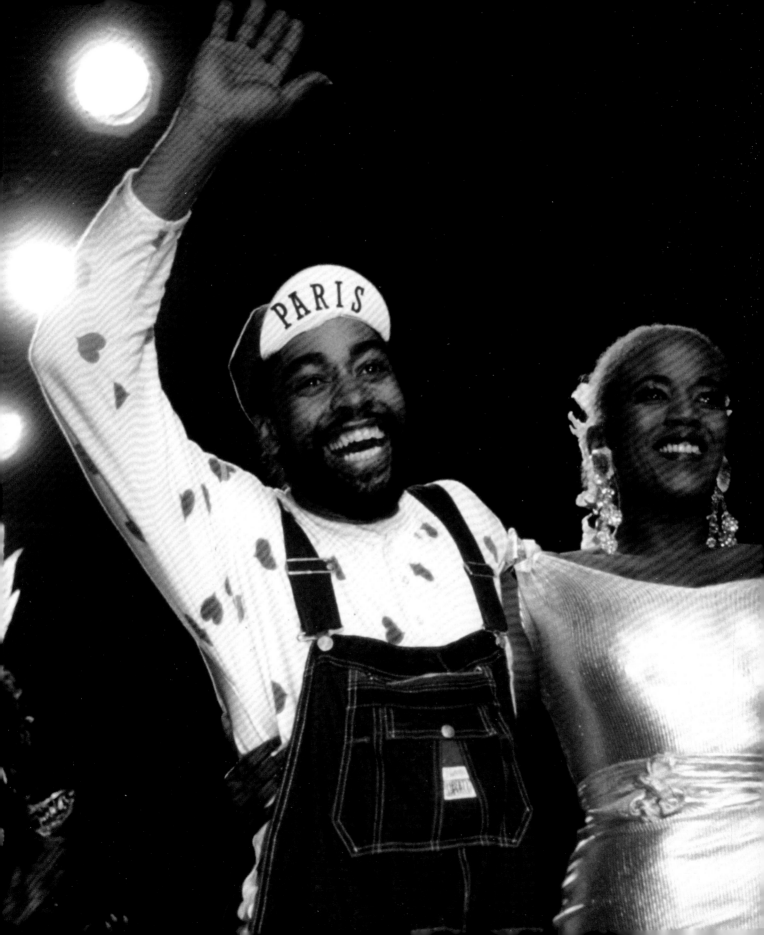

This catalogue is published by the Fine Arts Museums of San Francisco in association with Yale University Press on the occasion of the exhibition *Patrick Kelly: Runway of Love* at the de Young, San Francisco, from October 23, 2021, to April 24, 2022, and at the Peabody Essex Museum, Salem, Massachusetts, June 25 to November 6, 2022.

Patrick Kelly: Runway of Love is organized by the Philadelphia Museum of Art in collaboration with the Fine Arts Museums of San Francisco.

The organizing curator is Dilys E. Blum, the Jack M. and Annette Y. Friedland Senior Curator of Costume and Textiles, with curatorial support from Monica E. Brown (1949–2015), senior collections assistant for costume and textiles, and Laura L. Camerlengo, former exhibition assistant for costume and textiles, at the Philadelphia Museum of Art.

The presenting curator is Laura L. Camerlengo, associate curator of costume and textile arts at the Fine Arts Museums of San Francisco.

Presenting Sponsor
Diane B. Wilsey

Additional support is provided by the Textile Arts Council of the Fine Arts Museums of San Francisco and Mr. Hanley T. Leung.

This catalogue is published with the assistance of the Andrew W. Mellon Foundation Endowment for Publications.

Library of Congress Cataloguing in Publication Control Number: 2021935649

ISBN: 978-0-300-26023-6

Yale University Press
P.O. Box 209040
302 Temple Street
New Haven, CT 06520-9040
yalebooks.com/art

Fine Arts Museums of San Francisco
de Young, Golden Gate Park
50 Hagiwara Tea Garden Drive
San Francisco, CA 94118-4502
famsf.org

Leslie Dutcher, director of publications
Trina Enriquez, editor
Victoria Gannon, editor
José Jovel, publications associate
Barbara Morucci, editorial assistant

Project management and editing by Lesley Bruynesteyn
Picture research by José Jovel
Proofread by Susan Richmond with Trina Enriquez
Reading and vetting by Jonathan M. Square
Designed and typeset by Yolanda de Montijo, Em Dash
Color separations, printing, and binding by Conti Tipocolor, Italy